Coming Home!

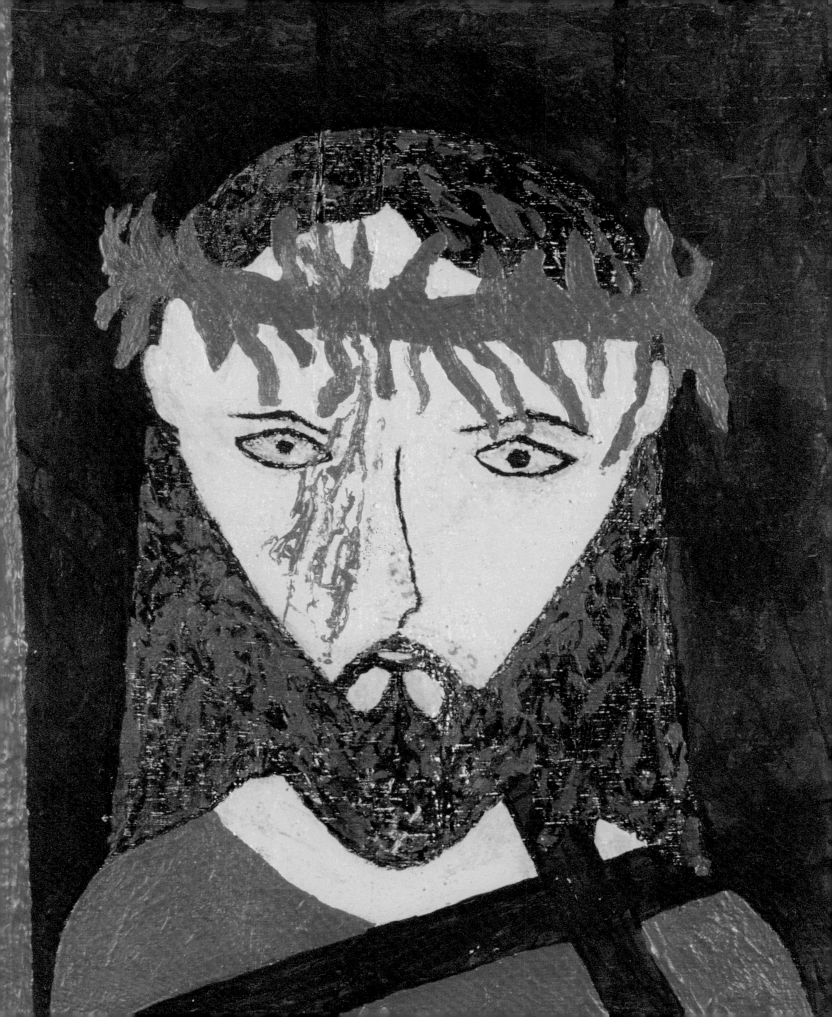

Coming Home!

Self-Taught Artists, the Bible and the American South

Carol Crown, University of Memphis

With contributions by Erika Doss, Hal Fulmer,

N. J. Girardot, Paul Harvey, Lee Kogan, Babatunde Lawal,

Leslie Luebbers, Cheryl Rivers, and Charles Reagan Wilson

Art Museum of the University of Memphis in association

with the University Press of Mississippi, Jackson

This book is published in conjunction with the exhibition **Coming Home! Self-Taught Artists, the Bible and the American South,** organized by the Art Museum of the University of Memphis.

Exhibition itinerary

June 19–November 13, 2004, Art Museum of the University of Memphis, Memphis, Tennessee

February–March 2005, Florida State University Museum of Fine Arts, Tallahassee, Florida

May–July 2005, Museum of Biblical Art, New York, New York

NATIONAL ENDOWMENT FOR THE ARTS

This exhibition and book have been made possible in part by the National Endowment for the Arts, The Rockefeller Foundation, Humanities Tennessee, and the University of Memphis College of Communication and Fine Arts.

www.upress.state.ms.us

The University Press of Mississippi is a member of the Association of American University Presses.

Frontis: Felix Virgous, *Head of Christ* detail, plate 112

Copyright © 2004 by the Art Museum of the University of Memphis

All rights reserved

Manufactured in Canada

07 06 05 04 4 3 2 1

Library of Congress Cataloging-in-Publication

Coming home! : self-taught artists, the Bible and the American south / Carol Crown ; with contributions by Erika Doss . . . [et al.].

p.cm.

Catalog of an exhibition at the Art Museum of the University of Memphis, Memphis, TN, June 16–Nov. 13, 2004; the Florida State University Museum of Fine Arts, Tallahassee, FL, Feb.–Mar. 2005; and at the Gallery at the American Bible Society, New York, NY, May–July 2005. Includes bibliographical references and index.

ISBN 1-57806-658-1 (cloth : alk. paper) — ISBN 1-57806-659-X (pbk. : alk. paper)

1. Outsider art—Southern States—Exhibitions. 2. Art, American—Southern States—Twentieth Century—Exhibitions. 3. Art and religion—Southern States—Exhibitions. I. Crown, Carol. II. Doss, Erika Lee. III. University of Memphis. Art Museum. IV. Florida State University Museum of Fine Arts. V. American Bible Society. Gallery.

N6520.C66 2004

709'.75'07473—dc22 20033026677

British Library Cataloging-in-Publication Data available

Contents

Foreword

Lee Kogan

In the 1930s, John Dewey articulated a philosophical idea of multiperspectival scholarship that remains relevant today in the analysis and interpretation of the work of self-taught artists. His idea was that the examination of subjects across a spectrum of America's diverse populations and disciplinary frameworks encourages conversation and critical thinking that leads to the layered understandings and shared meanings that are at the core of an active, pluralistic democracy.

During the first decades of the twentieth century, such American modernist artists as Robert Laurent, Yasuo Kuniyoshi, Marsden Hartley, and Elie Nadelman were attracted to folk artifacts that resonated with their own aesthetic principles and seemed to evoke the democratic American spirit. Decades later in 1976, the Bicentennial sparked a surge of patriotic fervor and folk art collecting, which led to the seminal *Black Folk Art in America: 1930–1980* that expanded and renewed interest in vernacular expression and began the breakdown of barriers of race, gender, education, and other social and economic considerations.

In the past decade, the context of American culture and attitudes toward folk art has changed and helped expand the parameters of and discourse about the work and its meanings and implications. Folk art has gained considerable respect in the official art world, as museums have acquired work by self-taught artists or sponsored exhibitions of traditional or contemporary work. Museums devoted to folk art have expanded, and other museums have added folk art departments. A flurry of articles and publications featuring folk art, artists, and collectors continues unabated. Academic programs, courses, and symposia study and disseminate information about folk art, and a healthy market allows for the building of public and private collections.

Understanding the heritage of folk art and the depth of its cultural rooting has aided in demythologizing the racist and class-bound notions of "outsider" artists as culturally isolated. This catalogue for *Coming Home! Self-Taught Artists, the Bible and the American South* focuses on the religious impulse among folk artists, examines the similarities and variations of beliefs among them and approaches their work from the perspectives of traditional fine art, iconography, cultural studies, politics, religious studies, and communication theory. Fresh insights, gained through this serious and careful scholarship, should serve as a springboard to encourage scholars in other disciplines to study the work of self-taught artists and their role in American culture.

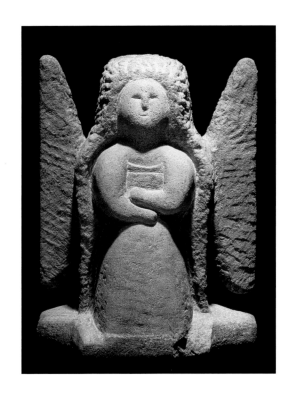

To the memory of Sandy Lowrance and Doug Lemmon,
two colleagues lost along the way whose contributions and creative energies
continue to inspire and inform *Coming Home!*

Acknowledgments

Many people and institutions have contributed to *Coming Home!* These include faculty, staff, and graduate students of the University of Memphis in the Department of Art, the Art Museum of the University of Memphis (AMUM) and members of its Board, McWherter Library, and the College of Communication and Fine Arts; the staffs of libraries, archives, and collections at other institutions, including the Jenks Memorial Collection of Adventual Materials, Aurora University, the American Folk Art Museum (AFAM), Intuit: The Center for Intuitive and Outsider Art, and the Folk Art Society of America; and granting agencies, such as Humanities Tennessee, the National Endowment for the Arts, and the Rockefeller Foundation. Scholars of contemporary folk art and Southern religion, especially Lee Kogan, Roger Manley, and Charles Reagan Wilson, gave the exhibition support and encouragement from an early stage.

A project like *Coming Home!* involves such an extraordinary number of people that it is impossible to thank everyone; *Coming Home!* is the product of all their efforts. Among those who stayed the course, working on every stage of the project are Leslie Luebbers, AMUM's director, whose inspiration, encouragement, and hard labor have been instrumental in the origin, development, and realization of *Coming Home!*

Most involved in the project's final stages were Lisa Francisco Abitz, AMUM's assistant director, who along with David Horan from the Department of Art, traveled the country to photograph works of art. Cheryl Rivers, Folk Art Institute (AFAM), has been my intellectual companion; few know so much about contemporary folk art, Evangelical Protestantism, and American history. I have also been deeply touched by the assistance of many gallery dealers and also by collectors, especially Robert Cargo Folk Art Gallery, Bob Roth, Carl and Babe Mullis, Dan and Kriti Cleary, Craig Wiener, Randall Lott and Nancy McCall, and Ann and William Oppenhimer, who have not only opened their homes to me but broadened my understanding of the art they love.

Finally, I must thank my family for their seemingly endless support and patience. My daughters, Amanda, Melissa, and Bridget, went on field trips with me. My husband, Richard R. Ranta, served as my traveling companion, photographer, and sometimes editor. My Mom and my Dad, who is 96 (and a self-taught wood carver), have always been my inspiration.

Carol Crown,
October 2003

< William Edmondson, *Angel*, plate 23

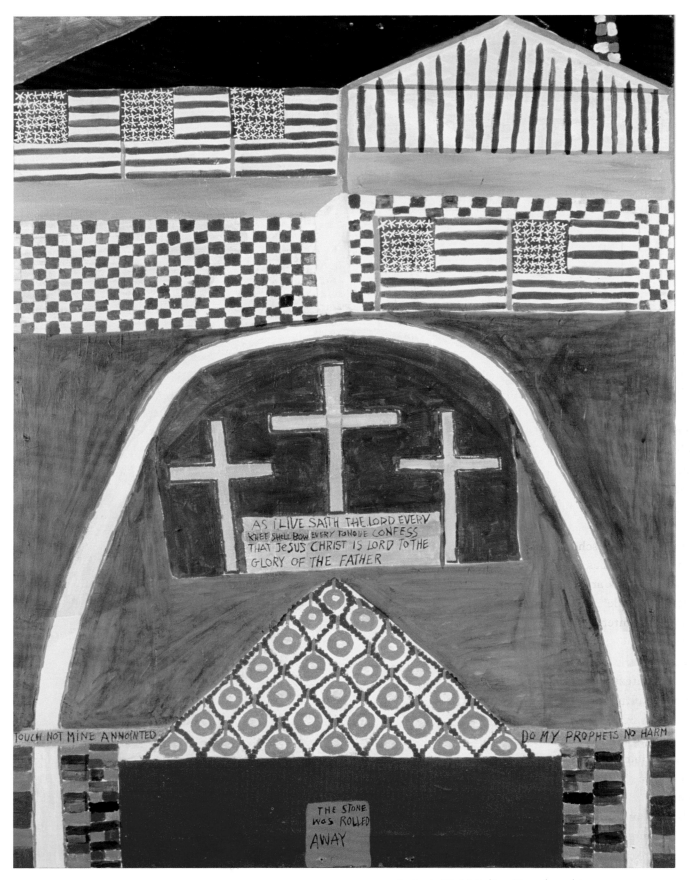

Benjamin "B. F." Perkins, *Homeplace,* plate 73

Introduction

Leslie Luebbers

Coming Home! Self-Taught Artists, the Bible and the American South examines the art of vernacular painters and sculptors inspired by evangelical Christianity and its cultural milieu in the southeastern United States. "Coming Home" refers to the Christian belief in the New Jerusalem, the paradise prophesied in the Bible—the earthly pilgrim's final home. Understood within the framework of American history, the term also has patriotic overtones, alluding to the idea of America as the gateway to the New Jerusalem. "Self-Taught Artists" identifies the unschooled practitioners, also sometimes described as vernacular, visionary or contemporary folk artists, who are the makers of this art. The "Bible" is the foundation for their highly individual interpretations. The "American South," cradle of a vibrant tradition of music, literature, and popular expressive forms inspired by religion, is the context in which this art arises. Although similar cultural products may be found in other locations in the United States, the South remains the source and the area of concentration of this living religious cultural tradition that is clearly distinct from, for example, the Spanish/Mexican/Catholic traditions of the Southwest or those of Native Americans.

The interpretive approach of *Coming Home!* joins three major developments in the recent history of art and cultural studies: a recognition of a religious impulse in modern and contemporary art; the expansion of the subject matter of art history to include the nonacademic artistic traditions and contemporary practices of America's many cultural groups; and new scholarship that applies the methodology of material culture studies to an exploration of how images function in American religious experience.

In 1975, Robert Rosenblum, in his seminal book, *Modern Painting and the Northern Romantic Tradition: Friedrich to Rothko*, established the continuity of religious motivation in the painting of artists formed within the Protestant traditions of Northern Europe and America. A decade later, *The Spiritual in Abstract Painting: 1895–1985*, organized by Maurice Tuchman and the Los Angeles County Museum of Art, examined the religious motivations behind and meanings embedded in abstract painting. Rosenblum's and Tuchman's achievements are examples of a significant shift in art history and contemporary art during the 1970s and 1980s from formalism toward what critic Suzi Gablik called "the reenchantment of art." Although not all of the artists identified in this art historical reevaluation belonged to religious or quasi-religious groups, all of them share a belief in the individual's direct aspiration to the divine.

During these same two decades, a related endeavor expanded the definition of American art beyond the fine art academy and museum to encompass the cultural production of previously marginalized women, black, Hispanic, Native American, and other groups. Feminist art historians, led by Linda Nochlin, exposed the repressive social agendas of artistic representation and sought to recover women artists of the past, while contemporary women artists challenged ways of seeing and thinking about gendered images and about the traditional women's artistic media long regarded by the establishment as minor or craft forms. Similar combinations of intellectual, artistic, and political enterprise continue to enlarge the scope of American art. The emergence of self-taught or vernacular artists, as the confusion about their name implies, followed several entwined paths, from outsider (or psychologically abnormal) artists, promoted by French artist Jean Dubuffet, to a renewed interest in living American folk art traditions, to an effort, similar to the feminist endeavor, to recover and present the work of black artists, who rarely had access to academic training.

Nomenclature notwithstanding, the work of these disparate groups gained considerable attention beginning in the late 1970s in art fairs, books, gallery and museum exhibitions, museum collections, and, eventually, museums—the American Folk Art Museum and the American Visionary Art Museum—dedicated to their work. While they are "marginal" in the sense that they are not of the academy and museum mainstream, the artists in *Coming Home!* are rarely "outsiders" or those who, in the term's original connotation, are isolated from society due to aberrant emotional or social behavior. On the contrary, their ideas and images emerge from traditions of evangelical Christianity that are indispensable to understanding the American South. Nevertheless, the term "outsider," an inherently exclusionary term, is still used to encompass artists like those in the exhibition. *Com-*

ing Home! takes a tactical position against this practice by focusing on the correlations and connections of its artists with those of the established mainstream and the new mainstream enlarged by tributaries of feminist, ethnic, and traditional American folk artists.

During the 1990s, a young generation of scholars turned its attention to images associated with American religious life. Led by art and cultural historians David Morgan and Sally Promey, "The Visual Culture of American Religions" project assembled scholars in several disciplines in a multi-year study. The group coalesced around recognition of four factors: the strong religious traditions in American history; the enormous recent growth in conservative religions of all kinds across the nation; the importance of the visual culture of religion (architecture, painting, sculpture, and popular images related to all kinds of religious practices); and the startling void of scholarship at the intersection of visual culture and religious studies. The group's goals were to look at methodologies appropriate to academic inquiry for this subject, to explore major issues in the history of American religious imagery, and to produce case studies that would demonstrate the potential contribution of further work to a more complete understanding of the American experience. In general, their approach was to examine images not as reflections of religious ideas or practices, but as participants in the social construction of religious ideas and practices; in short, not what images are, but what they do. *The Visual Culture of American Religions* (2000) assembles the case studies and summarizes the project.

Scholarly work on the art of American untrained artists is just emerging from its important initial phase—discovery and description. Although exciting books and exhibits were produced during this time, efforts at analysis rarely surpassed artistic biography. In almost every case, art related to religious life was considered "visionary," or the ex-

pression of entirely personal imaginings, and these "visions" have been shown along side, and thus compared to, depictions of alien space invasions or similar fantasies. A second, historical and contextual period of scholarship began in the late 1990s. The multivolume *Souls Grown Deep: African American Vernacular Art* (2000 and 2001), edited by Paul Arnett and William Arnett, focusing on Southern black artists, is its most spectacular early product. Still, to date, little substantive attention has accrued to the role of religion in the work of self-taught artists.

Coming Home! and the essayists in this book, responding to the need for investigation of the intersection of religion and American life, weave a rich multidisciplinary tapestry of historical analysis and new scholarship. In terms of vernacular art and religious studies, Carol Crown, in her thematic discussion of the exhibition, considers iconography in relation to specific evangelical doctrines. She and Erika Doss examine the form, meaning, and purpose of self-taught artists' work in the context of mainstream art history, and Doss argues that religion, faith, and spirituality permeate the spectrum of American visual art, as they do American life. Doss, Babatunde Lawal, and Norman Girardot describe the function of visual art in the individual and social practice of religion and as a method of mediating spiritual, social, and political issues. Paul Harvey and Hal Fulmer elucidate, respectively, the historical development of Southern evangelical denominations and distinctions among them, and the implications of these for personal, social behavior, and attitudes regarding domestic and international politics. Charles Reagan Wilson examines the pervasive influence of religion on and the relationships among Southern visual, musical, literary, and performance arts.

The intention of the organizers of *Coming Home! Self-Taught Artists, the Bible, and the American South* is to contribute to dialogue emerging at the junction of art and religion.

Specifically, their goals are to demonstrate the artistic and cultural significance of the work of Southern vernacular artists within the broad framework of American visual art; to evaluate the importance of religion in this art and to look at the history and faith systems in which it arises; to demonstrate that the religious themes in visual art are paralleled in other forms of artistic expression in the South and that, collectively, they participate in, construct and represent a distinctive and complex American culture.

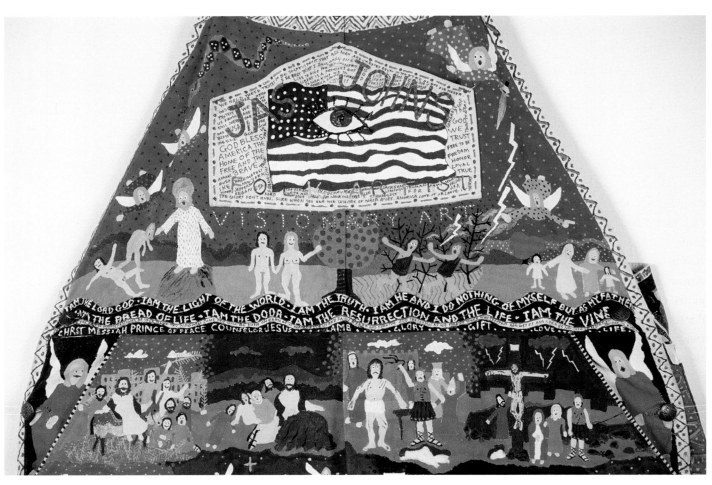

Illus. I-1

Jas Johns (1941–2003)

Heaven and Hell Britches detail, 2000–2002

Acrylic paint on overalls, 65 x 27

Collection of the Artist's Estate

The Bible, Evangelical Christianity, and Southern Self-Taught Artists

Carol Crown

Coming Home! Self-Taught Artists, the Bible and the American South examines the impact of the Bible on the work of unschooled makers of art in a region where evangelical Christianity is the dominant religion.[1] It is not an exhibition of purely religious art nor does it advocate a particular religious doctrine. Instead, *Coming Home!* explores and attempts to better understand how the Bible, seen through the lens of evangelical Christianity, has influenced the subject matter, meaning, and function of artworks made by Southern self-taught artists.[2]

Unlike the religious art of earlier eras, the creations of unschooled artists working in the South are not normally commissioned by nor intended for an institutional patron. Rather, these works are highly personal expressions, made by artists who have in mind a variety of functions: decorative, critical, didactic, proselytistic, or contemplative. Many of these artists identify themselves as evangelical Christians and share common religious beliefs, but even the work of those who do not espouse this brand of faith or who believe themselves untouched by its influence does not always escape the impact of evangelical Christianity in the South.

Coming Home! is organized into a narrative at harmony with evangelical Christianity's Bible-based beliefs, of which the most important is the advocacy of the Bible as the authoritative voice of God. Many of these Christians believe that the Bible's words should be taken literally, accepting its stories not as myth but as the history of God's people. From the story of Creation and the disobedience of Adam and Eve in the Garden of Eden (see plate 113), they deduce that humanity is marred by sin. From the New Testament story of Jesus, the Son of God, they proclaim that Jesus is the new Adam (see plate 121), whose death and resurrection nullify the sin committed in the Garden. Moreover, because conservative Christians believe that the Bible is true, they understand its prophecies to be promises that God will keep. These beliefs, fundamental to evangelical Christianity, inform the organization of *Coming Home!* into four sections. *Southern Religious Life* establishes the importance and the context of church life in the South. *The Garden of Eden* focuses on the Old Testament story of Adam and Eve in Paradise (see illus. I-1). *The New Adam* presents the central figure of Christianity, Jesus Christ, the savior of humankind, and *The New Heavens and Earth* displays the biblical prophecies of Paradise restored. Along the way, viewers have the opportunity of considering how artworks with a wide variety of subjects, meanings, functions, and styles rise from the cultural and religious context in which they were created.

15

Clementine Hunter (1886 or 1887–1988)

Near Nachitoches, Louisiana

Clementine Hunter, *Crucifixion with Red Zinnias*
detail, plate 46

Important sources for Hunter's religious heritage are Shelby Gilley, *Painting by Heart*, Gary B. Mill's *Forgotten People*, Randall M. Millar's "Failed Mission," in *Catholics in the Old South*, ed., Randall M. Millar and John L. Wakelyn, and James Wilson's *Clementine Hunter*.

Clementine Hunter was a prolific painter whose vibrant memory paintings record the daily activities of her neighbors in the vicinity of Melrose Plantation, near Natchitoches, Louisiana. Hunter drew on her experience for detailed scenes of plantation work; hundreds of paintings record workers picking cotton, picking gourds and figs, shaking pecans from trees, and doing laundry. With sly humor, Hunter also recorded the pastimes of her neighbors. Groups of ladies relax playing cards, while couples dance, fight, and fall over drunk outside nearby honky-tonks. Completing Hunter's account of plantation life is a large number of paintings that capture the special religious character of the region. Hunter's works testify to her intimate knowledge of Protestant and Catholic religious traditions and reflect the varied religious life of African Americans who lived near Natchitoches, situated at the border between Protestant northern Louisiana and the Catholic-dominated south.

A Creole, who spoke French until her marriage, Hunter received her brief education from French-speaking nuns. She was a lifelong member of St. Augustine Catholic Church in Isle Breville, recorded in Gary B. Mills's *Forgotten People* as the first Catholic church in the United States built for people of color. Thus, it is not surprising that Hunter's religious paintings often reflect her Catholic background. She paints priests saying mass and casually includes a nun and priest among a very pregnant Mary's escorts to the manger in scenes relating to Jesus's birth. For *Crucifixion with Red Zinnias* (see plate 46), Hunter adopts the formal symmetry and simplified motifs of printed holy cards, flanking the central crucifix with vases of flowers, candlesticks, and angels. Hunter's Christ, however, is black, and her flowers are not the customary baroque bouquets of religious prints but the bright zinnias that adorn the altars of rural churches throughout the South.

Other paintings do not have a specifically Catholic character but reflect the spiritual values of a wider African American community. Hunter's *Wake* (see plate 50) and *Wedding* (see plate 51) depict the importance attached to these rituals by African Americans of all faiths. In *Wake* numerous friends, neighbors, and family members gather to honor the deceased with extravagant bouquets, and in *Wedding*, the bride and groom dressed in appropriate attire are (along with an elaborately decorated wedding cake) the focus of attention. The richly detailed *Tent Revival* (see plate 48), with its exhorting preacher, mourner's bench, and worshipers ecstatically thrashing with the Holy Spirit, is further evidence that, like other African American Catholics in the Deep South, Hunter did not let denominational loyalty impede her participation in the exuberant and personalized spirituality of her neighbors.

Cheryl Rivers

Illus. I-2
Herbert Singleton (b. 1945)
Burning Church, n.d.
Carved and painted wood relief, 13 x 66.5
Collection of Robert A. Roth

SOUTHERN RELIGIOUS LIFE

The South's artistic traditions demonstrate the centrality of the Bible and the prominence of the preacher in religious and social life. In depictions by unschooled artists, preachers often address a congregation with Bible in hand or one on the pulpit in front of them. William Edmondson's limestone *Preacher* (see plate 24), dressed in long-tail jacket and bow tie, asserts both the primacy of God's word by holding his Bible upright before him and, in his finery, the socially prominent role of the preacher in the black community. A self-portrait presents the black untrained artist Sister Gertrude Morgan as God's minister in *Poem of My Calling* (see plate 68). These distinctions of gender and race are important; conservative white churches in the South are more likely to give leadership roles to males, whereas black churches are traditionally more accepting of women leaders. However, male preachers, whether white or black, are generally perceived as being at the church's head. Even so, self-taught artists do not always portray the clergy as being virtuous. Herbert Singleton's *The Biggest Baptist Is the Biggest Sinner* (see plate 95), a painted relief carving that portrays a black preacher fondling a female parishioner, comments on the hypocrisy of the clergy. Much the same attitude is taken by Sultan Rogers in his three-dimensional carving *Preacher* (see Plate 85), whose facial contortions suggest that he is literally talking out of the side of his mouth.

Many artworks in this section record the round of worship activities that evangelical Christians experience throughout a lifetime: baptisms, weddings, funerals, wakes (see plate 50), worship services, and tent revivals. Among several examples are Charlie A. Owens's *Holy Church of God-in-Christ* (see plate 72). Owens, a black Baptist, captures the elation of a congregation belonging to the Memphis-based Church of God in Christ. Linda Anderson shows a white congregation caught up in the spirit in *Mt. Vernon Fire Baptized Pentecostal Holiness Church* (see plate 6). In *Tent Revival* (see plate 48), Clementine Hunter, a Catholic, portrays an exhorting preacher, mourner's bench, and ecstatic worshippers participating in a rapturous evangelical worship service. On the other hand, LeRoy Almon, Sr.'s *My Church* (see plate 3) testifies to the presence of evil in even the most unsuspected place.

The artworks representing Southern religious life in *Coming Home!* often function in several ways. First, some works are memory paintings that nostalgically record or celebrate the social and religious observances that bind Christians together and validate their religious rites. By contrast, representations like Singleton's demonstrate an African American penchant for using art as social commentary. Singleton, who is not affiliated with any denomination, nonetheless admits that Christianity has left a strong imprint on his life.[3] His perceptions of institutionalized religion's failures and the horror of social inequality have inspired much of his art. His *Burning Church* (see illus. I-2), a painted low relief carving depicting an African American church set on fire by a hiding Klansman, offers a striking and more critical view of religion in the South.

THE GARDEN OF EDEN

The story of Adam and Eve in the Garden of Eden forms part of the creation narrative found in the Old Testament book of Genesis; their disobedience constitutes a primary theological doctrine, Original Sin. The goodness Adam and Eve shared with God's creation was lost when they disobeyed the Lord's command and succumbed to the serpent's bidding to eat of the Tree of the Knowledge of Good and Evil. Expelled from Paradise, the First Parents were fated to experience human mortality. According to evangelical Christianity, their sin has been handed down from generation to generation, marring all humanity. As Hal Fulmer writes elsewhere in this catalog, humanity's innate sinfulness is at the heart of religion in the South. It is also at the heart of *Coming Home!*

Many artworks that tell the Garden's story focus on a single episode, while others recount the complete tale. Hugo Sperger's *Creation* (see plate 97) represents this latter approach. Using a technique known as continuous narrative, which calls to mind comic strip illustrations, Sperger presents the story of humanity's creation in three registers, beginning at the upper left and zigzagging to its conclusion at the lower right. Across a tree-filled landscape, the scenes are depicted in small lush bowers inhabited by tiny figures, whose simple forms, exaggerated poses, gestures, and facial contortions, along with citations drawn from Scripture, suffice to convey the major events. Sperger was not trained in such artistic techniques as modeling and three-dimensional perspective, which could make his imagery more lifelike, but his lack of training may be an advantage. The method Sperger uses has been traditionally employed by artists more interested in meaning and expression than verisimilitude. In other words, Sperger's painting suggests that what matters is not how the events in the Garden actually *looked* but what they *meant*. He simplifies human and natural forms, while exaggerating certain features. He also condenses space, emphasizes decorative details to create a primary and expressive language that easily communicates the story with charm, naiveté, and humor, while conveying the beauty and abundance of humanity's first home as well as the protagonists' emotions.

Depictions of Eden often vary in their functions, from purely narrative to decorative; some reveal perceptive insights and offer unprecedented interpretations, while others summarize major teachings of the Christian faith. Larry Stinson selects a moment preceding the Fall of Adam and Eve for his *Garden of Eden* (see plate 98), providing a lighthearted view of Paradise, where playful animals surround the nude figures as they enjoy a peaceful, innocent moment. By contrast, the Kentucky artist Edgar Tolson, who saw in the Fall the complete history of humankind, focuses on the Temptation (see plate 109). Anderson depicts a less provocative moment in *Adam Naming the Animals* (see plate 5). Taking inspiration from Gen. 2:19–20, where Adam at God's behest names the animals, she imagines how this moment might have looked in Paradise. In keeping with the biblical story, her painting presents an idyllic view of the Garden and populates it with a large company of creatures, including a ram, wildebeest, snake, leopard, elephant, and, in the distance, a spouting whale.

Less sanguine, much less figurative, and even more symbolic is Lonnie Holley's *Thou Shall Not* (see plate 45). Taking a child's homemade scooter and upturning it, Holley drove a cross through the toy, its horizontal bar carrying the words of the painting's title. It calls to mind the assemblage art of academically trained sculptors, who compose three-dimensional works from found and altered objects, but Holley's work actually belongs to a long tradition of African American vernacular art with a pharmacopeic or medical intent.[4] Holley's title echoes the order God issued in the Garden as

Edgar Tolson (1904–1984)

Campton, Kentucky

In discussing Edgar Tolson's many renditions of the Adam and Eve story (see plate 109), Michael Hall once commented, "He believes that the Temptation set a course for history. The Crucifixion simply reiterated and reinforced all that was set in motion at the fall. Only Christ's promise separates the two events in Tolson's mind." Tolson's mode of interpretation, known as biblical typology and used from the times of the early church fathers, reads Old Testament figures and events as prefigurations of the Christian story. In this exegetical tradition, history takes its meaning from God's relationship to the Old Adam and to Jesus, the New Adam, the incarnation of the Son of God, who will save humankind through his suffering and death. With Jesus's resurrection comes the promise that humankind represented by the Old Adam will be restored to the dignity lost in the Fall.

Conservative Christians understand the doctrines of Original Sin and salvation through Christ as the basis of faith. It is not surprising that Tolson, a sincere believer who struggled all his life with the desire to follow every precept of faith despite a consciousness of the innate sinfulness of humanity, found himself drawn over and over to Adam and Eve's Fall. The literal and psychological truth of the story of the Fall had great attraction for Tolson, a "called preacher" who resigned from the ministry in 1961 because of his inability to live according to the high standards he demanded of himself.

Although the Adam and Eve theme was first suggested to Tolson by an art professor at the University of Kentucky who had discovered Tolson's early work and wanted to see how the carver could handle the human nude, Tolson made the theme of the Fall of Man the center of his life's work. He carved more than one hundred versions of the Temptation, including a celebrated eight-part tableau that recounts the Genesis story in detail. For Tolson, this story represents "all the stories possible—all through the Bible. That's from the beginning to the end, from Genesis to Revelations. . . . It's about the whole thing. . . . That's something to think about!"

Cheryl Rivers

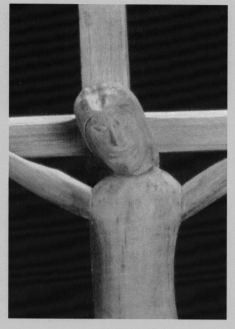

Edgar Tolson, *Crucifixion* detail, plate 108

well as those he gave to Moses on Mt. Sinai, the Ten Commandments. Holley's *Thou Shall Not* encapsulates the doctrine of Original Sin, demonstrates the dreadful consequences of human evil, and, using the symbol of the cross, seeks both to curse and cure it.

THE NEW ADAM

And so it is written, The first man, Adam, was made a living soul; the last Adam was made a quickening spirit.
—I Cor. 15:45

St. Paul's comparison of Adam and Christ in his letter to the Corinthians led to the designation of Christ as the Second or New Adam. Because Jesus is the Son of God, his death on the cross serves as a perfect sacrifice, redeeming humankind from Adam's sin. To emphasize his role as redeemer, contemporary self-taught artists often create images of Christ that are fundamentally iconic, non-narrative, and formal. This nondiscursive approach focuses viewer attention on Christ, encouraging meditation on his role in the divine economy.

In *Coming Home!* two paintings by the African American artist Sam Doyle, one undated and untitled but representing Christ's nativity (see plate 22) and *I'll Go Down* (see plate 23) depicting his Crucifixion, frame the story of Jesus's earthly life and emphasize his dual nature as God and man. These paintings serve as contemplative devices that affirm basic teachings of the Christian faith. In the depiction of Christ's birth, the child is nestled in a manger between his kneeling mother and the standing figure of his father with a staff. The scene takes place within an outdoor setting of monumental grandeur, suffused with pastel colors and illuminated by a starry sky. The largest and most brilliant star drenches the child in light, uniting heaven and earth, the divine and physical, in an event of cosmic significance—the birth of

God in human form. *I'll Go Down*, which is painted on louvers, carries a simple depiction of the Crucifixion. Christ is pictured on the cross, hanging limp and bloodied from his wounds, the slats reinforcing the brokenness of his body.

The artists featured in *Coming Home!* almost always present the crucified Jesus as the suffering Savior and invite the viewer to meditate on the torment he experienced on the Cross. The works by Jesse Aaron and Chester Cornett are good examples. Aaron's and Cornett's large-scale Crucifixions (see plates 1 and 19) are among the most impressive artworks in the exhibition. Aaron fashioned the truncated figure of Jesus that forms his *Crucifixion* from a found piece of wood, using a chainsaw. Cornett made his work out of wood, incised and painted it, and used human hair for the beard. Although these artworks are dissimilar in conception and construction, they are both composed of fundamentally stylized shapes and are intensely expressive. Aaron's Christ is made of a single piece of wood, its odd shapes forming the figure's head and limbs, its sharp curves defining the torso and its tattered surface suggesting Christ's wounds. There is no cross, yet the figure's stumplike arms seem pulled and strained as if Christ's body sagged with weight. The gaunt, plank-like body of Cornett's Christ is incised with anatomical details, his arms outstretched and his head suggestive of a grizzled and grinning skull.

Hunter's *Crucifixion with Red Zinnias* (see plate 46) emphasizes the torments Christ suffered on the Cross while nonetheless conveying, through the strong verticality of his body and the alert pose of his head (framed by the upright spikes of the crown of thorns), his victory on the cross. Hunter's painting is all the more compelling because the artist represents the Son of God as black. Making Jesus black was no doubt the result of personal convictions, enabling Hunter to identify more closely with the Lord, but her depiction of a black Jesus may have, as it does for many African

Americans, a broader, social connotation. Such images may be intended to symbolize the spiritual and moral victory of African Americans over racial oppression.[5]

Portrayals of the suffering Christ appear in history as early as the tenth century as drawings in medieval manuscripts or in the form of monumental sculpture. Like the makers of contemporary folk art, medieval artists were often less concerned with simulating nature than with evoking an emotional response. In fact, contemporary folk and medieval art share many similarities. *Jesus: Behold the Man* (see plate 55) by Anderson Johnson and Felix Virgous's *Head of Christ* (see plate 112) are reminiscent of Byzantine icons, which likewise present the face of Christ frontally posed and filled with pathos. In its dense illustration and copious detail, Elijah Pierce's *Crucifixion* (see plate 77) might be compared to Late Gothic altarpieces. Similarities also exist between contemporary folk and medieval portrayals of scenes from the Book of Revelation. It is highly unlikely that contemporary folk artists directly studied the work of such medieval predecessors; instead, the similarities between these art forms stem from a common artistic heritage grounded in Christianity, indebtedness to the Bible, and preference for an expressive non-naturalistic style.[6]

Last Supper, #6 (see plate 43) from a series of Last Supper images made by William Hawkins, looks both to the distant past and the present.[7] This adaptation of Leonardo da Vinci's famous fresco, in which Hawkins combines painted figures and photographs cut from magazines, evokes the creations of contemporary trained artists and, in particular, appropriation art, a modernist practice that incorporates another artist's image, alters it, and thereby transforms the original meaning. *Last Supper, #6* changes Leonardo's painting so that Christ's disciples form a racially integrated group of people that includes males and females, in effect, challenging the idea that Christ's foremost follow-ers were all white males and the historical association between Christianity and white patriarchal society.

THE NEW HEAVEN AND EARTH

The final section of *Coming Home!* is its most intellectually compelling, historically satisfying, and aesthetically diverse. The imagery deals with Bible prophecy and is the logical outcome of the theology that informs evangelical Christianity. In the eyes of those who believe that the Bible is the voice of God, there is every reason to expect that God will keep the promises that it records.[8]

Prophecy belief, which has a long history within Judeo-Christianity, is rooted in passages found in the Old Testament books of Ezekiel and Daniel and the New Testament Book of Revelation, although important writings occur elsewhere in the Bible.[9] These prophecies focus on the events of an undisclosed future time when the cosmic forces of good (God) and evil (Satan) engage in deadly battle to determine the fate of human history. Often referred to as "apocalyptic," a word deriving from a Greek term that means "unveiling," these prophecies are said to reveal secrets involving the world's cataclysmic destruction and the Lord's ultimate victory over evil. The Book of Revelation is traditionally ascribed to St. John the Apostle (see illus. I-3). Isolated on the Aegean island of Patmos, probably in the late first century AD, John claims that an angelic messenger transported him to heaven where he experienced a bewildering vision. Using a richly poetic language, John describes a fantastic drama, enacted on a cosmic stage, filled with disjointed episodes, and performed by baffling supernatural beings. So intermingled are the natural and the supernatural, so packed with symbols and allusions and so rich in metaphor and meaning that the book still provokes controversy among scholars and students of the Bible. While most academ-

Chester Cornett (1912–1981)

Fort Thomas, Kentucky

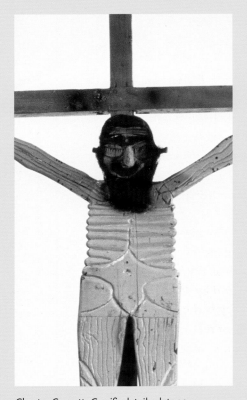

Chester Cornett, *Crucifix* detail, plate 19

One might assume that self-taught artists of evangelical background would avoid three-dimensional crucifixes, associated with the Roman Catholic Church and criticized by fundamentalist Protestant denominations as idolatrous or contrary to the second commandment's ban on graven images. Nonetheless, many Southern self-taught artists assert their independence to create moving and personal versions of the Crucifixion. Chester Cornett was an unconventional artist who prized his independence from cultural norms. Best known for his idiosyncratic chairs, Cornett reinterpreted the traditional eastern Kentucky styles that he had learned from his grandfather and uncles according to his own aesthetic preferences.

Cornett's arresting *Crucifix* (see plate 19) has none of the careful execution of his chairs. The cross is crudely formed of unfinished two-by-fours, and the figure of Christ is shallowly carved. Cornett emphasizes the humanity of Christ with stark incisions that delineate ribs and veins and with a grizzled beard, made of human hair, much like his own. The inscription on the plaque, now barely legible, once clearly read: "THE COMING AGIN / THIE WILL BE COMING / ONE A CLOUD WHEN / HE COMES AGIN LES ALL / BE REDY TO GO OUT AND MEET / HIM WHIM OR LORD COMES." This emotional and personal work was Cornett's only one with a religious message.

Two competing narratives explain the circumstances of the crucifix's construction. Michael Owen Jones reports in *Craftsmen of the Cumberlands* that Cornett made the work while living in Indiana, where he had moved, hoping to earn more money. Discouraged and alienated from his family, Cornett installed the *Crucifix* in his front yard for the edification of passers-by. Other sources, including Michael Hall in *The Ties That Bind*, claim that Cornett constructed the *Crucifix* in Kentucky after dreaming of a flood that he thought would precede the Second Coming. To prepare for the flood, Cornett built a twenty-foot ark with a seven-foot cabin and affixed the *Crucifix* to the bow. The expected flood did not come, but the ark broke loose from its mooring in a storm and broke up as it washed downstream. Cornett then salvaged the *Crucifix* and reworked it in its present form. Whatever the circumstances of its creation, the *Crucifix* is certainly the work of an artist who found relief from hardships, disappointments, poverty, and illness through his art and through his Christian faith.

Cheryl Rivers

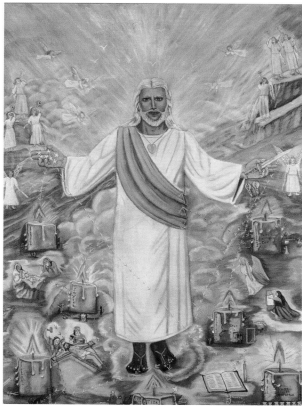

Illus. I-3
Myrtice West (b. 1932)
Who Dare Record the Word of God (#1 in the Revelations Series),
1980s
Oil on cloth, 47 x 39
Collection of Tamara and Rollin Riggs

ics agree that such apocalyptic writings, which flourished between the second century BC and the first century AD, were created in response to political and religious injustices and intended as messages of moral indignation and expressions of spiritual encouragement, evangelical Christians believe that John's vision points to the imminent destruction of the world.

Early Christians believed that Christ's return to earth would happen any time, but when the Lord did not appear and Christianity was legitimized, expectancy in Christ's immediate return diminished. The influential Church Father Augustine of Hippo, writing in the early fifth century, pro-

claimed that Christ had already in his birth, death, and resurrection established his kingdom on earth (see plate 35). Nonetheless, prophecy continued to hold a particularly strong attraction for Christians who suffered adversity and persecution. Central to this kind of thinking is the belief that good and evil are real forces engaged at this very moment in a deadly struggle. The immediate outcome of this battle will establish a new world order where Christ will rule, his people will thrive and righteousness will prevail.

In his perceptive book *When Time Shall Be No More: The History of Prophecy Belief in America*, Paul Boyer documents how belief in biblical prophecy permeates the culture of contemporary America (see plate 91).[10] As might be expected, its presence is especially strong within the orbit of evangelical Christianity. Prophecy belief has infiltrated the programs of conservative Christians on radio and television, inspired hundreds if not thousands of prophecy books, and prompted the writing of contemporary novels such as the best-selling twelve-book series *Left Behind* by Tim LaHaye and Jerry B. Jenkins. Prophecy is the subject of magazine articles, the topic of religious seminars, and the focus of religious films, such as *Thief in the Night* (1972), *Road to Armageddon* (1977), and, more recently, *Left Behind: The Movie* (2000) and *Left Behind II: Tribulation Force* (2002). End-time prophecy is the subject of traditional folk and gospel songs and also of contemporary Christian rock, and it has even entered the realm of Christian kitsch. Look for bumper stickers ("Beam me up Lord"), wristwatches ("One Hour Nearer the Lord's Return"), and postcards, prints, and placemats. Prophecy is rampant on the web; just try www.armaggedonbooks.com.

The end-time focus of prophecy belief also pervades the secular world. Prophecy belief inspired the novel *The Omen* (1976) by David Seltzer, which prompted, Boyer says, a whole genre labeled "secular apocalyptic"[11] and the making of a long

line of popular movies, including *The Omen* (1976) and its sequels, *Damien: Omen II* (1978) and *The Final Conflict* (1981).[12] Prophecy belief also influences rock and pop music (David Bowie, Elvis Costello, and the Sex Pistols), as well as contemporary fine art and music.

Despite the broad influence of prophecy belief on contemporary American culture, its impact on the work of self-taught artists, even those working in the South, where its influence might best be predicted, has been little recognized. Two exceptions are the 1997–1998 exhibition, *The End Is Near!*, organized by the American Visionary Art Museum in Baltimore, which examined apocalyptic imagery in the work of contemporary self-taught artists, and *Millennial Dreams*, organized by Gerard C. Wertkin for the American Folk Art Museum, which examined American folk expressions of end-time concerns—Puritan gravestones, Shaker drawings and furniture, charts, works of Southern artists, and so forth.[13] *Coming Home!* approaches the contributions of self-taught artists in a different way, situating their art within the particular religious, artistic, and cultural context of the American South. Organized into the subsets, "Prophecy," "Day of Reckoning," and "Coming Home!," this last section examines the artistic and religious traditions that inspire unschooled artists to express their beliefs in prophecy; presents the supernatural beings and dramatic events of the final cosmic battle; explores this art's aesthetic language; and illustrates how contemporary folk artists have imagined the fulfillment of Bible prophecy.

Prophecy

Prophecy belief has a long and flourishing history in America. The Puritans, who saw the country as a forerunner of the New Jerusalem, conceived of America as a holy nation destined by God to be "a city upon a hill" and the model of a godly society (see plate 40). "To this day," Robert C. Fuller maintains, "Americans retain the implicit faith that they are God's chosen nation."[14] The enthusiasm for prophecy gained one of its most ardent and influential supporters when the lay Baptist preacher William Miller (1782–1849), once a deist and a skeptic, announced that Christ would return to earth about 1843, a date later refined to October 22, 1844. Miller's teachings attracted huge audiences that crammed auditoriums and camp meetings where large charts (see plate 102) were used to teach his theories. Popular demand (and a firm belief in Miller's theories) provoked Joshua V. Himes (1805–1895), a Boston minister and a gifted publicist, to launch two magazines and print thousands of pamphlets and brochures to promote Miller's teachings. The Millerites, who at the height of the movement may have numbered as many as 100,000, waited with determined expectancy for Christ's return. When the Lord failed to appear, resulting in what has come to be known in religious history as the "Great Disappointment," the movement soon fell apart.

The Millerites established Adventism, or the belief in Christ's imminent return to earth, as a major theme in American religion and fostered the emergence of the Advent Christian Church, the Seventh-Day Adventists, and the Jehovah's Witnesses. Moreover, their illustrated charts, devised as instructional tools to explain Miller's end-time theories to large crowds, continued to be produced. Several Advent Christian charts, some the work of professionally trained artists and some not, are now housed in the Jenks Memorial Collection of Adventual Materials at Aurora University, Aurora, Illinois, which was founded by the Advent Christian Church in 1893. These objects demonstrate the continued manufacture of prophecy charts into the twentieth century.

One of the most important charts in the collection is the so-called *Millerite Chart of 1843* (see

plate 102), a lithograph which was actually made in 1842. This is the movement's standard chart, the one most often used before the "Great Disappointment" of 1844.[15] The *Chart of 1843* contains a time-line, key dates and commentary (so that those who used it could correctly understand its contents), and illustrations. Among these are the Crucifixion and several apocalyptic motifs, such as the beasts described in Daniel and other motifs from the Book of Revelation, including the Dragon with Seven Heads, Ten Horns, and Seven Crowns and the Whore of Babylon.

The chart's distinguishing feature is the large image of a human form at the upper left. It derives from Daniel 2:36–45, where Daniel, a Jewish youth at the court of Babylon, interprets King Nebuchadnezzar's dream of a huge statue of a man with a head of gold, chest of silver, thighs and belly made of brass, and legs of iron with feet of iron and clay, which is destroyed by a hurling stone. Often called the Colossus of Nebuchadnezzar, the statue is interpreted by Daniel as symbolizing four kingdoms or successive eras of human history, each inferior to the era that preceded it.

The *Bingham Prophecy Chart* (see plate 8), measuring 89 x 140.5 inches, is typical in size and format. Signed and dated 1927 in Portland, Oregon, it was made by George Bingham, who attended art school in New York City and taught drawing at the YMCA. After moving to Portland, Bingham opened a frame shop and freelanced as a graphic artist.[16] His chart most obviously demonstrates the impact of the earlier Millerite tradition in its depiction of the Colossus and its apocalyptic beasts. In fact, Bingham's chart offers a smorgasbord of biblical motifs, demonstrating a proliferation of apocalyptic scenes, which include the Woman on the Moon (see illus. I-4), the Four Horsemen of the Apocalypse, and the Four Angels at the Corner of the Earth. The motifs also reveal Bingham's artistic training in the use of techniques he learned at art school, such as the modeling of

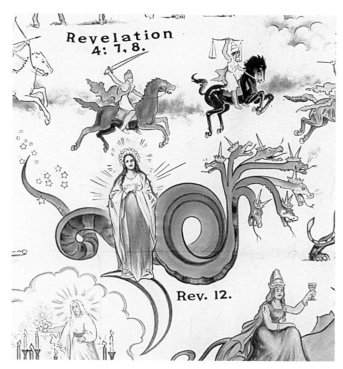

Illus. I-4
Woman on the Moon
Bingham Prophecy Chart detail, plate 8

three-dimensional forms and their visualization in space. Despite this increased naturalism, however, Bingham's chart retains a fundamentally schematic structure. The motifs are clearly distinguished, carefully labeled, and logically placed, seeming to flow from the upper left where Adam and Eve are expelled from Paradise to the lower right, where heaven is pictured as an earthly garden.

At least one artist represented in the Jenks Collection was self-taught. Born on the Island of Gotland off the coast of Sweden, Josephine Lawson was confined to a wheelchair for most of her life. After arriving in America in the late 1880s, Lawson learned English and then traveled extensively as a missionary. She settled in Pasadena, California, where she taught herself to make prophecy charts like the one representing the *Colossus of Daniel 2* (see plate 60). Besides explaining how she was inspired to make her prophecy charts, Lawson has left comments on how she used the charts and

Josephine Lawson (1866–1963)

Pasadena, California

Daniel saw the stone that was hewed out the mountain
Daniel saw the stone that came rolling through Babylon
Daniel saw the stone that was hewed out the mountain
Coming down to redeem a mighty world

Oh Jesus was the stone that was hewed out the mountain . . .

—Hymn

Josephine Lawson, *Prophecy Chart, Colossus of Daniel 2* detail, plate 60

Verse: *Instructions:*

We are searching for the stone

> *The singers search under tables, chairs. . . .*

Is this the stone?

> *The leader holds up a worldly object [such as a dollar bill].*

No, that's not the stone

> *Everyone shakes his head in disagreement and the money is thrown away.*

We are praying for the stone

> *They kneel and pray.*

We have found the stone

> *The leader holds up a picture of Christ or a Bible.*

You can have the stone

> *The leader offers the picture or Bible there by issuing an invitation to accept Christ.*

An Advent Christian minister and self-taught artist, Josephine Lawson was born in Sweden, visited the South only once, and settled in California, yet her quaint drawing of the Colossus of Nebuchadnezzar (see plate 60) fits neatly within a long religious tradition that had an impact on the art and music of the South. The enormous statue and the stone that destroys it appear in the dream of Nebuchadnezzar, King of Babylon, a story recorded in the Book of Daniel. In the nineteenth century, the Colossus became an important symbol in American religious circles concerned with Bible prophecy, figuring prominently in the teachings of the influential Baptist lay preacher William Miller. He theorized that the Colossus symbolized human history and the rock that struck it down stood for Christ, whose return to earth, he believed, was imminent. Miller's end-time calculations, which attracted thousands, were neatly explained through the use of a visual teaching aid: the *Millerite Chart of 1843* (see plate 102).

Lawson, who made her chart in 1917, left an account in her autobiography, *Wheel Chair Evangelism*, explaining how a popular late nineteenth-century book, *The World's Great Empires*, written by Mariam McKinstry, inspired her. The book's illustrations feature a huge Colossus, which may have served as Lawson's model, for both are extremely similar. Apparently, the religious tradition also inspired a hymn, "Daniel Saw the Rock," which Diane Hyde Sasson reports was used at tent revivals and camp meetings and is still current in several versions. Sasson also points out that a North Carolina oral tradition documents that the song, which was acted out as it was sung, also made use of visual teaching aids, albeit of a different kind.

Carol Crown

The verse and instructions cited here are adapted from Sasson's article, "'The Stone': Versions of a Camp-meeting Song Collected in North Carolina," *Southern Folklore Quarterly* 42, 4 (1978): 377–78.

people's reaction to them, demonstrating the charts' fundamentally didactic nature as well as their proselystic purpose.[17]

Like prophecy belief, the use of prophecy charts spread to other religious groups. A Pentecostal preacher, the self-taught artist Samuel David Phillips also created illustrated charts. Born in Georgia, Phillips was ordained an "Evangelist of the Gospel" by the Association of Pentecostal Assemblies of Atlanta, 1934.[18] He later moved north, where he created portable charts to teach prophecy and illustrate his lectures at the Progressive Pentecostal Mission on Chicago's Southside. Rev. Phillips's charts deal with a wide variety of subject matter, but his depiction of the *Beast of the Sea* (see plate 76) demonstrates a strong affinity with the prophecy chart tradition.

The Millerite charts and their descendants form the core of a long tradition of prophecy art (see plate 9). Much of this art is closely related and often shares iconographic similarities in the depictions of the Colossus and the apocalyptic beasts from Daniel and Revelation. Found in a wide variety of media, the tradition has migrated not only into the realm of power-point presentations used at prophecy seminars but into the world of television, where the Colossus can be found at the side of doomsday preachers. There are, however, many other works of prophecy art made by unschooled artists that show no direct relationship to the Millerite-inspired tradition and may even have been made without knowledge of it. Nonetheless, the creations of many self-taught artists, including William Alvin Blayney, Howard Finster, Annie Lucas, Myrtice West (see plate 119), William Thomas Thompson, and Robert Roberg, who all make imagery inspired by the Book of Revelation and who are each featured in *Coming Home!*, are similarly grounded in prophecy belief and share a related proselytistic purpose.

Day of Reckoning

Two large paintings, Rev. Howard Finster's *The World Is Now Living Between Two Great Superpowers* (see plate 37) and *Satan Takes Over* (see plate 120), the eighth painting in West's "Revelations Series," proclaim that God's final reckoning of humankind is imminent. These artworks witness to the social, political, moral, religious, climatic, and environmental ills of contemporary life and testify to the widespread perception among evangelical Christians that the world is ripe for revolution. So depraved has humanity become that these Christians ask, "How much longer will God contain his anger?" And, as they watch the evening news, they comment, "See! It's just like it says in the Bible!"[19] After the establishment of the state of Israel in 1948, an event said to be prophe-

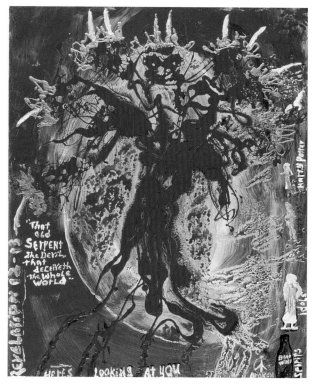

Illus. I-5
William Thomas Thompson (b. 1935)
That Old Serpent the Devil, 2001
Acrylic on linen, 48 x 36, Collection of the Artist

sied in the Bible, and the capture of Jerusalem in 1967, many evangelicals believe the end-time clock is surely ticking. In 1985, Finster may have been thinking of the United States and Russia as the world's two superpowers. Today, end-time interpreters of contemporary events might identify those powers as Christian America and the followers of Islam and perceive their contest as foreshadowing the ultimate battle between Christ and the hosts of Satan.

Although evangelicals are united in their belief of the Lord's Second Coming, few agree on the exact sequence of history's last events. Bible study has taught them to expect some extraordinary end-time developments, which are known in conservative Christian circles as the Rapture, Christ's Second Coming, the Great Tribulation, the Battle of Armageddon, the Millennium, and the New Heavens and Earth.[20] The timing of the Rapture and Christ's Second Coming perplexes Christians most. A theological concept grounded in the Bible but first introduced in the nineteenth century, the Rapture refers to that moment in the apocalyptic drama when the faithful will be swept away from earth to heaven.[21] Bible students argue about whether the Rapture will take place before, during or after the Tribulation, a term referring to that awful moment when, as one writer says, "All hell will literally break loose on earth."[22] The moment of Christ's Second Coming is also debated (see plate 118). The belief in Christ's imminent return goes back to the religion's earliest days and has never been absent for long in Christian history. Millennialism is the idea that the thousand years (millennium) of peace and prosperity noted in Rev. 20:3 should be taken literally: Christ will reign on earth for a thousand years. For those who accept this idea, the question has always been whether the Lord will appear before or after the Millennium, leading to the terms "premillennialism" and "postmillennialism." Premillenialism, once endorsed by some Early Christian theologians, now

prevails, especially among conservative Christians and many artists in *Coming Home!*

Evangelicals hold differing views about not only the chronology of end-time events but also the identities of its major players. The biblical prophecies name a formidable cast of characters described in vivid symbolic language. Among these is the Woman on the Moon, portrayed in Rev. 12, as, "clothed with the sun, and the moon under her feet, and upon her head a crown of twelve stars." Although Catholic tradition most often identifies this woman as Mary, the mother of Jesus, evangelicals more commonly perceive her as a symbol of Israel (see plate 106). The Christ of the Second Coming, who appears in Rev. 19, is often pictured riding on horseback at the head of his armies. *That Old Serpent the Devil* (see illus I-5) has seven heads and ten horns and seven crowns upon his heads and is identified in the Bible as "that old serpent of old, called the Devil and Satan" (Rev. 12: 9). The Great Whore of Babylon, the Beast Who Comes out of the Sea, and the Beast Who Comes out of the Earth are all Satan's cronies. The Great Whore of Babylon, "arrayed in purple and scarlet color, and decked with gold and precious stones and pearls, having a golden cup in her hand full of abominations and filthiness of her fornication" (Rev. 17: 4), has sometimes been associated with papal Rome or even the modern day city of New York (see plate 83). The Dragon bestows his authority on the Beast Who Comes out of the Sea (Rev. 13:1–3). This creature is described as having seven heads and ten horns, looking like a leopard and having the feet of a bear and the mouth of a lion (see plate 116). He is often associated with Antichrist and the infamous "666" of Rev. 13:18. The Beast Who Comes out of the Earth (Rev. 13:11) is a creature having two horns like a lamb and has sometimes been identified with the False Prophet, a figure named in Rev. 19:20. Of all these characters, possibly the most allusive is Antichrist, an evil being mentioned only a few times

in the Bible as one who denies Christ's incarnation. Throughout history, Antichrist has been variously identified as the Emperor Nero, the Pope, Napoleon Bonaparte, Adolf Hitler, Henry Kissinger, Mikhail Gorbachev, or Saddam Hussein (to mention only a few of the most well known).

The artworks displayed in this section of *Coming Home!* present the major end-time players described by the apocalyptic prophets of the Bible. In keeping with the vivid scenes and dramatic action of these prophecies, the artists rely on figurative imagery and employ a highly expressive style. Pentecostal William Thomas Thompson uses violent brushstrokes of dripping color to depict such actors as Antichrist, Satan, and the awful Whore of Babylon (see plate 104), also the subject of Robert Roberg's *The Whore of Babylon Riding on a Beast with Seven Heads* (see plate 83). Roberg takes a more lighthearted approach but also exploits color, using hot pink for the beast, which is framed against the water's vivid blue. West's *Christ Returns as Church Gets Ready; King of Kings and Lord of Lords* (see plate 118) and Thompson's painting *Faithful and True (Christ of the Second Coming)* (see plate 103) are inspired by Rev. 11:1–16, where John sees heaven open and Christ riding at the head of an army on a bold white horse. Calling to mind the equestrian portraits of Roman emperors and statues of Civil War generals, these paintings evoke a mood of impending triumph. More pacific is Eddie Lee Kendrick's *The Second Coming of Christ! On the Clouds!* (see plate 57). It shows a bust-length depiction of the Lord framed by rippling clouds above a cityscape where people approach a church, clearly identified as "The Church of God in Christ" and perhaps referring to the church Kendrick attended in Higgins, Arkansas.[23]

The formal aesthetics and the striking inventiveness of many self-taught artists and their freedom from academically imposed restraints have long made their work attractive to trained artists.

The stone carvings of Tennessee's William Edmondson were first discovered by the photographer Louise Dahl-Wolfe in the 1930s, who brought them to the attention of Alfred Barr, the director of the Museum of Modern Art.[24] Barr selected Edmondson for a show in 1937, making him the first black person and the first self-taught artist to have a solo exhibition at MoMA.

Edmondson's limestone *Angel* (see plate 23), just over eighteen feet tall, is presented in a pose of strict frontality and containment, assuming in the strong, stable placement of its solid forms and in the simplicity of its abstracted shapes a monumental presence. *Green Angel* (see plate 64) by Charlie Lucas, on the other hand, is life size yet miraculously weightless in effect: lifting its arms in a diagonal pose, the angel seems to pirouette ecstatically in space. Formed of odd pieces of metal silhouetted against an old green door, this piece finds similarities in the assemblage art of trained artists like Richard Stankiewicz (1922–1982), who creates sculpture from cast-off metal pieces.[25] Composed of three figures made of found objects, including two musical instruments, Joe Minter's *The Last Trumpet* (see plate 66) demonstrates the assemblage aesthetic so often associated with Southern vernacular and contemporary fine artists. Apparently a reference to the Seven Trumpet Judgments, described in Revelation, the last trumpet salutes the coming of Christ's kingdom and God's eternal rule, the subject of the final section of *Coming Home!*

Coming Home!

The final component of *Coming Home!* focuses on prophecies of heaven recorded throughout the Bible and most eloquently by John in the Book of Revelation. To describe his vision of the New Heaven and the New Earth, John employs a metaphor that saw centuries of use:

> And I John saw the holy city, new Jerusalem, coming down from God out of heaven, prepared as a bride adorned for her husband. And I heard a great voice out of heaven saying, Behold, the tabernacle of God is with men, and he will dwell with them, and they shall be his people, and God himself shall be with them, and be their God. (Rev. 21:2–3)

And in one of the most beautiful passages of world literature, he adds,

> And God shall wipe away all tears from their eyes; and there shall be no more death, neither sorrow, nor crying, neither shall there be any more pain: for the former things are passed away. (Rev. 21:4)

Besides the metaphor of the holy city, the New Jerusalem, John suggests the use of a second metaphor to symbolize the heavenly domain. Recalling imagery used in Genesis, later passages in Revelation refer to the River of Life and the Tree of Life, suggesting that the Edenic paradise will be restored:

> And he shewed me a pure river of water of life, clear as crystal, proceeding out of the throne of God and of the Lamb. In the midst of the street of it, and on either side of the river, was there the tree of life, which bare twelve manner of fruits, and yielded her fruit every month: and the leaves of the tree were for the healing of the nations. (Rev. 22:1–3)

These motifs, the city and the garden, symbolizing Paradise restored, became the most favored and constant symbols used to signify God's kingdom in the literature and art of Christianity. In *Coming Home!* the Holy City is represented, for example, by Finster's *There Is a House of Gold* (see plate 38) and his *Holy White City Coming Down* (see plate 33). The heavenly garden is represented by the richly flowering *Tree of Life* made by Nellie Mae Rowe (see plate 87) and Thompson's depiction of the same subject (see plate 105), which erupts in verdant energy. On the other hand, Hunter's petite

example *The Moon and the Stars* (see plate 49) may be intended to represent an actual landscape, but its idyllic vision of the evening skies equally suggests Paradise. Both motifs—city and garden—appear in West's *Christ and Bride Coming into Wedding* (see plate 117), where the holy couple stands within the gates of the New Jerusalem, located above the River of Life on either side of which is the Tree of Life.

Landscape also figures prominently in Anderson's *Sunrise on the Peaceable Kingdom* (see plate 7), which presents an idyllic scene of a mountainous view where the morning sun dawns upon an unexpected scene. Three children, interspersed throughout a large placid gathering of wild and domestic animals, play and pet the beasts as if they were stuffed toys. Inspired by the Old Testament prophecy of Isaiah (11:6), who describes Paradise as a realm where the wolf and the lamb, the leopard and goat, the calf and the young lion live at peace, the painting recalls works of the same title by the early American folk artist Edward Hicks (1780–1849).

Like Lorenzo Scott's *Reunion in Heaven of the "House of Prayer" Children* (see plate 88), Hunter's painting *Frenchie Goin' to Heaven* (see plate 47) is more concerned with picturing the soul's translation to heaven than the actual kingdom itself. Throughout history Christians have wondered about when heaven begins: immediately after death, at the soul's purgation, or at the end of human history.[26] Neither Scott's nor Hunter's depictions endorse a specific timetable. Roger Rice offers one conception of how sinners get to heaven in *Gospel Train* (see plate 82). Drawing upon a theme inspired by gospel songs, Rice pictures the roller-coaster ride of a roofless train filled with repentant sinners.[27] Nude figures scramble on board, while others lean out to offer a helpful hand. At the far end of the train stands the white-garbed figure of Christ, arms outstretched in a gesture of salvation.

Howard Finster (c. 1915 or 1916–2002)

Summerville, Georgia

Howard Finster, *Visions of Other Planets* detail, plate 39

A Baptist minister with little formal schooling, Rev. Howard Finster worked in a wide variety of media and forms. His most celebrated creations are Paradise Garden and the World's Folk Art Church, but his enormous output also included paintings, prints, sculptures, architectural models, and mixed media pieces, which he put to work for the Christian faith. In his intent to proselytize, his work almost always serves a *rhetorical* function. Sometimes he resorted to the traditional Southern practice of preaching hellfire and damnation but other times aimed to make the medicine go down with a bit of honey. *There Is a House of Gold* (see plate 38) is a good example of the latter approach.

To make this elegant and monumental vision of heaven, Finster used enamel and glitter on Masonite and, in typical fashion, combined image with text. Incorporating the words of Jesus from John 14:2, "In my Father's house are many mansions," Finster elaborates: "There is a house of Gold beyond the light of the sun, at the end of mans work for it is done, rest for the soul in a house of Gold The truth of it all no one has told." Then, he adds:

> **A vision emblem of one top section of one of the twelve peaks, which are leading upward from my father's house. Eye hath not seen or ear heard or even entered the mind what God has in store for them who love him and keep his sayings. By Howard Finster December 16, 1978 1000 and 271 paintings.**

The result is a serene image of heaven presented to the viewer for contemplation and comfort and the promised reward for a life well lived. Calling himself "A Second Noah" and "God's Last Red Light," Finster often warned that the world's growing immorality along with other signs—the floods, droughts, and tidal waves reported in the news and the earth's increasing pollution—strongly suggests humankind is living in the world's last days. Having made, signed, and numbered more than fifty thousand artworks, Finster bemoaned, "All they [other people] want me to do is paint. All I want to do is preach."

Carol Crown

In the South, where many believe the Will of God is evidenced in the Bible and the Bible is so influential in life's affairs, it is difficult, if not impossible, to separate religion from social life and politics. The walls between the religious and the secular often collapse, as suggested by two images of Paradise made by Rev. Finster and Alabama's Rev. Benjamin "B. F." Perkins. Finster's *Visions of Other Planets* (see plate 39) uses the Stars and Stripes as a patriotic emblem and a compositional device to preach the prophecy of the Holy City. Picturing at the upper left a small, white, ornate castle within a wreath of stars, Finster places similar motifs behind the flag's red bars, whose handwritten letters preach the reality of "The New Heaven and Earth" and the necessity of faith in Jesus Christ.

Perkins's depiction *Homeplace* (see plate 73) unites the religious and the patriotic in his version of Paradise. Painted in brilliant colors of red, white, and blue, *Homeplace* was inspired by Perkins's own home, which was destroyed but is known from photographs. Like it, the house in *Homeplace* is pictured with a curved driveway, carports, and upstairs porch, as well as a yard of religious monuments that Perkins built, including Calvary's three crosses and Christ's sepulcher. A student of biblical prophecy and an intensely patriotic man, Perkins created his home as an earthly reflection of his celestial one. *Homeplace* offers the vision of a perfect realm, blending the New Testament and the patriotic Southern landscape, Christ and Country, to all those pilgrims coming home! For the early Pilgrims who came to the New World hoping to establish in the untouched Paradise of America, God's holy Kingdom, Rev. Perkins's *Homeplace* might not seem too distant from their conception of Paradise.[28]

IN CONCLUSION

Art rarely exists in isolation. It is caught up in the mind and world of its creators. The artworks featured in *Coming Home!* and created in the South, a region where Christianity permeates everyday experience, evidence the passing fancies, deep apprehensions, and the heartfelt passions of their makers. Whether a work suggests its maker is a devout, lapsed, or hypocritical Evangelical, belongs to a different Christian tradition or completely exists outside the religious orbit, this art typically bears the imprint of, if not an obsession with, Southern Christianity.

1. Although "fundamentalist" is often employed to describe members of the Christian faith in the American South, the term used in this essay is "evangelical." "Fundamentalist" more accurately describes a subcategory of evangelical Christianity. As Joel Carpenter observes in *Revive Us Again: The Reawakening of American Fundamentalism* (New York: Oxford University Press, 1977), 8, "Fundamentalists are evangelicals, but not all evangelicals are fundamentalists." Fundamentalists lead a stricter lifestyle, attempting to isolate themselves from both the world's temptations and its contaminations, and generally favor a more literal interpretation of the Bible than most evangelicals, although both recognize the Scriptures as the central source of religious truth and are conservative in outlook. Fundamentalists, like evangelicals, exist not only in the South but elsewhere throughout the country and the world. What unites these two components of conservative Christianity, whether evangelical or fundamentalist, are four beliefs: an unbroken faith in the Bible's authority as containing the Word of God, the necessity of being born again through Jesus Christ, the responsibility of sharing their faith, and the Bible's prophecies of God's ultimate triumph over evil. For a study of contemporary fundamentalists and their literal interpretation of the Bible, see Nancy Tatom Ammerman, *Bible Believers: Fundamentalists in the Modern World* (New Brunswick: Rutgers University Press, 1987).

2. Citations from the Bible in this essay are from the King James Version.

3. Telephone interview by the author with the artist, August 2003.

4. As Theophilus Smith explains, the prohibition, "Thou Shall Not" can also be read as, "prescription or cure, and furthermore as

incantation or spell. Holley's work . . . can be seen as a kind of healing charm or, to use the black folk vernacular, a good 'mojo.'" See Theophus Smith, "Working the Spirits: The Will-To-Transformation in African American Vernacular Art," *Souls Grown Deep: African American Vernacular Art of the South*, Vol. 2, Paul Arnett and William Arnett, eds. (Atlanta: Tinwood Books, 2001), 46–63.

5. Kymberly N. Pinder, "Our Father, God; our Brother, Christ; or are We Bastard Kin?: Images of Christ in African American Painting," *African American Review*, 31, 2 (Summer 1997), 223–33, studies the motif of the suffering Christ in the work of African American artists such as Archibald Motley, Jr., and William Johnson. For the tradition of the black Jesus in American art and literature, see Stephen Prothero, *American Jesus: How the Son of God Became a National Icon* (New York: Farrar, Straus and Giroux, 2003).

6. Not all contemporary folk artists are unaware of the work of their academically trained colleagues. Lorenzo Scott, for example, freely admits that his visit to the New York Metropolitan Museum of Art whetted an appetite for the art of Renaissance and Baroque masters. His paintings often demonstrate, in form and iconography, the stamp of the distant past. Scott's emulation of such Renaissance techniques as modeling and spatial illusionism and his paintings' sumptuous gold-colored frames confirm the art that inspires him is post-medieval. Another contemporary folk artist who has studied Western European art history is Purvis Young, who taught himself about the work of such great artists as Rembrandt, Gauguin and Picasso, by studying their work in books at his local library.

7. William Arnett, "William L. Hawkins," *Souls Grown Deep: African American Vernacular Art of the South*, Vol. 1 (Atlanta: Tinwood Books; in association with the Schomburg Center for Research in Black Culture, the New York Public Library, 2002), 430.

8. Evangelical fascination with prophecy belief is the subject of many scholarly tomes, among the best and most popular being those by Paul Boyer, *When Time Shall Be No More: Prophecy Belief in Modern American Culture* (Cambridge: Belknap Press of Harvard University Press, 1992) and Charles B. Strozier, *Apocalypse: On the Psychology of Fundamentalism in America* (Boston: Beacon Press, 1994).

9. For differing views on the interpretation of Bible prophecy, consult Bruce M. Metzger and Michael D. Coogans, eds., *The Oxford Companion to the Bible* (New York: Oxford University Press, 1993), 649–54; F. X. Cross and E. A. Livingstone, eds., *The Oxford Dictionary of the Christian Church*, 3rd edition (New York: Oxford University Press, 1993), 1392–94; Merrill F. Unger, *The New Unger's Bible Dictionary,* rev. and updated edition, R. K. Harrison, ed. (Chicago: Moody Press, 1988), 1039–40, 1076–79;

and Stanley M. Burgess and Gary B. McGee, eds., *Dictionary of Pentecostal and Charismatic Movements* (Grand Rapids: Zondervan, 1996), 728–40.

10. Boyer, *When Time Shall Be No More, passim.*

11. Boyer, *When Time Shall Be No More*, 8, notes that W. Warren Wagar explores a massive outpouring of apocalyptic fiction in *Terminal Visions* (1982), "listing more than three hundred novels, plays, poems, and science-fiction stories dealing with the end of the world."

12. See also Kim Newman, *Apocalypse Movies: End of the World Cinema* (London: Titan Books, 1999).

13. Roger Manley, *The End Is Near!: Visions of Apocalypse, Millennium, and Utopia* (Los Angeles: Dilettante Press, 1998); and Gerald C. Wertkin, *Millennial Dreams: Vision and Prophecy in American Folk Art* (New York: Museum of American Folk Art, 1999).

14. Robert C. Fuller, *Naming the Antichrist: The History of an American Obsession* (Oxford: Oxford University Press, 1996), 44.

15. Clyde E. Hewitt, *Midnight and Morning* (Charlotte: Venture Books, 1983), 118. For a history of the chart's creation, see also Edwin Le Roy Froom, *The Prophetic Faith of our Fathers: The Historical Development of Prophetic Interpretation*, Vol. 4 (Washington: Review and Herald, 1954), 733–37, and more recently, David Morgan, *Protestants and Pictures: Religion, Visual Culture, and the Age of American Mass Production* (New York: Oxford University Press, 1999), 123–59.

16. This information can be found in a letter written by Bingham's granddaughter, dated 2000, in the files of the Jenks Memorial Collection of Adventual Materials, Aurora University.

17. Lawson's comments can be found in her autobiography of which there are two versions. The earliest is *Reminiscences from a Simple Life* (Oakland: Messiah's Advocate, 1920) and the second, adapted from the first but expanded, *Wheel Chair Evangelism* (Pasadena, N.p., n.d.). See especially, *Reminiscences*, 94, 98, and *Wheel Chair Evangelism*, 110.

18. Cleo Wilson, "Sermons on Scrolls: The Religious Art of Reverend Samuel David Phillips," *The Outsider* 3, 1 (Summer 1998): 12.

19. Ammerman, *Bible Believers*, 44. This is an excellent source for understanding fundamentalism and the enthusiasm for prophecy among conservative Christians.

20. See Robert G. Clouse, Robert N. Hosack, and Richard V. Pierard, *The New Millennium Manual: A Once and Future Guide* (Grand Rapids: Baker Books, 1999), for brief discussions of these events and Tim La Haye and Thomas Ice, *Charting the End Times: A Visual Guide to Understanding Bible Prophecy* (Eugene: Harvest House Publishers, 2001), for a time-line and further discussion.

21. First introduced through the teachings of J. N. Darby in the mid-

nineteenth century, the Rapture has become an important concept in the theology of conservative Christians, especially those who endorse a kind of teaching known as dispensational premillennialism. For an overview, see the entry for "Rapture" in *Encyclopedia of Religion in the South*, ed. Samuel S. Hill (Macon: Mercer Press, 1984), 635.

22. *New Millennium Manual*, 66.

23. Alice Rae Yelen, *A Spiritual Journey: The Art of Eddie Lee Kendrick* (New Orleans: New Orleans Museum of Art, 1998), Fig. 3.

24. *The Art of William Edmondson* (Nashville: Cheekwood Museum of Art; Jackson: University Press of Mississippi, 1999), treats the history and creations of this Tennessee artist.

25. *Souls Grown Deep*, Vol. 2, 454.

26. Colleen McDannell and Bernhard Lang, *Heaven: A History* (New Haven: Yale University Press, 1988), xiii.

27. The lyrics of one version of the gospel song, recorded for the movie, *The Gangs of New York*, begins: "Come on people / Got to get on board / Train is leavin' / And there's room for one more." Another version can be found at www.cyberhymnal.org.

28. For the influence of the biblical New Jerusalem in American history, see Conrad Cherry, ed., *God's New Israel: Religious Interpretations of American Destiny*, rev., updated edition (Chapel Hill: University of North Carolina Press, 1998), esp. 1–53; and Sacvan Berocovitch, *The American Jeremiad* (Madison: University of Wisconsin Press, 1978), *passim*.

The Bible and the Evangelical South

Paul Harvey

I, myself, being a Deep South white, reared in a religious home and the Methodist church realize the deep ties of common songs, common prayer, common symbols that bind our two races together on a religio-mystical level, even as another brutally mythic idea, the concept of White Supremacy, tears our two people apart.[1] —Lillian Smith

More than any other region of the country, the South has been defined by its close identification with evangelical styles of religious expressions and its intense relationship with scriptural texts, one simultaneously literalist (hence the association of Southern religion with fundamentalism) and visionary (hence the powerful self-taught artistic expression such as is on exhibit here). "I grew up with that," William Faulkner reminisced about the pervasive influence of evangelicalism. "I assimilated that, took that in without even knowing it. It's just there. It has nothing to do with how much I might believe or disbelieve—it's just there."[2]

While most notably expressed in white and black Baptist, Methodist, Presbyterian, and Holiness/Pentecostal churches, the tradition also deeply rooted itself in cultural practices and beliefs that extended far beyond institutional denominations. And if the image of Southern evangelicalism seems dominated by plain meeting houses, fundamentalist fire-and-brimstone sermons, and repressive restrictions, the Southern artistic imagination nevertheless has been infused with rich biblical imagery that has exploded in word and sound and in the visual arts (see plate 101). This influence is seen in the rich literary tradition of such figures as Flannery O'Connor, William Faulkner, Alice Walker, and Walker Percy; in the musical sounds of shape-note singing, black spirituals, and white and black gospel; in the oratory of countless chanted sermons and such well-known evangelists as Billy Graham; and in the wonderfully expressed visionary art works in this exhibition.

Evangelical Christianity in the South, according to Samuel S. Hill, Jr., is an archetypal "culture-religion" characterized by a reliance on the Bible (see plate 110) as the "sole reference point of belief and practice," a stress on "direct and dynamic access to the Lord," an individualistic sense of morality, and informal "low-church" worship styles. Southern orthodoxy, according to Hill, has been characterized by an inward-looking conservatism that sees individual conversion (rather than social reform or any larger purpose) as the central role of religious institutions.[3]

In the twentieth century, white Southern evangelicalism particularly became associated with fundamentalism and premillennialism, the belief and prediction of an imminent return of Christ to bring home his children, and a time of tribulation and apocalyptic Armageddon prior to the establishment of God's final kingdom (see plate 67). The influence of

Myrtice West (b. 1923)

Centre, Alabama

Myrtice West, *Daniel Chapter 2* detail, plate 119

Myrtice West has spent most of her life in the small town of Centre, Alabama, where she created her most famous paintings, the Revelations Series. Composed of thirteen paintings, the series represents the apocalyptic visions of St. John, traditionally believed to be the author of the New Testament's Book of Revelation. It was begun in the late 1970s and is often associated with the tumultuous life of Myrtice's only daughter, Martha Jane, who was the victim of spousal abuse. Murdered by her husband shortly after the series was completed, Martha Jane inspired the depictions of the Bride of Christ (see plates 117 and 118) in West's Revelations paintings. West also created two other series inspired by Bible prophecy. They picture the end-time visions of the Old Testament books of Ezekiel and Daniel.

West's paintings demonstrate a close reading of the Bible. For example, the figure of the man with gleaming white hair surrounded by seven candle sticks in *Who Dare Record the Word of God*, (see illus. I-3, p. 23) is found in Rev. 1:12–20, where John describes a man, similarly clothed, with hair "white like wool, as white as snow," who appears in the midst of the seven candlesticks. This is the Son of Man. Another figure West represents is the Colossus of Nebuchadnezzar (see plate 119), found in Daniel 2, which describes a statue made of gold, silver, bronze, and iron seen by the King of Babylon in his dreams. This statue and the depiction of the Son of Man are well known throughout the history of art, and similar renditions can be found especially in medieval times. The Colossus is also found in the instructional charts (see plates 8 and 102) made to teach Bible prophecy in nineteenth- and twentieth-century America. More inventive and unique in subject matter is *Satan Takes Over* (see plate 120) from the Revelations Series. Depicting how Evil dominates the contemporary world, even the church and the U.S. Capitol, this painting is the direct result of a nightmare that West experienced. Its aim is to show that the end-time clock is ticking, God's judgment of humanity is at hand, and Christ's Second Coming is imminent.

West grew up attending Baptist and Methodist churches and is staunchly conservative in her religious beliefs. Her art demonstrates the central role the Bible plays in her religious life and the pervasive influence of prophecy belief and the Scofield Reference Bible in the South. West's work is didactic in nature and evangelistic in purpose and reveals the impact of fundamentalist ideals and the end-time theology known as pre-millennial dispensationalism, which foresees Christ's Second Coming occurring before the establishment of God's millennial kingdom on earth.

Carol Crown

conservative commentary in the Scofield Bible, prepared by a Congregational and Presbyterian clergyman and scholar, Cyrus Ingerson Scofield, was widespread. The Scofield edition fit the propensity of Southern evangelicals to seek literalist biblical readings that rejected the trends of academic theology and biblical criticism that had swept into American seminaries from German universities. In many pulpits, the words of Scofield appended to the text were nearly equivalent to Holy Scripture itself.

Meanwhile, African American Christians in the South also have a historically intense relationship with an evangelicalism that has both oppressed and sustained them. While conservative in theology, historically black Christianity has invited a more expansive reading of the social implications of the Gospel and has nurtured cultural forms that have left an indelible mark on twentieth-century American culture. Beginning in the late eighteenth century, black slaves (and free people of color) in significant numbers converted to Christianity. White evangelicals brought the Gospel to slaves even while reassuring slave owners that this message would teach obedience and humility to their captive workers. Many slaves accepted Christianity but adapted it to suit their own purposes. Black Christians created their own religious culture, one with distinctive practices most notably expressed in spirituals, chanted sermons, and ring shouts. Following the Civil War, independent African American religious institutions carried on and extended black evangelical culture. Black gospel music became a primary vehicle of its expression in the twentieth century. The ecstatic worship forms central to African American religious expression with their sense of suffering and redemption have inspired much Southern visionary art, seen in this show in works such as Charles A. Owens's *Holy Church of God-in-Christ* (see plate 72) and the black Christ crucified in Clementine Hunter's work.

Southern religion emerged as a regionally distinctive force in the late eighteenth and early nineteenth centuries. Rejecting hierarchical forms of religion,

Methodist, Baptist, and Presbyterian preachers traveled throughout the region, exhorted passionately to call sinners home, and successfully turned what had been an unruly and famously irreligious populace into the home of the "Bible Belt." Methodists and Baptists, especially, were successful at evangelizing the Southern populace, so that by the late nineteenth century the two groups accounted for over three-quarters of Southern believers. Although the Methodists emphasized free will in salvation and practiced sprinkling rather than full baptism, and Baptists generally preached a more Calvinist doctrine of predestination and practiced strict church discipline and full baptism, the two groups collectively developed a dominant regional religious culture. Both were vibrantly evangelical and pietist; both stressed the inward state of the soul over the importance of outward behavior; and, over the course of the nineteenth and twentieth centuries, both increasingly attracted converts from all sectors of society and gradually built up huge denominational bureaucracies that supported thriving publishing enterprises.

Black Baptists (who accounted for about 60 percent of the black Christian population) and Methodists followed suit. Presbyterians and Episcopalians supplied a smaller but important supplement to the dominant Baptists and Methodists, attracting a more upper-class and educated set of believers drawn to more formal theology and liturgical practice. Finally, smaller Protestant groups—Disciples of Christ, Quaker, Lutheran, and many others—and Catholics accounted for small but significant sets of believers, often concentrated in particular locales, most of the Catholics, for example, residing in Louisiana and most of the Quakers in North Carolina.

In the twentieth century, Holiness and Pentecostalism made their way into the South and permanently imprinted Southern religious expression into American popular culture (see plate 6). The Holiness churches, usually offshoots of Methodism, emphasized a second work of grace following conversion, "sanctification," in which the believer's soul was

infused and purified by the Holy Spirit. Pentecostals, perhaps the fastest growing evangelical religion worldwide in the twentieth century, preached that the action of the spirit on the believer would be evidenced by speaking in tongues. Among whites, the Church of the Nazarene, the Assemblies of God, and the International Pentecostal Holiness Church encompass the majority of Holiness and Pentecostal believers. These churches have nurtured such cultural icons as Elvis Presley, Jimmy Swaggart, and Oral Roberts. The artist William Thomas Thompson was converted to the Pentecostal Holiness Church at age thirteen. His paintings based on the Book of Revelation are in part an artistic rendering of the visionary premillennialism of early Pentecostalism that draws heavily from an intensive study of the apocalyptic writings that conclude the New Testament. Among African Americans, the Church of God in Christ, founded by Bishop Charles Harrison Mason in Memphis in the early twentieth century, is by far the dominant denominational expression of black Pentecostalism. Black Baptists and Holiness/Pentecostal churches nurtured many of the most important black popular cultural performers of the twentieth century—Thomas Dorsey (the father of gospel music), Sam Cooke (who grew up in a Holiness church), Al Green (who performs still at the Memphis home of the Church of God in Christ), B. B. King, Mahalia Jackson (black gospel's first superstar performer), and Aretha Franklin.

Evangelical Protestantism among whites and blacks has figured centrally in the continuing racial drama at the heart of Southern history. Evangelical Christianity in the South historically has responded closely to the dominant world of unequal racial power in the region. Three major themes have defined this relationship: racism, racial interchange, and interracialism. In each case, a close reading of the Bible has produced an evangelicalism both tragic and triumphant, one that has fatally defended and almost magically undermined an historically unjust and oppressive racial order.

The religious expressions of Southern common folk emerged from an entangled racial and cultural history. White and black Southern religious cultures drew from common evangelical beliefs and attitudes and exchanged musical and oratorical styles and forms. On occasion, they shared moments of religious transcendence before moving back into the world defined by color. In the case of the camp meetings of the early nineteenth century, and again in Holiness/Pentecostalism in the twentieth century, mobile common folk created a democratic religious impulse that impelled close bonds, a strict moral code forbidding worldly pleasure, and hypnotic worship practices that induced receptivity of bodies to the Spirit. Whites and blacks drank in the Spirit together, and blacks delivered a message that, for a time, whites eagerly embraced. Once these initial enthusiasms settled into institutional routines, white and black believers moved into separate and (usually) distinct religious organizations. But in those liminal moments, the bars of race sometimes lowered. When they did come down, however, they opened up possibilities for cultural interchange that fed into the "shared traditions" outlined by historian and anthropologist Charles Joyner. Like Huck and Jim on the raft, black and white Southerners, Joyner argues, "continued to swap recipes and cultural styles, songs and stories, accents and attitudes. Folk culture simply refused to abide any color line, however rigidly it may have been drawn."4

Southern evangelical Christianity also has nurtured a subversive tradition of interracialism, one largely underground prior to the civil rights movement. Interracialism refers to self-conscious political efforts to undermine the system of racial hierarchy that defined Southern social life from the end of Reconstruction to the civil rights movement of the 1950s and 1960s. While religious institutions were resistant to change, many religious folk devoted themselves to a racial revolution precisely because they perceived God as its author. In more recent times, the civil rights movement—the central drama

of twentieth century Southern history—took on an evangelical Protestant cast itself, a sort of regionwide revival movement. Civil rights leaders, as well as their opponents, understood the history of their times as part of sacred (albeit competing and contradictory) narratives about God's intent and purposes in history.

Artists in the region have drawn deeply from the well of Southern evangelicalism, from the biblical imagery and cultural practices that have fashioned a distinct regional tradition. The South may have been the Bible Belt, but like Joseph's coat, it was a belt of many colors, embroidered with a rich stitching together of words, sounds, and images from the inexhaustible resource of the Scriptures.

1. Lillian Smith to Martin Luther King, Jr., March 10, 1956, *How Am I to Be Heard: Letters of Lillian Smith*, ed. Margaret Rose Gladney (Chapel Hill: University of North Carolina Press, 1993), 193.

2. Frederick L. Gwynn and Joseph L. Blotner, eds., *Faulkner in the University: Class Conferences at the University of Virginia, 1957–58* (Charlottesville: University of Virginia Press, 1959), 86.

3. Samuel S. Hill, *Southern Churches in Crisis* (New York: Holt, Rinehart and Winston, 1967); Samuel S. Hill, "Religion," in *The Encyclopedia of Southern Culture*, ed. Charles Reagan Wilson and William Ferris (Chapel Hill: University of North Carolina Press, 1989), 1269.

4. Charles Joyner, *Shared Traditions: Southern History and Folk Culture* (Urbana: University of Illinois Press, 1999), 25. For the slave era, Mechal Sobel makes a similar argument in *The World They Made Together: Black and White Values in Eighteenth-Century Virginia* (Princeton: Princeton University Press, 1987).

Illus. III-1

Mark Rothko (1903–1970)

Yellow Band, 1956

Oil on canvas, 86 x 80

NAA—Thomas C. Woods Memorial

Sheldon Memorial Art Gallery

and Sculpture Garden

University of Nebraska-Lincoln

Visualizing Faith: Religious Presence and Meaning in Modern and Contemporary American Art

Erika Doss

Although often overlooked, religious belief and issues of faith are significant factors for modern and contemporary American artists of many styles and backgrounds. Consider, for example, the roughly contemporaneous American artists Nellie Mae Rowe and Mark Rothko (1903–1970). In 1948, shortly after the death of her second husband, Rowe began to make found-object sculptures and brilliantly colored drawings that recollected her childhood in the rural South, her everyday life in post–World War II America and her personal spirituality. Drawings such as Untitled (Creation; see plate 86) and *Tree of Life* (see plate 87), featuring vividly rendered images of dogs, angels, barnyard animals, plants, and children, testify to Rowe's unique interpretation of Biblical narratives and her imagining of more peaceable gardens. "I try to draw because He is wonderful to me," Rowe remarked shortly before her death. "I just have to keep drawing until He says, 'Well done, Nellie, you have been faithful.' Then I will know that I have finished my work."[1]

Similarly, in 1947, after experimenting with Surrealist styles and exploring the subjects of classical mythology, Rothko began to develop large paintings such as *Yellow Band*, 1956 (see illus. III-1), which featured dazzling rectangles of color that seemed to float or pulsate on the canvas. "I'm *not* an abstractionist," Rothko insisted in the 1950s, adding:

I'm interested only in expressing basic human emotions—tragedy, ecstasy, doom, and so on—and the fact that lots of people break down and cry when confronted with my pictures shows that I communicate those basic human emotions. . . . The people who weep before my pictures are having the same religious experience I had when I painted them. And if you . . . are moved only by their color relationships, then you miss the point![2]

Or compare the stylistically similar paintings of John "J. B." Murray and Mark Tobey (1890–1976), both of whom adopted distinctive compositions of "all-over" calligraphic patterning for specific religious purposes. Murray began creating "spirit drawings" such as his two paintings, both Untitled (see plates 70 and 71), after experiencing a vision from God to move his hands "in a manner willed by His power." A member of a Southern Baptist church where glossolalia, or speaking in tongues, was not uncommon, Murray's glossographia were the visual embodiment of his personal religious beliefs: painted prophecies of good and evil, visually elaborate incantations of a deeply private faith.[3]

Transferring the word of God into visual form, Murray's art is similar to that of Southern evangelical artists such as Sister Gertrude Morgan and Howard Finster, whose paintings (see, for example, Morgan's *Poem of My Calling*, plate 68, and Finster's *Days of Creation*, plate 30) are similarly crammed with dense script and obsessively detailed imagery.

Likewise, Tobey developed his painterly technique of "white writing" in the mid-1930s, after he became an adherent of Baha'i—an Iranian religious movement which envisions itself as a unifying faith for all people—and was inspired by the decorative and rapidly transcribed style of Arabic calligraphy manifest in the written revelations of Baha'i's nineteenth-century founder. Paintings such as *Canticle*, 1954 (see illus. III-2), and *Prophetic Night*, 1956, with their subtly rendered yet frenetic brushwork, overlay of luminous color, and titles referring to spiritual themes (a canticle is a liturgical song taken from the Bible) embody Tobey's belief in the Baha'i principles of "the unity of the world and the oneness of mankind" and in the mystical and revelatory value of the visual arts. As critic Selden Rodman remarked in 1957, Tobey was "firmly persuaded that the critical moment in a good painting takes place in a kind of trance—a mystical state in which the artist's soul or unconscious guides his hand."[4]

These comparisons suggest that American artists of all varieties are clearly engaged in visualizing faith. Some, such as Murray and Tobey, are drawn to the subject of religion as a means of defining and expressing the dimensions of their beliefs. Others, including artists ranging from William Hawkins to Kiki Smith (b. 1954), select religious subjects as a means of interrogating the institutional boundaries of mainstream belief systems. Hawkins's *Last Supper* #6, 1986 (see plate 43), for example, challenges traditional Western European notions of the participants in that biblical scene by picturing Christ's disciples as a diverse group of men and women, black and white. (His first version, done in 1984, featured a black Christ, and his ninth version, done in 1987, pictured Jesus as Stevie Wonder.)[5] Similarly, Smith's *Virgin Mary*, 1992 (see illus. III-3), diverges from conventional representations of the mother of Christ as a divine conduit of grace by depicting Mary as a fleshy, vulnerable, and distinctly human figure.[6]

Some artists engaged in the intersections of art and religion see themselves as visionaries whose art mediates between a mysterious physical universe and their personal, subconscious, and imaginative understandings of that universe. Howard Finster recounted many times that he was a "man of visions," divinely appointed to "paint sacred art" after experiencing a visionary call in 1976. Likewise, Minnie Evans turned to religious art after experiencing vivid dreams and revelations and hearing the voice of God command her to "draw or die" (see plate 26).[7] Other artists, such as Tobey, chose to explore the visual operation of belief on optical terms, probing the "spiritual capacities of purely visual sensations."[8] Whatever their motivations and however much they differ in style, their art raises a number of questions about the intersections of religious faith and visual art. How, for example, does religion "work" visually? How do images and objects embody, reveal, and negotiate religious faith and spiritual interests? How does visual culture constitute—not merely illustrate—religious practice and experience? How and why do visionary artists use pictures, often blended with words, to express the spiritual impulses they experience? Why are pictures such an important means of translating or questioning religious beliefs? What is the relationship between pictures and what have been assumed to be the primarily oral and text-based traditions of the so-called religions of the book: Judaism, Christianity, and Islam?

My primary concern in the intersections of pictures and religion stems from my larger interests

in how pictures provide insights into who and what we are as an American people, culture, and nation. From the "city on the hill" creation myth of the New England Puritans and the missionary zeal of the Southwestern Spanish padres to the contemporary rise of New Age spirituality and political interests in a "faith-based initiative," religion has been fundamental to the culture and identity of the United States. As historian Nathan Hatch writes, "Deep and powerful undercurrents of democratic Christianity distinguish the United States from other modern industrial democracies;" while America has become one of the most religiously diverse countries in the world, Christianity remains central.[9] Importantly, however, in the United States, Christianity has always been a mutable and evolving system of belief: indeed, religion has consistently been private and subjective in America, and Christianity is among faith systems that Americans have repeatedly defined and configured in order to mesh with changing personal, social, and political needs. Recently, for example, Americans demonstrated an apparent "return to religion": polls from 2000 reveal that 85 percent of Americans believe that religion is "very" or "fairly" important in their lives, 81 percent believe in an afterlife, and 96 percent of Americans believe in God. "Americans' fascination with spirituality has been escalating dramatically," sociologist Robert Wuthnow reported in 1998, a claim certainly substantiated among contemporary American artists.[10]

Andy Warhol's (1928–1987) last major cycle of paintings, 1986, for example, consisted of around forty silk-screened canvases, large and small, based on Leonardo da Vinci's fresco, the *Last Supper*.[11] Robert Gober, Andres Serrano, Renée Cox, Guillermo Gómez-Peña, and Alma Lopez are among contemporary American artists whose work is permeated with references to Catholicism. Likewise, Jewish artists Hélène Aylon, Ruth Weisberg, and Allan Wexler are especially engaged by *midrashic*

activities centered on recontextualizing and defining sacred Judaic texts and traditions. In the late 1990s, popular Christian artist Thomas Kinkade, the self-avowed "Painter of Light," was represented by 350 galleries and 5,000 retail outlets, which sold some 20 million of his "limited edition" prints.[12] And the work represented in *Coming Home! Self-Taught Artists, the Bible and the American South* further substantiates the strong religious interests and motivations for painters and sculptors located in the southeastern United States. Artists who are labeled "modern" and "contemporary," like Rothko, Tobey, Warhol, and Weisberg, and those called "self-taught" or "outsider," such as Rowe, Murray, Morgan, and Finster, share interests in faith and spirituality and express them in visually diverse strains.

Interestingly, however, the intersections of art and religion, especially regarding modern and contemporary American artists, remain largely underconsidered among art historians and critics. Some art museums have recently begun to explore these intersections, most notably in exhibitions focused on the religious perspectives of African American, Native American, Latin American, queer, and/or women painters and sculptors. Yet by centering on artists already marginalized by the so-called "mainstream" art world, such shows perpetuate the idea that only America's multicultural "others" and "outsiders" are particularly attentive to spiritual subjects and issues of faith.[13] Similarly, such recent exhibitions as *Testimony: Vernacular Art of the African-American South*, 2000, and *Let It Shine: Self-Taught Art from the T. Marshall Hahn Collection*, 2001, highlighted the importance of religion, particularly evangelical Christianity, among a number of Southern "self-taught" artists.[14] However well-intended, by featuring painters and sculptors who have been arbitrarily categorized as "different" from "mainstream" artists on the random basis of formal art education, such exhibitions reinforce assumptions that the visual expression of

Nellie Mae Rowe (1900–1982)

Vinings, Georgia

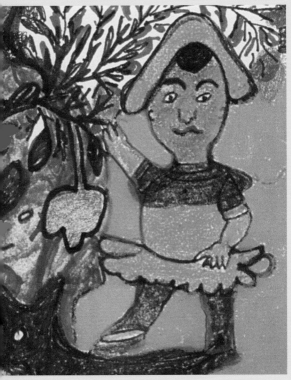

Nellie Mae Rowe, *Tree of Life* detail, plate 87

Deeply spiritual throughout her life, Nellie Mae Rowe was a member of the African Methodist Church and also attended the local Baptist church. Rowe reasoned that God did not "give her children," but did bless her with special artistic talent. Rowe's greatest need for spiritual assistance came during the last years of her life when, suffering from melanoma, her profound faith helped her face death without complaint.

Gospel music, a popular form emanating from church hymns, was another source of Rowe's creative expression. As a child she learned about the music from her mother, Louella Williams, who sang and played the organ at home. She listened to the local gospel music radio station, played recordings at home, and sang and played on the organ tunes such as "Call on God and Tell Him What You Want."

Evidence of Rowe's religious orientation may be recognized in motifs and text references in early and more mature drawings. The most common religious or biblical reference in the artist's drawings before 1978 was the cross, which appears as a central element or off to one side. Other symbols or vignettes with religious connotations include the hand, foot, Tree of Life, lamb, and Garden of Eden. In a more mature work, *Nellie Mae Making It to Church Barefoot*, large footprints in the foreground near a church refer to a symbolic meaning of humility. In *I Will Sea You at the Rafter Some Sweat Day*, a whimsical spin to a serious subject is highlighted by the placement of a large dog in the center of the composition with the inspirational Rapture in the top right corner. *Praise Hands* features uplifted black hands in the foreground protecting a lamb, a symbol for Jesus, in the background. Rowe created several drawings in which the Tree of Life is the featured element. In the version featured in *Coming Home!* (see plate 87), Adam and Eve flank the Tree of Life, which is surrounded by other figures and many animals, suggesting a personalized and peaceable kingdom.

For her funeral, Rowe requested that her friend Barbara Mitchell sing "99 and a Half Won't Do," a song that reiterates Rowe's belief that in the end nothing less than total faith in God is acceptable.

Lee Kogan

Illus. III-2
Mark Tobey (1890–1976)
Canticle, 1954
Casein on paper, 17.75 x 11.81
Gift of the Sara Roby Foundation, Smithsonian
American Art Museum, Washington, D.C.

Illus. III-3
Kiki Smith (b. 1954)
Virgin Mary, 1992
Wax, cheesecloth, and wood with steel base, 67.5
x 26 x 14.5
Collection of the Artist

religious belief lies mostly in the purview of a seemingly isolated group of "self-taught" artists living primarily in America's Bible Belt.

Assumptions about artistic difference demand critical and historical scrutiny, as do those that limit or disregard the visual presence and meaning of religious belief. The deep significance of faith among many American artists necessitates that art historians, critics, and curators reconsider the cultural and historical biases that shaped such assumptions and rendered the opposing definitions of "mainstream" and "modern" art versus "outsider" and "self-taught" art. By extension, we need to recognize and respect the abiding importance of issues of faith, spirituality, and the sacred among American artists of all varieties. Finally, we need to generate more complicated considerations of the intersections of art and religion, recognizing, for example, the distinctions between art that affirms belief and art that probes and interrogates faith and analyzing, by extension, the different ways that religion "happens" visually.

Until recently, issues of religion were largely overlooked in the social and cultural history of twentieth-century American art because of critical misunderstandings of an assumed separation of a modernist avant-garde from religious inquiry and of modernism in general from religion.[15] In fact, issues of faith and spirituality were very much a part of modern art in America as artists of diverse styles and inclinations repeatedly turned to the subjects of religious belief and piety. Henry Ossawa Tanner, Marsden Hartley, Georgia O'Keeffe, Aaron Douglas, Joseph Cornell, Rothko, Tobey, Barnett Newman, Betye Saar, Ana Mendieta, Bill Viola, Lesley Dill, and Kiki Smith are just a few of the twentieth- and twenty-first-century American artists who explored the intersections of iconography, religious orthodoxy, and issues of faith. Yet these factors have often been disregarded because of abiding assumptions that modern art was predi-cated on the rejection of various traditions and belief systems—including religion.

As art historian Sally Promey explains, perhaps the strongest determinant in this "modernist divide" regarding art and religion is the lingering paradigm of the secularization theory of modernity.[16] In the developmental, or progressive, model of Western civilization to which this theory is attached, religion is viewed as childlike, immature, primitive, and group—or "sect"—oriented; hence, it is the opposite—or "other"—to a notion of modernism that has been constructed as adult, sophisticated (or complex), innovative, and individualistic—or "self"—oriented. Along these lines, modern American art that clearly embodies religious sensibilities, such as Tobey's *Canticle* and Warhol's *Crosses (Twelve)*, ca. 1981–82 (see illus. III-4), has mostly been considered from the vantage of formal artistic experimentation rather than in terms that disclose their religious content and meaning. Works of art that feature religious imagery are often disparaged as coercive forms of religious persuasion and relegated to the category of "religious" art: art that professes a certain faith tradition and aims to place believers in the vicinity of the holy—and to persuade nonbelievers of divine authority. As such, "religious" art has been less critically engaged with modern art's supposed focus on formal issues and on artistic self-expression and, hence, has been considered "nonmodern" or even "antimodern." Paintings by Rowe, Murray, and Finster are thus categorized on "religious" terms, while works by Rothko, Tobey, and Warhol are considered "modern." Such categorizations are absurd in light of the evidence itself, as a comparison of Hawkins's and Warhol's versions of the Last Supper suggests. But they also discount the patently religious impulses of the artists themselves.

Some of this critical and historical oversight can be attributed to the deeply private piety of some

modern and contemporary American artists. Warhol, for example, who was born in Pittsburgh and raised Byzantine Catholic (also called Greek Rite Catholicism), remained a devout Catholic throughout his life (to the point of attending services at St. Vincent Ferrer, a Catholic church in New York, several times a week), but rarely discussed his religious faith. This is not surprising; while religion is central to American self and national identity, the dimensions of spiritual belief are generally personal and self-contained. Yet, from the 1960s until his death in 1987, Warhol produced a large body of art that focused explicitly on religious subjects. As art historian Bradford Collins argues, Warhol's "death and disaster" paintings of 1962–63, a series based on tabloid newspaper photographs of car crashes, suicides, and electric chairs, specifically refer to the central, crucial meaning that death and divine judgment hold among Byzantine Catholic believers.[17] Although his gallery dealers could not sell many of these gruesome Pop art paintings, Warhol continued to make them, producing some one thousand death-related canvases in 1962 alone, which further suggests their deeply personal and pious meaning. Among the last works of this most public of modern American artists were his well-known *Last Supper* paintings and canvases such as *Crosses (Twelve)* (see illus. III-4): minimal, dramatic depictions based on photographs of Christian devotional objects. However private Warhol's belief, in other words, the evidence of his art reveals a personally meaningful spirituality that calls for further consideration.

Reconsidering arbitrary art historical categories and reckoning with critical oversights include recognizing how paintings and sculptures not only reveal but negotiate issues of faith and spirituality. Assemblage artist Ed Kienholz (1927–1994), best known for room-size environments of life-size figures and objects that bitingly critique modern social and political conditions, often employed Christian religious symbols and icons in his work. The installation sculpture *76 J.C.s Led the Big Charade*, 1993–94 (see illus. III-5), for example, whose title puns on the lyrics to the theme song from *The Music Man* ("76 trombones led the big parade"), features seventy-six framed icons of Christ, mounted on the handles of children's toy wagons and bearing the arms and feet of plastic baby dolls. Kienholz admired faith but detested its abuse; he was profoundly cynical, as he said, about "the hypocrite who prays in church on Sunday and then preys on his neighbors and associates the rest of the week."[18] Made from recycled materials and found objects, Kienholz's installation clearly calls into question the meaning and practice of religious faith in everyday life.

Several artists represented in *Coming Home!* share Kienholz's assemblage aesthetic, including Hawkins Bolden (see plate 11), Lonnie Holley (see plate 44), J. L. Hunter (see plate 52), Charlie Lucas (see plate 64), Joe Minter (see plate 65), and Nellie Mae Rowe, all of whom created elaborate artistic environments in and outside their homes. As a number of art historians have demonstrated, the complex iconographical details of their "yard shows" demonstrate the retention and reformulation of specific African spiritual elements and traditions, such as the use of motion emblems that can be traced to the *dikenga* cosmogram of the Kongo, or the display of protective talismans similar to those of Kongo *nkisi* rituals.[19] Their yard art also reveals the influence of what religious studies scholar Theophus Smith terms "conjuring culture," an enduring form of spiritual practice common among African Americans that draws on Biblical narrative, images, and metaphors to challenge oppressive social and cultural conditions in the United States. As Smith argues, conjuring is a "magical means of transforming reality," a coded and highly significant system "for mapping and

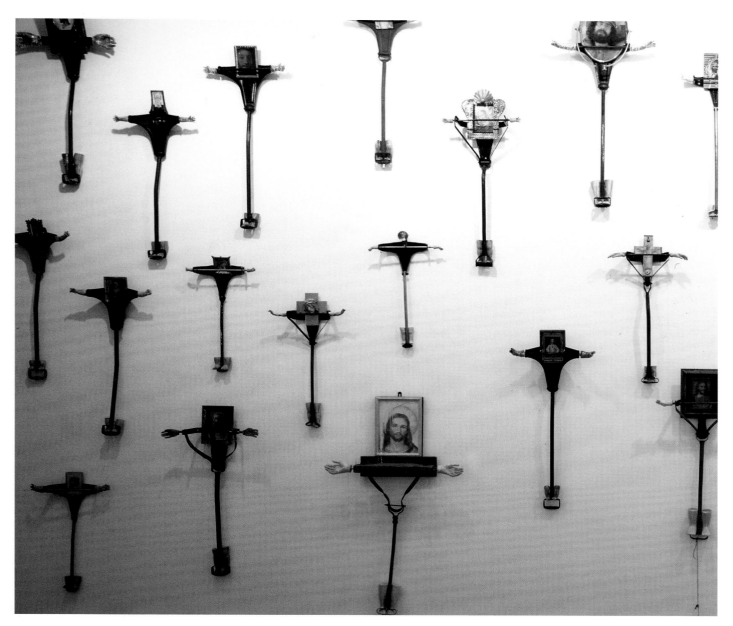

< Illus. III-4
Andy Warhol (1928–1987)
Crosses (Twelve), ca. 1981–1982
Synthetic polymer paint and screen print on
canvas, 20 x 16
The Andy Warhol Museum, Pittsburgh; Found-
ing Collection, Contribution The Andy Warhol
Foundation for the Visual Arts, Inc., 1998.1.264

Illus. III-5
Edward (1927–1994) and Nancy Reddin
Kienholz (b. 1943)
76 J.C.s Led the Big Charade, 1993–94
76 wall-mounted mixed media pieces,
dimensions variable
Collection of Nancy Reddin Kienholz

Joe Minter (b. 1943)

Birmingham, Alabama

In the midst of Joe Minter's *African Village in America*, a dense environment of lush plantings and installations, stands a modest sign that reads, "THANK YOU GOD FOR THE HOLY GHOST FAITH VISION AND DREAM IN 1989 TO BE A WORKER IN THIS VINEYARD BUILT BY YOUR HAND MY LORD THY GOD IN LOVE AND PEACE TO OPEN THY CHILDREN EYES. AMAN." Joe Minter, who "at one time . . . wouldn't say a word," had prayed "to have me a view" that would enable him to "communicate with the world." Since 1989, Minter has created a series of installations that eloquently commemorate the history of Africans in America. For Minter, the lives of African Americans characterized by "tribulation, patience, experience, and hope" can serve as an *imitatio Christi* or *exemplum fidei* for all Americans.

Minter introduces his journey through history at the rear of his property, which abuts two of Birmingham's historic African American cemeteries. Next to this "ancestral burial ground," circular African huts painted red, green, yellow, and black and surrounded by warrior figures honor the civilization and values that sustained African Americans in the New World. The adjacent installation inscribed with verses from the Old and New Testaments represents the Christian foundation of African American life. Minter continues these African and religious themes by placing protective figures wearing masks and carrying forked spears and images of Christ on the cross throughout the environment. The central area of the environment represents the signal events of the civil rights struggle and recognizes both the leaders and the ordinary people who risked considerable danger through their participation. Minter's eloquent use of materials such as iron chains and bars recalls the enslavement of African Americans, the oppression of minorities, the low-paid and dangerous labor of African Americans in Birmingham mills, and the imprisonment of civil rights activists like Martin Luther King.

Minter has recently expanded his environment across the street to another small yard and house built to contain installations and autonomous works that bring the themes of the larger yard into the personal realm. Before the house stands a moving depiction of parents and child linked together by chains that here represent familial bonds. One room pays homage to past generations that, despite poverty, turned modest cabins into warm and secure homes for their children. *Jesus Loves the Little Children* (see plate 65), an assemblage of cast-off rubber dolls, a stroller, and a lithograph of Jesus, enlarges on the theme of love for children as it calls to mind the hymn of the same name so often sung in Protestant Sunday schools. Autonomous works like the *The Last Trumpet* (see plate 66) urge believers to look into their own hearts to prepare for the Second Coming and the completion of human time.

Cheryl Rivers

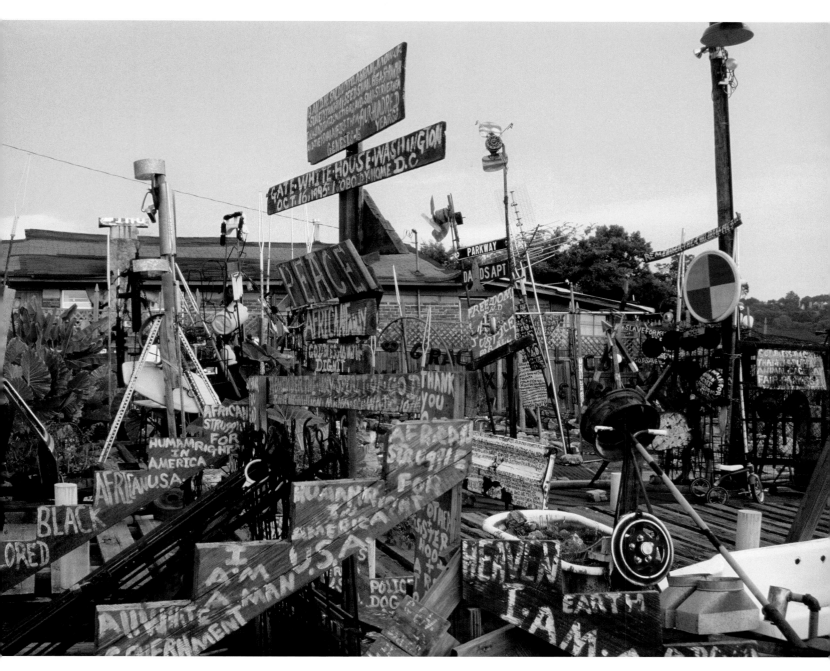

Illus. III-6
Joe Minter (b. 1943)
African Village in America, 2003
Birmingham, Alabama

managing the world in the form of signs" that is both oppositional and life-affirming.[20]

Minter, for example, has labored on his yard art in Birmingham, Alabama, since the late 1980s, when he was laid off from an automobile body shop where he had worked for years (see illus. III-6). Filled with found objects, natural materials, welded-metal sculptures made of abandoned industrial and farm tools, signs quoting biblical verse, protective charms, and pictures of black leaders such as Malcolm X and the Reverend Martin Luther King, Jr., Minter's yard is an alternative aesthetic environment that specifically addresses issues of social injustice, African American history, and the dimensions of faith. His sculptures similarly embody a critical consideration of Christian tropes and tenets. *Jesus Loves the Little Children* (see plate 65), which features a baby stroller filled with abandoned and disheveled dolls and a framed print of a beaming Jesus embracing a small child, juxtaposes Christian idealism with the realities of a modern American society where the education and welfare of the nation's youngest citizens are underfunded and disregarded.

These sculptures by Minter and Kienholz reveal that not all art that visualizes faith simply affirms belief; rather, their work questions and appraises religious belief by scrutinizing its assumptions and practices. Such interrogations can be controversial; heated response to Andres Serrano's *Piss Christ*, 1987, threatened funding for the National Endowment for the Arts in the early 1990s, and in 2001, the Brooklyn Museum of Art's display of Renée Cox's photograph "Yo Mama's Last Supper" (in which the African American artist portrayed herself, naked, as Christ) met with angry mayoral threats to deny future public funds to the museum. Such intolerance, or perhaps simply fear of the powerful dimensions of art focused on religious iconography and systems of belief, is further seen in attempts to "clean up" (and tear down) various examples of yard art, or the apparent refusal by

John "J. B." Murray's preacher to allow the artist to distribute his prophetic glossographia among his fellow Baptist churchgoers.[21] Yet questioning systems of belief and redefining and reshaping the dimensions of personal faith are enduring facets of America's national and religious identity. Recognizing these abiding, and often conflicted, characteristics is key to further assessing the presence and meaning of religion in modern and contemporary American art.

1. Nellie Mae Rowe quoted in Judith Alexander, *Nellie Mae Rowe: Visionary Artist, 1900–1982* (Atlanta: Southern Arts Federation, 1983), 11.

2. Mark Rothko quoted in Selden Rodman, *Conversations with Artists* (New York: Devin-Adair Company, 1957), 93–94.

3. J. B. Murray quoted in *Baking in the Sun: Visionary Images from the South: Selections from the Collection of Sylvia and Warren Lowe* (Lafayette: University Art Museum, University of Southwestern Louisiana, 1987), 56; see also Alice Rae Yelen, *Passionate Visions of the American South: Self-Taught Artists from 1940 to the Present* (New Orleans: New Orleans Museum of Art, 1993), 141, and William Arnett, "John B. Murray," in *Souls Grown Deep: African American Vernacular Art of the South*, Vol. 1, ed. Paul Arnett and William Arnett (Atlanta: Tinwood Books; in association with The Schomburg Center for Research in Black Culture, The New York Public Library: 2000), 464–81.

4. Rodman, *Conversations with Artists*, 5; on Tobey's religious practice see Katherine Plake Hough and Michael Zakian, *Transforming the Western Image in Twentieth-Century American Art* (Palm Springs: Palm Springs Desert Museum, 1992), 63, and Matthias Barmann and Kosme de Baranano, *Mark Tobey* (Madrid: Art Data, 1997), n.p.

5. For other versions, see *Popular Images, Personal Visions: The Art of William Hawkins 1895–1990* (Columbus: Columbus Museum of Art, 1990); *Passionate Visions of the American South*, 163; William Arnett, "William L. Hawkins," in *Souls Grown Deep*, Vol. 1, 426–31.

6. Erika Doss, *Twentieth-Century American Art* (Oxford: Oxford University Press, 2002), 9–10.

7. Joanne Cubbs, "New Geography: Mapping Meaning in Self-Taught Art from the South," in *Let It Shine: Self-Taught Art from the T. Marshall Hahn Collection* (Jackson: University Press of Mississippi, 2001), 36–38.

8. David Morgan, "Religion in the Context of Art," in *Like a Prayer:*

A Jewish and Christian Presence in Contemporary Art (Charlotte: Tryon Center for Visual Art, 2001), 29.

9. Nathan O. Hatch, *The Democratization of American Christianity* (New Haven: Yale University Press, 1989), 5; Diana L. Eck, *A New Religious America: How a "Christian Country" Has Become the World's Most Religiously Diverse Nation* (New York: HarperCollins, 2001).

10. Statistics taken from "Spirituality," *New York Times Sunday Magazine* (May 7, 2000): 84; Robert Wuthnow, *After Heaven: Spirituality in America Since the 1950s* (Berkeley: University of California Press, 1998), 1.

11. See Jane Daggett Dillenberger, *The Religious Art of Andy Warhol* (New York: Continuum, 1998), 101 and *passim*; Peter Kattenberg, *Andy Warhol, Priest: "The Last Supper Comes in Small, Medium, and Large"* (Boston: Brill, 2001), 5 and *passim*; and Corinna Thierolf, "All the Catholic Things," in *Andy Warhol, The Last Supper* (Munich: Neue Pinakothek, 1998), 23–53.

12. See, for example, Erika Doss, "Robert Gober's 'Virgin' Installation: Issues of Spirituality in Contemporary American Art," in David Morgan and Sally M. Promey, eds., *The Visual Culture of American Religions* (Berkeley: University of California Press, 2001), 129–45, 322–24; Eleanor Heartney, *Postmodern Heretics: The Catholic Imagination in Contemporary Art* (forthcoming); Heartney, *Faith: The Impact of Judeo-Christian Religion on Art at the Millennium* (Ridgefield: Aldrich Museum of Contemporary Art, 2000); Susan Orlean, "Art for Everybody: How Thomas Kinkade Turned Painting into Big Business," *The New Yorker* (October 15, 2001): 124–30.

13. Such exhibitions included *Spirituality in Contemporary Art by Women* (Watson Gallery, Wheaton College, Norton, Massachusetts, 1990); *Seven Visions: The Spirit of Religion in Contemporary Regional Art* (Arnot Art Museum, Elmira, New York, 1991), *Dreams and Shields: Spiritual Dimensions in Contemporary Art* (Salt Lake Art Center, Salt Lake City, Utah, 1992), *Ceremony of Spirit: Nature and Memory in Contemporary Latino Art* (The Mexican Museum, San Francisco, 1993–1994), *Consecrations: The Spiritual in Art in the Time of AIDS* (Museum of Contemporary Religious Art, Saint Louis University, 1994–1995), and *Art & Religion: The Many Faces of Faith* (The Balch Institute for Ethnic Studies and Villanova University Art Gallery, 1997); for further discussion see Doss, "Robert Gober's 'Virgin' Installation," 132–34.

14. *Testimony. Vernacular Art of the African-American South: The Collection of Ron and June Shelp* (New York: Harry N. Abrams; in association with Exhibitions International and the Schomburg Center for Research in Black Culture: 2001); and *Let It Shine*. For an excellent discussion of the limitations of artistic labels such as "self-taught" see Arthur Danto, "The End of the Outsider," in *Testimony*, 30–41, 184–85.

15. Recent scholarship which reconsiders the role of religion and modern American art includes Morgan and Promey, *Visual Culture of American Religions*; David Morgan, *Visual Piety: A History and Theory of Popular Religious Images* (Berkeley: University of California Press, 1998); *Like a Prayer*; and Dawn Perlmutter and Debra Koppmann, eds., *Reclaiming the Spiritual in Art: Contemporary Cross-Cultural Perspectives* (Albany: State University of New York Press, 1999).

16. Sally M. Promey, "The 'Return' of Religion in the Scholarship of American Art," *Art Bulletin* LXXXV, 3 (September 2003): 581–603.

17. Bradford Collins, "Warhol's Modern Dance of Death," paper given at the Department of Art and Art History Visiting Scholars Colloquium, University of Colorado, Boulder, February 13, 2002. One of Warhol's last works, titled *Heaven and Hell Are Just One Breath Away!* 2 c. 1985–86, suggests his abiding retention of such beliefs; for an illustration see Dillenberger, *Religious Art of Andy Warhol*, 42.

18. Rosetta Brooks comments about *76 J.C.s Led the Big Charade* in *Kienholz: A Retrospective* (New York: Whitney Museum of American Art, 1996), 242. This work was made in collaboration with Nancy Reddin Kienholz.

19. See, for example, Grey Gundaker, "Tradition and Innovation in African-American Yards," *African Arts* 26, 2 (1993): 59–62; Grey Gundaker, ed., *Keep Your Head to the Sky: Interpreting African American Home Ground* (Charlottesville: University Press of Virginia, 1998); Robert Ferris Thompson and Joseph Cornet, *The Four Moments of the Sun: Kongo Art in Two Worlds* (Washington, D.C.: National Gallery of Art, 1981); and essays in *Black Art, Ancestral Legacy: The African Impulse in African-American Art* (Dallas: Dallas Museum of Art, 1989) including Robert Ferris Thompson, "The Song that Named the Land: The Visionary Presence of African-American Art," and R. Perry, "African Art and African-American Folk Art: A Stylistic and Spiritual Kinship," 35–52.

20. Theophus H. Smith, *Conjuring Culture: Biblical Formations of Black America* (New York: Oxford University Press, 1994), 4.

21. As noted in William Arnett, "John B. Murray," 477.

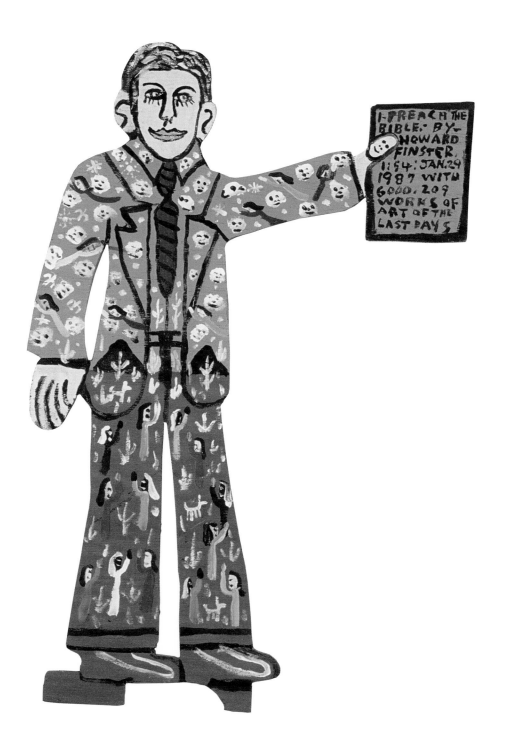

Illus. IV-1
Howard Finster (1915 or 1916–2001)
I Preach the Bible #6000.209, 1987
Cut out figure, enamel paint on panel, 13 x 9
Collection of John Denton

The Word and the World: Evangelical Christianity, the Bible, and the Secular South

Hal Fulmer

In the beginning was the Word and the Word was with God and the Word was God. —John 1:1

In the South, first and foremost, there is the Word. There are other books and other authors, to be sure, but only one text is empowered with a capital letter, and it is the Bible, divinely inspired, inerrant, and literal. For the religious Southerner, the events of a daily world emanate from, filter through, or stand opposed to what folks called Scripture. The Bible cuts through the life of the South, for those who are its followers and those who are not. Depending on one's point of view, the South is a region alternately guided by, or dominated by, the power of the Bible. Historically and contemporarily, it is a pervasive text, whose influence affects the Southerner's understanding of politics, society, history, and the future (see plate 74)

At the heart of Southern religion is a theology of humanity's innate sinfulness, Christ's perfect sacrifice and God's personal involvement in the life of the sinner and the saint. In the South, the world and all its activities are divided into two distinct groups: the sacred (those which follow God's preordained and perfect plan) and the secular (human actions separate from God). For the Southerner, the Bible is the principal source of explanation for understanding God's Will on issues as diverse as abortion, capital punishment, race relations, interpersonal behavior, and world politics. Abortion, for example, is murder; capital punishment is not

murder, but an act sanctioned in the Old Testament laws given to Moses. For the white Southerner, especially at the time of the Civil War, the hierarchy of the races (white enslaving black) was ordained by God for Christianizing a heathen people and perpetuating order in society. Interpersonally, adultery and fornication, both sins of the flesh, are wholly outside the realm of Godliness, and activities that might lead to these behaviors (such as dancing and drinking) are equally reviled. In a vision of the world at large, salvation's grace comes from God, but the delivery of that message through evangelism and the protection of the freedoms necessary to deliver that message are the work of God's own people on earth. In the South, God's Will is actively sought and devoutly followed. Failure to act in accordance with this Will identifies a person as a sinner (not yet repented and saved) or a backslider (once repentant but now living a secular life). The principal interpreters of God's Will are the clergy, and in the South, this group has never been shy about making this Will clear to their congregations (see illus. IV-1).

The white Southern interpretation of the Bible historically was almost always conservative. White Southern preachers supported slavery in the Old South and advocated secession to protect the institution. In the 1840s and 1850s, the main

Rev. Benjamin "B. F." Perkins (1904–1993)

Bankston, Alabama

Rev. "B. F." Perkins, *May We All Let Jesus Come into Our Harts* detail, plate 75

Rev. "B. F." Perkins was a resolute patriot (he served four years in the Marines), a committed Christian, and a student of Bible prophecy. He was a minister of the Assembly of God Church and then a bishop in the Church of God. After retirement, he settled near Bankston, Alabama, where he built the Hartline Assembly of God Church and a folk art environment that included his house on a sixteen-acre plot of land. Now gone, the house, brilliantly painted in red, white, and blue, appears with its curved driveway, "carports," and upstairs porch in many of his paintings, including *Homeplace* (see plate 73), where Perkins imagines a perfect realm. Christ's victory over death pervades a landscape that is inescapably American. Equally religious and patriotic is the preacher's rendition of a large American flag, which carries a globe decorated with a gold cross and the words "Jesus is the Light of the World" (see plate 74). The pledge of allegiance appears at the bottom of the painting, while at the top, Rev. Perkins adds, "America is great because of religious freedom to worship God according to the dictates of our own hearts USA Let everyone defend it with our lives if need bee." And along the side, he exclaims, "Thank God for America USA." Clearly, in Perkins's mind there is little separation between church and state or the private and public spheres.

Perkins's blend of intense patriotism and strong religious fervor has roots in the discourse, begun in the Pilgrims' era, about America's prophetic destiny and religious significance. In the seventeenth century, speculation about America's role in God's plan led the Boston minister Increase Mather to imagine America as a forerunner of the New Jerusalem. Nearly a hundred years later, Jonathan Edwards, a Massachusetts pastor, referred to the coming millennial kingdom of God as a work that would surely begin in America. Edward's grandson Timothy Dwight, speaking only a few weeks after the signing of the Declaration of Independence, hailed the emerging nation: "Arise, shine, for thy light is come." After the Civil War and following World War II, the conviction that America enjoys a special place in God's plan lost favor. Even so, Paul Boyer, author of *When Time Shall Be No More*, observes that belief in America's sacred destiny still vigorously informs modern culture. Indeed many evangelicals and many Southerners who believe that the gospel is relevant to public life still hold strong convictions about the United States' divinely appointed role in human history.

Carol Crown

branches of evangelical Protestantism split over the issue of slavery with the formation of Southern Baptist, Southern Methodist, and Southern Presbyterian churches. It became apparent that region, not religion, was the unifying force.

Following the Civil War, those same preachers continued decades-long defenses of the war and promoted a politically conservative South that denied any realistic union between blue and gray, black and white. Theologically, Southern Baptists and Southern Methodists might argue at length in their journals about the amount of water necessary for a proper (and scriptural) baptism. On the issues of the Civil War, the value of slavery, the necessity of secession, and the heresies of a North that had fallen away from a true understanding of the Scriptures, there were few, if any, differences. The various white Southern churches became a Southern Protestant Church, functioning in most political activities with singular purpose and rhetoric. The death of such well-known Southerners as Robert E. Lee became major rhetorical moments in the post-war South, as clerical figures used the occasion to celebrate the mythologies of the Old South and the Lost Cause.

Long after Appomattox, Southern believers were being reminded that the Civil War was fought to protect the Constitution and the Bible. Reunions of Southern soldiers at United Confederate Veterans' meetings always featured lengthy invocations by pastors. A recurrent phrase was to implore the blessings for the region from "the God of Abraham, Isaac, and Jacob, the God of Lee, Davis, and Jackson." In one line, the great patriarchs of the Old Testament were linked to the great Confederate leaders and time collapsed across the centuries to a fixed point of Southern apologia.

Almost a hundred years after the Civil War, in the latter half of the twentieth century, the great enemy was Communism, and white Southern clergy again made use of Scripture to note the declining morality of the country and the clear relationship between immorality, Communism, and Satan. Perhaps the best known of all the white Southern preachers during this time was Billy Graham, who attacked Communism relentlessly from his pulpit, on his radio and television programs, and in his writings. For many Southern preachers, the Soviet Union replaced the Yankees as Satan's ally.

In these years, the country was experiencing the upheaval associated with the civil rights movement. Billy Graham also interpreted the Scripture in ways that chagrined many white Southerners, claiming that all people, of all races, were equal in the sight of God. Even before *Brown vs. Board of Education* in 1954, Graham was attempting, occasionally with success, to integrate his crusades in the Deep South. Many of Graham's lesser-known white brothers of the cloth still contended that God's Scripture clearly described blacks as children of Ham, cursed by God, and socially and politically inferior. Martin Luther King, Jr., another well-known Southern preacher, read those Scriptures differently and understood that before God, all people were spiritually equal and deserving of political equality. If white Southern interpretations of the Bible were almost always conservative, the black Southern interpretations of Scripture held out the hope of change, not only in the world to come, but in this present world. Rather than waiting for Christ to return to usher in a new and better place, individuals divinely inspired and led by God could help change the world now. From the days of slavery through the civil rights era to the present, black Southern preachers have called forth the Scriptures to comfort and change their listeners and their world. These differing interpretations, one white and one black, are hallmarks of the tension in the Southern religious experience. What remains for both groups, however, are that the affairs of Caesar and of Christ are often intertwined (see plate 39).

For the Southerner, black and white, the Bible is a text to be read literally for its spiritual truths and the implications of these truths in a secular world (see plate 4). Sin is not an abstract concept; sin is real and identifiable with particular individual behaviors, such as alcohol consumption, sex outside of marriage, homosexuality, and, occasionally, dancing. At a sociopolitical level, sin takes the form of legislation perceived as anti-Scriptural, including the legalization of abortion, the demise of capital punishment, and the removal of prayer at various ceremonial events such as high school football contests or graduations.

Like sin, the Devil is also real (see plate 100); evil is not an internalized condition but an external entity. Satan receives support from a variety of sources beyond his own supernatural squad of demons. For the white Southerner, especially, there are liberal legislators, anti-Christian legislation, entire countries (most notably those that were, or remain, Communist), and even apathetic individuals who decline to choose sides in the cosmic battle of Good and Evil. Sin and Satan are not removed from the Southerner's daily life, but as St. Peter noted in his epistle, the Devil is like a lion, prowling constantly, seeking those who would fall away from the faith.

Southern religion is most often in the jeremiad tradition, calling people to accountability for their sins and imploring them to seek redemption, both personally (through an acceptance of Christ's sacrifice and a changed life) and through the support of activities that perpetuate God's Will. This jeremiad tradition (taking its name from the Old Testament prophet Jeremiah) is distinctly prophetic, arguing that people have turned away from God's Will and need to repent. Such repentance is personal but also social and political. The repented believer is expected to support causes that further God's efforts on earth and to defeat causes that hinder his efforts. Southerners well understand sin. Leading a redeemed life is difficult, and the power of sin, like the power of grace, is real and tangible. From this sin comes guilt, and Southerners understand guilt perhaps best of all. Clearly, it is a theme that dominates Southern fiction, drama, cinema, and history. Without sin and its corresponding guilt, Southern preachers remind their flocks, there would be no urgency to repent. For the Southerner, then, sin and guilt can be overcome by grace, temporarily in the limitations of the current age but eternally in the age to come. It was this guilt, from the sin of segregation, that fueled Martin Luther King's oratory and actions as he attempted to convince the white South and the entire nation of the need for social repentance and political change.

In addition to the perils of sin, Scripture addresses interpersonal relations, particularly the role of women. Traditionally, the white Southern church has deemphasized overt leadership roles (especially preaching) for women while black churches have been more accepting. In some black churches, women, such as the self-taught artist Sister Gertrude Morgan (see plate 69), are often prophetesses, divinely inspired by God, to call his people back to redemption. In white churches, at least for most of the last century, women were relegated to secondary duties and were ineligible to serve on major church committees or to be ordained as deacons. Some religious groups in the South are particularly literal in their attention to small details, such as Paul's admonition that women should not cut their hair and should attend religious services with their heads covered. In addition to these Pauline admonitions, women in Scripture are often associated with sin and temptation; conservative pastors are quick to point out that Eve succumbed to Satan's temptation in the Garden of Eden, thus condemning all of humankind to Original Sin. Similarly, in the Book of Revelation, a dominant figure of the last days is the *Whore of Babylon* (see plate 83).

Finally, the Bible is a source book for Southern-

ers about what believers call the "last days" or "end times," that period leading up to the return of Christ (see plate 118). Drawing upon various Scriptures that point to particular events known as "signs," these end times have clear social and political references, ranging from a perceived decline in general morality to the creation of the state of Israel in 1948. Foreign affairs are interpreted through this lens of last days, with special attention paid to activities in the Middle East and China (the latter perceived as one of the super-governments cited in the Book of Revelation). In the aftermath of the September 11 terrorist attacks, the battle between a Christian America and the followers of Islam can be interpreted as a foreshadowing of the final battle between Christ and Satan, leading to the ultimate victory of Christianity and the ushering in of a lasting heavenly peace for believers. In this regard, America is seen as a "last best hope" for the world, a bastion of godliness and a bulwark against Satan's advances. The presidency of George W. Bush is seen as God-inspired and true to Scripture and is viewed by many white Southerners as a sharp antithesis to the presidency of Bill Clinton, also a Southerner, but representing the region's penchant for sin. Black Southerners, on the other hand, unlike their white brothers, see these presidencies differently, once again revealing the conflicting ways in which the two groups blend their interpretations of religion and politics.

There is a specific schedule of events for these end times. Declining morality, increasing sin (especially of a sexual nature), a loss of individual rights, and a general turning away from strictly interpreted scriptural admonitions are the context for the last days. So, too, are "wars and rumors of wars," as Christ noted in his discussion of these days, as are natural disasters such as earthquakes and floods (see plate 29). Finally, at the very end (always depicted as possibly occurring today), there will be the removal of believers, those who have repented and accepted Christ's sacrifice, at an

event known as the Rapture when Christ returns for his own (see plate 34). Many rural Southern cemeteries, black and white, have graves facing east, the direction from which the Bible says Christ will return. As more than one aging believer has been known to remark, "I want to be able to jump right up and see Jesus when he returns." Following the Rapture, there ensue seven chaotic and godless years known as the Tribulation, filled with brazen sin and notable for the Beast (see plate 90) and his mark ("666" according to the Scripture). After these seven long years, the ultimate battle between God and Satan takes place at Armageddon, with God the certain victor. The lasting peace of the millennium follows as does an eventual eternal heaven for those who are God's children. All of these events are eagerly and, in some cases, fearfully awaited as actual events by believers and are a prime source of Southern sermon material calling for sinners to repent.

In summary, for Southerners, the Bible is not metaphorical; rather it is an account of what happened historically and what will happen at that point where history becomes eternity. While white and black Southerners differ on their interpretations of the various scriptural texts, the Bible remains a work meant to be taken literally, one that extends a powerful influence into the daily lives, socially, politically, and spiritually, of the region's inhabitants.

Sister Gertrude Morgan (1900–1980)

New Orleans, Louisiana

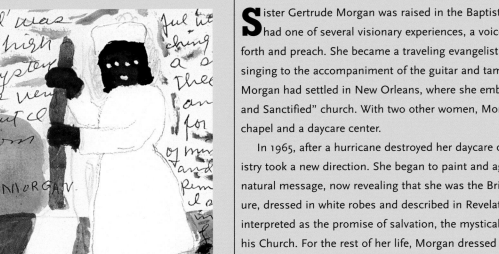

Sister Gertrude Morgan, *Poem of My Calling*
detail, plate 68

Sister Gertrude Morgan was raised in the Baptist Church. In 1934, she had one of several visionary experiences, a voice telling her to go forth and preach. She became a traveling evangelist, preaching and singing to the accompaniment of the guitar and tambourine. By 1939, Morgan had settled in New Orleans, where she embraced the "Holiness and Sanctified" church. With two other women, Morgan established a chapel and a daycare center.

In 1965, after a hurricane destroyed her daycare center, Morgan's ministry took a new direction. She began to paint and again received a supernatural message, now revealing that she was the Bride of Christ. This figure, dressed in white robes and described in Revelation 21:1, is usually interpreted as the promise of salvation, the mystical union of Christ and his Church. For the rest of her life, Morgan dressed only in white, a practice with particular importance within Holiness and other evangelical denominations where sanctified members dress in white to signify their separation from the wicked world. Confident in her renewed calling, Morgan returned to proselytizing in the streets, where she urged her audience to prepare for the latter days. Morgan's paintings, used in her street ministry, often include self-portraits in which she is dressed in white, and explicate prophetic visions. In some works, Morgan places herself in heaven, standing between God the Father and Jesus.

Sister Gertrude Morgan's vibrant paintings are striking evidence of the Southern fundamentalist emphasis on biblical prophecy concerning end-time events. However, while many of Morgan's works recount the apocalypse foretold in the books of Daniel and Revelation, including the damnation of the wicked, her favorite subject is the redemption of the faithful, who will enjoy everlasting life with God in the New Jerusalem, often shown as an apartment house occupied by persons of all races.

In *Sister Morgan Did Some Great Work* (see plate 69), the artist engages in an imaginary dialogue with God that recalls the core of her preaching. God asks, "do you remember . . . reading the chartres in the streets—that's a great way of broadcasting God's word." These prophecy charts or charters are teaching aids that interpret the prophecies in Daniel and Revelation as stages in the course of history that culminate with the end of time when the faithful will find a home in heaven with God and the angels.

Cheryl Rivers

African Retention, Biblical Reinterpretation, and Double Meaning in African American Self-Taught Art

Babatunde Lawal

Biblical themes predominate in African American self-taught art from the South for three reasons. First, almost all the artists are Christians. Second, many trace the sources of their inspiration to the Scriptures or to a spiritual experience during which God or a mysterious voice reportedly commanded them to carve or paint. Third, they use art to celebrate their Christian faith and to reinforce the African American quest for freedom and social equality (see plate 12). In any case, the artists' spiritual experiences cannot be explained in terms of (Pentecostal) Christian influence alone, for this phenomenon is very common in Africa and has survived in African-derived "conjure" and Vodou rituals in New Orleans and other parts of the Deep South. The fact that African American Christianity contains a large dose of African carryovers led Margaret Walker to write:

We have been believers believing in the black gods of an old land. . . . And in the white gods of a new land we have been believers. . . . Neither the slavers' whip nor the lynchers' rope nor the bayonet could kill our black belief. In our hunger we beheld the welcome table and in our nakedness the glory of a long white robe. We have been believers in the new Jerusalem. . . .[1]

As the theologian, James H. Evans, puts it, "African-American theological development can be best understood as the convergence of an African-derived worldview, the complexities of the experience of slavery, oppression, survival, rebellion, and adjustment in the New World, and their encounter with the biblical text."[2] This essay focuses on how African American self-taught art reflects this convergence, concealing black-specific meanings beneath popular biblical themes.

AFRICAN RETENTIONS

Art plays an important role in indigenous African religion and rituals essentially because African creation stories often identify the human body as a piece of sculpture empowered by a life force or soul.[3] Death results when the soul leaves the body, yet death is not the end of life. Rather, it is a transformation from physical to metaphysical existence where the departed soul of an individual lives on and may reincarnate as a newborn baby to start another life on earth. Thus the body, as a living work of art, mediates the spirit in the physical world. As Jose Gil observes, the body has always been at the center of the negotiations of ideological, political, economic, and spiritual power in all societies throughout history.[4] This explains the popularity of spirit possession in indigenous African religion being perceived as the moment when a supernatu-

ral force takes over a medium's body, using it to interact and communicate with humanity. As a result, the medium behaves differently, speaking in tongues. Spirit possession assumes a more elaborate form in the mask when the body is consecrated and costumed to conceal and reveal the presence of the sacred. Because art performs representational, communicative, and aesthetic functions in African religion and rituals, the traditional African artist sometimes doubles as a priest or spirit medium. Important commissions may require some artists to undergo trances during which spirits tell them what to do.[5] Accordingly, most altar images are stylized to stress their significance as a bridge between the spirit and human worlds. The prominence usually given to the head in African art reflects the belief that it is the seat of the life force and a site of communion with the spiritual. The early phase of African American religion has been described as an "invisible institution" because of the secrecy surrounding it.[6] African captives continued to invoke spirits in the privacy of their cabins and during nocturnal ceremonies in cemeteries, despite their conversion to Christianity.

Drawing upon the worship traditions of Africa, as well as those of revivalist Christianity, the slaves created services that resembled the spirit-empowered ceremonies of their African ancestors. Both traditions assumed that authentic worship required an observable experience of the divine presence. "It ain't enough to talk about God, you've got to feel him on the altar of your heart," as one former slave explained. Ritual, in this perspective, was supposed to bring the divine power tangibly into this world, so that the people might be transformed, healed, and made whole. The presence of God became manifest in the words, the gestures, and the bodily movements of the believers. . . . [7]

This mode of worship has survived in various forms in many black church denominations.[8] The inseparability of art from religion led captives to reproduce African musical instruments from memory, using them in ritual ceremonies. For instance, a carved drum seized from captives in Colonial Virginia in the eighteenth century is stylistically so similar to the *atumpam* and *apentemma* drums of the Akan of Ghana and Cote d'Ivoire that it would seem to have been produced by a carver who had made similar drums in Africa before being enslaved.[9] In the nineteenth century, one slave was observed catching turtles and birds and using wire to incise cryptic designs on their bodies before allowing the creatures to escape, apparently to deliver the message implicit in the designs to his ancestors.[10] Some slaves reportedly made wooden and clay sculptures and danced around them in memory of their African ancestors.[11] Between 1860 and 1890 black slaves and former slaves from the Kongo who were employed as potters in the Edgefield district of South Carolina created glazed face vessels that might have been used in ritual contexts.[12] The visage of these vessels bears a striking resemblance to that of the carved minkisi ritual figures that they left behind in Africa.[13]

Certainly, the most conspicuous survival of the African past in African American religion is Vodou (the so-called Voodoo or Hoodoo), the belief that nature spirits can be invoked and manipulated for positive or negative purposes. A carved figure sculpture found in the 1930s in the back room of a barber's shop in New Orleans was covered with sacrificial materials (dry crust of blood and traces of chicken feathers), suggesting that it might have been used in Vodou rituals. In fact, the patterns on the figure's chest recall the veve, the ideogram intended to attract spirits during Vodou ceremonies. The emphasis on the head is reminiscent of the conceptual style of African sculpture.[14]

Formally trained African American artists of the nineteenth century ignored the ancestral style because it was misconstrued by Euro-Americans as

a failed attempt to imitate nature. Consequently, and in order to gain national recognition, these black "academicians" emulated the Euro-American convention with its emphasis on academic realism. However, an aesthetic revolution in Europe at the turn of the twentieth century resulted in the birth of modern art and with it a penchant for abstraction inspired by non-Western art, in general, and African sculpture, in particular. This encouraged formally trained black artists to return to their roots, ushering in the New Negro movement of the 1920s and 1930s, otherwise known as the Harlem Renaissance. On the other hand, many self-taught African American artists continued with what they had inherited from their antebellum ancestors, using art to enrich their lives and religious beliefs and helping to sustain African carryovers in basketry, woodcarving, iron-working, quilts, pottery, grave decorations, and so on.[15]

BIBLICAL REINTERPRETATIONS

As the free blacks and African captives of Colonial and antebellum North America became familiar with the Bible, they read new meanings into some passages. For example, since the term "Ethiopia" generally refers to the dark-skinned people of Africa, blacks viewed Psalm 68:31—"Princes shall come out of Egypt; Ethiopia shall soon stretch her hands unto God"[16]—as a promise by God to deliver them from the indignities of slavery (see plate 28). Thus, in his famous "Ethiopian Manifesto" of 1829, the black nationalist Robert Alexander Young declares:

As came John the Baptist, of old, to spread abroad the forthcoming of his master, so alike are intended these words, to denote to the black African or Ethiopian people, that God has prepared for them a leader, who awaits but for his season to proclaim to them his birthright.[17]

The fact is that the African captives who laid the foundation of black theology interpreted the notion of the New Jerusalem differently. They saw it as a Promised Land where blacks, the victims of racial oppression, would be relieved and possibly compensated for their past suffering.[18] In public, slaves sang the following:

I meet little Rosa early in the morning
O Jerusalem! early in the morning,
And I asked her, How [do] you do, my daughter,
O Jerusalem! early in the morning,
I meet my mother early in the morning
O Jerusalem! early in the morning.[19]

In private or inside black churches, they sang another:

My father, how long, . . . poor sinners suffer
 here?
And it won't be long, . . . poor sinners suffer
 here.
We'll soon be free, De Lord will call us home.
We'll walk the miry road, where pleasure never
 dies.
We'll walk de golden streets of de New
 Jerusalem. . . .[20]

However, as James Evans points out, "The conditions of slavery . . . made it often impossible or imprudent for African slaves to speak directly of their hopes. They were compelled to find a language that would unmistakably express their hopes for a reversal in their fortunes and at the same time conceal that message from the slave owners."[21] This necessity led to the use of double signifiers in church sermons, spirituals, literature, and visual representations to convey one message to the public and another to blacks. Captives composed spirituals that not only synthesized Christian hymns with African rhythms, but also turned popular biblical events into secret codes for send-

Josephus Farmer (1894–1989)

Milwaukee, Wisconsin

Although Josephus Farmer, who was born in Tennessee, held a series of physically demanding jobs to support his family, he saw himself primarily as a Pentecostal preacher. First "struck by the word of God" in 1922, when he was still in his teens, Farmer preached for his entire adult life, on street corners, at revivals, at El Bethel, a church he established in South Kinlock Park, Missouri, and at a number of churches in Milwaukee. In retirement, Farmer continued to preach through his art. His secular works honoring American presidents and African American cultural heroes preach American values just as his biblical works preach the Christian message.

Josephus Farmer, *The Great Exodus* detail, plate 28

When Farmer began to paint banners to illustrate his sermons, he was following a popular preaching style with roots in nineteenth-century Adventist movements. Indeed, Farmer's early banners, like the charts published by Adventist groups, often correlated imagery from biblical texts with predictions of the end-time events surrounding the Second Coming. Farmer's later relief carvings on biblical themes also serve as visual aids to preaching. These works first explicate the literal meanings of the text and then apply the text to contemporary situations, particularly the state of the congregations' souls. Farmer's vibrant *The Great Exodus* (see plate 28) is on one level the literal depiction of the Jewish Exodus from Egypt. With their flocks and herds, the Chosen People walk through the turquoise waters of the Red Sea. While most details derive from specific verses, Farmer adds one humorous note: two small faces peep out of baskets hung from a pole that a man balances on his back. Other images refer to events that immediately precede or follow the Exodus. Across the top of the relief, Farmer has arranged the ceremonial standards of the Twelve Tribes of Israel, mentioned in the Book of Numbers. At the upper right of the relief is the tent that houses the Tabernacle and the miraculous rod of Aaron.

Imaginative, extra-biblical details—a covered wagon and a figure riding a long-eared mule—allow Farmer to place the story in an American context. African Americans have long claimed the Exodus story as their own, identifying themselves as a Chosen People who have won freedom from slavery through their profound faith in God and who, with God's help, expect to achieve the unfulfilled promise of equality. Liberated from Pharaoh's rule, these African Americans search for freedom from racial oppression in the Promised Land.

Finally, *The Great Exodus* can be read as an adumbration of the end-time events of the Book of Revelation, which promises that believers in Christ, redeemed from the pain of this world, will live with God in a heavenly Promised Land.

Cheryl Rivers

ing strategic signals to fellow slaves. To quote Frederick Douglass (1817–1895), a former slave:

A keen observer might have detected in our repeated singing of

> O Canaan, Sweet Canaan,
> I am bound for the land of Canaan,

something more than a hope of reaching heaven. We meant to reach the North, and the North was our Canaan.

> I thought I heard them say
> There were lions in the way;
> I don't expect to stay
> Much longer here.
> Run to Jesus, shun the danger—
> I don't expect to stay
> Much longer here,

was a favorite air and had a double meaning. In the lips of some it meant the expectation of a speedy summons to a world of spirits; but in the lips of our company, it simply meant a speedy pilgrimage to a free State, and deliverance from all the evils and dangers of slavery.[22]

As Henry Louis Gates observed, "Black people created their own vernacular structures and relished in the double play that these forms bore to white forms. Repetition and revision are fundamental to black artistic forms, from painting and sculpture to music and language use."[23] Admittedly, the need for slaves to keep their masters in the dark might have contributed to the emphasis on double meaning throughout the African Diaspora. Yet many scholars are inclined to trace the roots of the practice to the visual and verbal metaphors of Africa, especially those associated with trickster figures, such as *Ananse* and *Esu Elegbara* of the Akan and Yoruba speaking peoples of West Africa respectively, and the "Signifying

Monkey" tales of black folklore in North America in which cunning and wit are made to outmaneuver brute force.[24]

DOUBLE MEANING IN SELF-TAUGHT ART

The Hebrew prophet Moses is frequently represented in African American self-taught art. Images of Moses convey much more than meets the eye, given the unique place he occupies in black liberation theology. For apart from being married to an Ethiopian woman (Num. 12:1), Moses led the Children of Israel out of Egyptian bondage. Thereafter he went to Mount Sinai where God gave him the Ten Commandments. *Comfort of Moses and the Ten Commandments* (see illus. V-1), made in 1988 by Richard Dial, shows Moses in the form of a chair holding two tablets, alluding to the Ten Commandments. The chair format recalls the "conjure chair" associated with African American folk magic[25] and identifies Moses as a "conjure" man who, in Exodus 14:21, "stretched out his hand over the sea; and the Lord caused the sea to go back."[26] This allowed the Children of Israel to pass through after which the sea overwhelmed and drowned their Egyptian pursuers.

Taking a cue from Exodus, African captives and free blacks of the slavery era expected God to send another Moses to rescue them from North American bondage, thereby investing the imagery of the biblical Moses with a second (and black-specific) meaning.[27] Hence the following spirituals:

> When Israel was in Egypt's land.
> Let my people go.
> Oppressed so hard they could not stand,
> Let my people go.
> Go down, Moses,
> Way down in Egypt land.
> Tell ole Pharaoh
> To let my people go.[28]

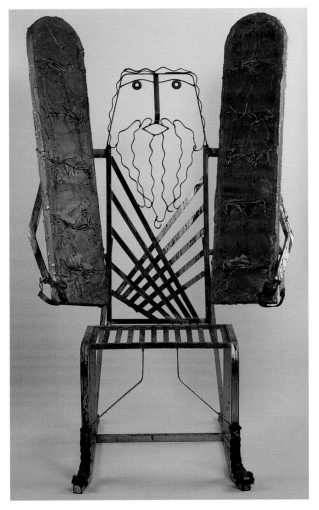

Illus. V-1
Richard Dial (b. 1955)
Comfort of Moses and the Ten Commandments, 1988
Metal, rope, wood, tree branches, and paint, 62.5 x 35.5 x 39.5
Museum of Fine Arts, Houston

When the children were in bondage,
They cried unto the Lord,
To turn back Pharaoh's army
When Pharaoh crossed the river,
The waters came together.
And drowned the ole Pharaoh's army,
Hallelu![29]

This expectation of a black messiah has resulted in a metaphorical identification of black civil rights leaders with Moses. Rev. George Kornegay of Bibb County, Alabama, a self-taught artist and member of the African Methodist Episcopal Zion Church (A.M.E. Zion), features Moses and Rev. Martin Luther King in his works, thus underscoring their messianic roles.[30] In an interview with William Arnett in the late 1990s, Reverend Kornegay invoked the spiritual "Go down, Moses" and declared: "Now, this is black folks' religion. I don't say the white folks didn't have no religion. I ain't saying that. But this is our inheritance. . . . This is when we come out of bondage. God meant for all us to be free."[31]

Even the imagery of Jesus Christ in African American self-taught art is loaded with black-specific meanings. Take for instance, Jesse Aaron's *Crucifixion* (see plate 1). The piece has been fashioned out of a forked tree branch, so that after adding a head to it, the "Y" shape signifies the cross and, simultaneously, the body and outstretched arms of the great messiah. An opening in the lower part of the body identifies the lower limbs. There are abrasions and cuts on the truncated body that suggest torture and suffering. The rough treatment of the physiognomy also hints at a traumatic state, despite the calm, dignified composure of the figure. From the orthodox Christian perspective, this imagery recalls the messiah who died on the cross, so that others might live, being resurrected and enthroned in everlasting glory as the "King of Kings." While subscribing to the poetics of "Christ, the Redeemer," black theology finds a parallel between his suffering/apotheosis and the African American historical experience and future expectations in the New Jerusalem. The parallel doubles the significance of that poetics, creating a special bond between Christ and blacks (see plate 122). As Thomas Hoyt has noted:

The kerygmatic aspect of a suffering messiah, like Jesus, especially serves as an analogue to black suffering. In their suffering, blacks have identified with the birth,

life, and resurrection of Jesus, and hence in Jesus blacks have found a true friend. While it has taken theologians and biblical scholars a long time to discover the humanity of Jesus, the humblest black Christian has always sung with enthusiasm the song 'What a friend we have in Jesus.' It is almost axiomatic that in interpreting Scripture those who are marginalized and those who have more of a stake in the status quo would bring a different set of questions to the text. . . . For blacks, Jesus is human and identifies with the poor by suffering on their behalf. He is the same Jesus who is the risen Christ and is the present and coming judge.[32]

African-born captives also easily identified with Christ because his resurrection/apotheosis dovetailed with their own belief in reincarnation and with the African praxis of venerating ancestors and deified culture heroes who serve as saviors, judges, and intercessors between the Supreme Being and humankind.[33] This correspondence paved the way for the synthesis that gives African American Christianity its uniqueness. Sam Doyle's image of Christ on the cross, titled *I'll Go Down* (see plate 21) is a classic example of the double meaning associated with this great messiah's imagery. While it predicts his resurrection, on the one hand, the title also puns on the spiritual, "Go Down, Moses," identifying Christ more closely with black salvation.

The absence of a cross in Jesse Aaron's *Crucifixion* makes the figure look like a supplicant with raised arms, not unlike the figure in Mary T. Smith's *Hallelujah Lady* (see plate 96). Although this gesture also occurs among white Christian worshipers, it is said to be more common among blacks.[34] That the gesture is an African retention in the black church is apparent from its prevalence in African religious ceremonies and its frequent depiction in ancient African art (see illus. V-2).[35] Among the Dogon of Mali, altar figures with upraised arms may represent a deified ancestor or a priest through whose body the spirit of an ancestor

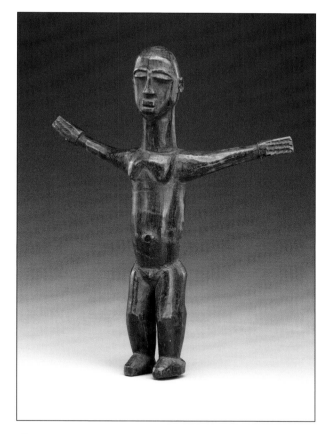

Illus. V-2

Altar figure (bateba), twentieth century, Lobi, Burkina Faso (West Africa)

Wood, height 9.5

Private Collection

may occasionally manifest itself. One of the raised arms of a typical Dogon altar figure is said to beseech Amma (the Supreme Being) for the good things of life (such as adequate rainfall), while the other hand is intended to ward off negative forces such as drought and disease. Among the Kongo people of Equatorial Africa, the "raised-arms" motif is called *booka*, a term that refers to a variety of attitudes, ranging from supplication and proclamation to a state of "being ecstatic, exultant, joyous, fine" or "being ready to fly with inherent spirit."[36] Kongo informants told Robert Farris Thompson that the gesture identifies the subject as "a conduit, a ford across the river, receiving and sharing

messages of happiness and power."[37] This explanation tallies with the significance that members of black churches attach to the gesture. As a former slave (cited earlier) puts it, "It ain't enough to talk about God, you've got to feel him on the altar of your heart."

VISUAL PREPARATIONS FOR THE NEW JERUSALEM

The idea of the New Jerusalem centers on the Christian belief in a golden age in the afterlife following the second coming of Christ and the Last Judgment, events prophesied in the New Testament Book of Revelation. Only the righteous would be admitted into this haven of everlasting bliss. Sinners would be sent to hell where they would be consumed by demons or fire. Both aspects of this afterlife are represented in African American self-taught art. The visions of hell warn sinners of the coming Armageddon, asking them to turn over a new leaf (see plate 76). Representations of the New Jerusalem, on the other hand, assure the righteous of future rewards, encouraging them to persevere in spite of the difficulties (see plate 81).

The old spiritual "When the Roll Is Called Up Yonder, I'll Be There," still popular in black churches today, reflects the expectation among blacks that the Last Judgment would be favorable to them, since, like Christ, they have passed through great tribulations and should be rewarded.[38] In anticipation of this celestial event, some African American self-taught artists create structures that recall the thrones associated with the Last Judgment in the Book of Revelation. The most spectacular of these thrones was created by James Hampton (1909–1964). Constructed between 1950 and 1964 and titled *The Throne of the Third Heaven of the Nations Millennium General Assembly*, it is an extraordinary assemblage of dis-

carded objects and about 180 pieces of modified furniture covered in gold and silver foils and purple craft paper. The arrangement of the pieces is such that the central chair signifies God's presence invisibly enthroned in divine splendor (see illus. V-3). On top of the chair is a sign that reads "FEAR NOT." The inscriptions on the other pieces identify them with biblical characters and events. The pieces on the left side of the chair refer to the Old Testament, focusing on Moses and the Law, while those on the right side refer to the New Testament, Jesus Christ, and divine grace. Some of the winged stands represent Adam and Eve, the Virgin Mary, prophets, saints, and so on.[39] The bilaterally symmetrical assemblage suggests a special convocation, as if God is about to make a major pronouncement on the future of humankind.

Although it was inspired by the New Testament Book of Revelation, Hampton's *Throne* has strong affinities with African American yard shows as well as the altars used in African-derived New World religions such as Vodou, Santeria, and Candomble.[40] It thus represents, as Robert F. Thompson puts it, "a unique fusion of biblical and Afro-American traditional imagery."[41] The latter sense becomes obvious once we realize that African captives in the slavery era used the Book of Revelation as a subterfuge for expressing and yet concealing their own vision of the New Jerusalem.[42] James Weldon Johnson has captured the essence of this vision in his famous book, *God's Trombones: Seven Negro Sermons in Verse*, published in 1927. The following is an excerpt from a sermon titled "The Last Judgment":

Oh-ooh, Sinner,
Where will you stand,
In that great day when God's a-going to rain
 down fire?
God's a-going to sit in the middle of the air
To judge the quick and the dead
.

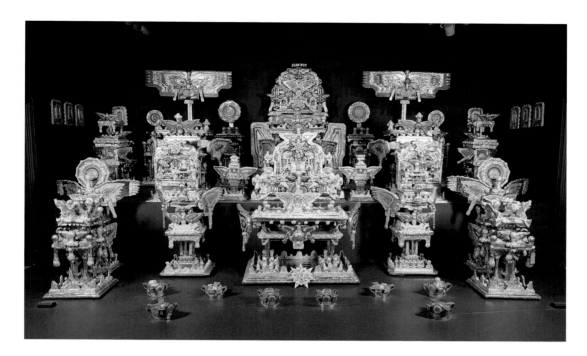

Illus. V-3
James Hampton (1909–1964)
The Throne of the Third Heaven of the Nations Millennium General Assembly, ca. 1950–1964
Mixed media assemblage, 126 x 324 x 174
Smithsonian American Art Museum, Washington, D.C., Gift of Anonymous Donors

And God will divide the sheep from the goats
The one on the right, the other on the left
And to them on the right, God's a-going to say
Enter my kingdom

And those who've come through great tribula-
 tions,
And washed their robes in the blood of the lamb
They will enter in—
Clothed in spotless white
With starry crowns on their heads
And silver slippers on their feet,

And harps in their hands;—
And two by two they'll walk
Up and down the golden streets
Feasting on the milk and honey
Singing new songs of Zion,
Chattering with angels
All around the Great White Throne.[43]

Although James Hampton uses gold foil to ac-
centuate different parts of his *Throne*, including

the crown, star, and angel motifs, it is the silver
wrapping that dominates, radiating a whitish glow
that suggests the numinous and the triumphant. A
photograph of the artist shows him standing on
the right-hand side of the central chair, like the
sheep in the sermon. He wears his own version of
the starry crown and holds another in his hands, as
though rehearsing the approaching "Millennium
General Assembly" and identifying himself and
black people in general with "those who've come
through great tribulations, / And washed their
robes in the blood of the lamb." Thus, it may be
more than mere coincidence that the millennial
association of Hampton's Throne brings to mind
Bishop James Theodore Holly's declaration of 1884
that "[The] crowning work of the will of God is re-
served for the millennial phase of Christianity,
when Ethiopia shall stretch out her hands directly
unto God. . . ."[44]

By and large, it is this enduring capacity to sig-
nal alternative meanings that gives African Ameri-
can self-taught art with biblical themes a universal
appeal. For despite the genre's emphasis on the

black experience, its underlying values are Christian, democratic, and humanistic, values meant to usher in a better future and a New Jerusalem where everybody, regardless of color, will fully enjoy freedom, equal opportunity, civil rights, and social justice.

1. Quoted in full in James H. Evans, *We Have Been Believers: An African American Systematic Theology* (Minneapolis: Fortress Press, 1992), n.p.

2. Ibid., 2. See also *This Far by Faith: American Black Worship and Its African Roots* (Washington: National Office for Black Catholics, 1977); Joseph M. Murphy, *Working the Spirit: Ceremonies of the African Diaspora* (Boston: Beacon Press, 1994), 169–70; Albert J. Raboteau, *Canaan Land: A Religious History of African Americans* (New York: Oxford University Press, 2001), 45, 47–48; Dorothea Fischer-Hornung and Alison D. Goeller, eds. *Embodying Liberation: The Black Body in American Dance* (Hamburg: LIT Verlag Munster, 2001), 27–28; and Babatunde Lawal, "The African Heritage of African American Art and Performance," in *Black Theatre: Ritual Performance in the African Diaspora*, ed. Paul C. Harrison, Victor L. Walker, and Gus Edwards (Philadelphia: Temple University Press, 2002), 39–63.

3. See Geoffrey Parrinder, *African Mythology* (London: Paul Hamlyn, 1967) and John S. Mbiti, *African Religions and Philosophy* (Oxford: Heineman, 1990).

4. Jose Gil, *Metamorphoses of the Body*, trans. Stephen Muecke (Minneapolis: University of Minnesota Press, 1998).

5. For details, see Warren L. D'Azevedo, ed., *The Traditional Artist in African Societies* (Bloomington: Indiana University Press, 1973) and Robert Horton, *Kalabari Sculpture* (Lagos, Nigeria: Department of Antiquities, 1965).

6. See Albert J. Raboteau, *Slave Religion: 'The Invisible Institution' in the Antebellum South* (New York: Oxford University Press, 1978) and Sterling Stuckey, *Slave Culture: Nationalist Theory and the Foundations of Black America* (New York: Oxford University Press, 1987).

7. Raboteau, *Canaan Land*, 45.

8. Following the tradition established by Carter Godwin Woodson and E. Franklin Frazier, I use the term "Black Church" to refer to what Joseph Murphy calls "the unity within the diverse elements of the African American religious experience." See Carter Godwin Woodson, *The History of the Negro Church* (Washington: The Associated Publishers, 1921); E. Franklin Frazier, *The Negro Church in America* (New York: Schocken Books, 1964) and Mur-

phy, *Working the Spirit*, 145–75, 231n.1.

9. Illustrated in John M. Vlach, *The Afro-American Tradition in Decorative Arts* (Athens: University of Georgia Press, 1990), 20; fig. 5.

10. Harry S. Edwards, *The Two Runaways and Other Stories* (New York: Century Press, 1889), 202–3, 205; quoted in Robert F. Thompson and Joseph Cornet, *The Four Moments of the Sun: Kongo Art in Two Worlds* (Washington: National Gallery of Art, 1981), 151.

11. Georgia Writer's Project, *Drums and Shadows: Survival Studies among the Coastal Georgia Negroes* (Athens: University of Georgia Press, 1940), 106.

12. For illustrations, see Vlach, *Afro-American Tradition*, 82–94; and Sharon F. Patton, *African American Art* (New York: Oxford University Press, 1998), 66 (fig. 20).

13. For details, see Thompson and Cornet, *Four Moments of the Sun*, 152–63, and Vlach, *Afro-American Tradition*, 81–94.

14. Illustrated in Herbert W. Hemphill, ed., *Folk Sculpture, USA* (Brooklyn: The Brooklyn Museum of Art, 1976), 59.

15. See Vlach, *Afro-American Tradition*; Cuesta Benberry, *Always There: African American Presence in American Quilts* (Louisville: Kentucky Quilt Project in association with the Museum of American Folk Art, 1992); Maude S. Wahlman, *Signs and Symbols: African Images in African American Quilts* (New York: Studio Books, 1993); Robert F. Thompson, "African Influence on the Art of the United States," in *Black Studies in the University: A Symposium*, ed., A. L. Robinson, C. C. Foster and D. H. Oglivie (New York: Bantam Books, 1969), 128–77; Regina Perry, "African Art and African American Folk Art: A Stylistic and Spiritual Kingship" in *Black Art Ancestral Legacy: African Impulses in African American Art* (Dallas: Dallas Museum of Art, 1989), 35–52, and Babatunde Lawal, "African Roots, American Branches: Tradition and Transformation in African American Self-Taught Art," in *Souls Grown Deep: African American Vernacular Art of the South*, Vol. 1, ed. Paul Arnett and William Arnett (Atlanta, Georgia: Tinwood Books; in association with The Schomburg Center for Research in Black Culture, the New York Public Library: 2000), 30–49.

16. King James Version of the Bible.

17. Robert Alexander Young, *The Ethiopian Manifesto: Issued in Defense of the Black Man's Rights in the Scale of Universal Freedom* (New York: Alexander Young, 1829), excerpted in *Classical Black Nationalism: From the American Revolution to Marcus Garvey*, ed. Wilson J. Moses (New York: New York University Press, 1996), 65. David Walker (1830), Maria Stewart (1833), and Henry Highland Garnet (1860) interpreted the biblical reference to Ethiopia in a similar way. See Moses, *Classical Black Nationalism*, 68–89, 90–98, 142–44.

18. James W. Johnson, *God's Trombones: Seven Negro Sermons in Verse* (New York: Viking Press, 1927); James H. Cone, *God of the*

Oppressed (New York: Seabury Press, 1975), 158–60, and Evans, *We Have Been Believers*, 13.

19. Eileen Southern, *The Music of Black Americans: A History*, 3rd edition (New York: W. W. Norton, 1997), 190.

20. Eileen Southern, ed., *Readings in Black American Music* (New York: W. W. Norton, 1983), 172.

21. Evans, *We Have Been Believers*, 146.

22. Frederick Douglass, *Life and Times of Frederick Douglass* (Hartford: Park Publishing Company, 1881), 157.

23. Henry Louis Gates, *The Signifying Monkey: A Theory of African American Literary Criticism* (New York: Oxford University Press, 1988), 85–86. See also C. Mitchell-Kerman, "Signifying," in *Mother Wit from the Laughing Barrel: Readings in the Interpretation of African American Folklore*, ed. A. Dundes (Englewood Cliffs: Prentice-Hall, 1973), 311–28.

24. See Gates, *The Signifying Monkey*, 85–86; Deidre L. Badejo, "The Yoruba and Afro-American Trickster: A Contextual Comparison," *Presence Africaine* 147, 3 (1988): 10, 15; Theophus Smith, "Working the Spirits: The Will-To-Transform in African American Vernacular Art," in *Souls Grown Deep: African American Vernacular Art of the South*, Vol. 2, ed. Paul Arnett and William Arnett (Atlanta: Tinwood Books, 2001), 47–49; and Femi Euba, "Legba and the Politics of Metaphysics: The Trickster in Black Drama," in *Black Theatre*, 167–80.

25. Smith, "Working the Spirits," 59.

26. For more details on the African American identification of Moses with "conjure" and Vodou, see Theophus H. Smith, *Conjuring Culture: Biblical Formations of Black America* (New York: Oxford University Press, 1994), 32–39.

27. See Wilson J. Moses, *Black Messiahs and Uncle Toms: Social and Literary Manipulations of a Religious Myth* (University Park: Pennsylvania State University Press, 1982), 30–48, and Smith, *Conjuring Culture*, 32–39, 63–64.

28. Southern, *Music of Black Americans*, 59.

29. John Lovell, *Black Song: The Forge and the Flame: The Story of How the Afro-American Spiritual was Hammered Out* (New York: Paragon House Publishers, 1972), 235. For an examination of African influences on the spirituals, see Eileen Southern, "An Origin for the Negro Spiritual," *The Black Scholar*, 3, 3 (1972): 12–13.

30. For illustrations, see George Kornegay, "Signals from Captivity (Told by Rev. George Kornegay)," in *Souls Grown Deep*, Vol. 2, 173 (figs. 96 and 97).

31. Ibid.

32. Thomas Hoyt, "Interpreting Biblical Scholarship for the Church Tradition," in *Stony the Road We Trod: African American Biblical Interpretation*, ed. Cain H. Felder (Minneapolis: Fortress Press, 1991), 29.

33. For a survey, see Mbiti, *African Religions and Philosophy*.

34. Thompson and Cornet, *Four Moments of the Sun*, 176–77. For other illustrations, see James M. Washington, ed., *Conversations with God: Two Centuries of Prayers by African Americans* (New York: HarperCollins, 1994), 129.

35. Thompson and Cornet, *Four Moments of the Sun*, 176–77. In Benin City (Nigeria), chiefs and court officials use this gesture when paying homage to the king (oba), a living embodiment of the royal dead. For an illustration, see Ulli Beier, "Le Nigeria et ses Populations," *Le Nigeria Independent: Edition Special du Nigeria Magazine* (March 1962): 102–3.

36. Ibid.

37. Ibid. However, among the Lega of the Democratic Republic of Congo, an image with "raised hands" is called "kasungalala." It represents a highly respected elder (kindi), a role model who raises his hands to stop violence and bring peace. See Daniel Biebuyck, "The Kindi: Aristocrats and their Art among the Lega," in *African Art and Leadership*, ed. Douglas Fraser and Herbert M. Cole (Madison: University of Wisconsin Press, 1972), 18.

38. Cone, *God of the Oppressed*, 158–60, and Evans, *We Have Been Believers*, 24.

39. For more on this work, see Lynda Roscoe Hartigan, *The Throne of the Third Heaven of the Nations Millennium General Assembly* (Montgomery: Montgomery Museum of Art, 1977); idem, "Going Urban: American Folk Art and the Great Migration," *American Art* 14, 2 (2000) and S. J. Gould, "James Hampton's Throne and the Dual Nature of Time," *Smithsonian Studies of American Art*, 1, 1 (1987): 47–57, and Babatunde Lawal, "Anticipating Ethiopia's Rise to Glory?: Rereading James Hampton's Throne of the Third Heaven of the Nations Millennium General Assembly," in *Souls Grown Deep*, Vol. 2, 98–103.

40. See Robert F. Thompson, *Flash of the Spirit: African and Afro-American Art and Philosophy* (New York: Vintage Books, 1984), 146; idem, *Face of the Gods: Art and Altars of Africa and the African Americas* (New York: Museum of African Art, 1993), 47–107, and Richard J. Powell, "Art, History, and Visions," *The Art Bulletin*, LXXVII, 3 (1995), 381.

41. Thompson, *Flash of the Spirit*, 146.

42. See Evans, *We Have Been Believers*, 13–15.

43. Johnson, *God's Trombones*, 55.

44. James Theodore Holly, "The Divine Plan of Human Redemption in its Ethnological Development," *A.M.E. Church Review*, 1 (October 1884): 84–85, quoted in Smith, *Conjuring Culture*, 237. For more details, see Lawal, "Anticipating Ethiopia's Rise to Glory?" 98–103.

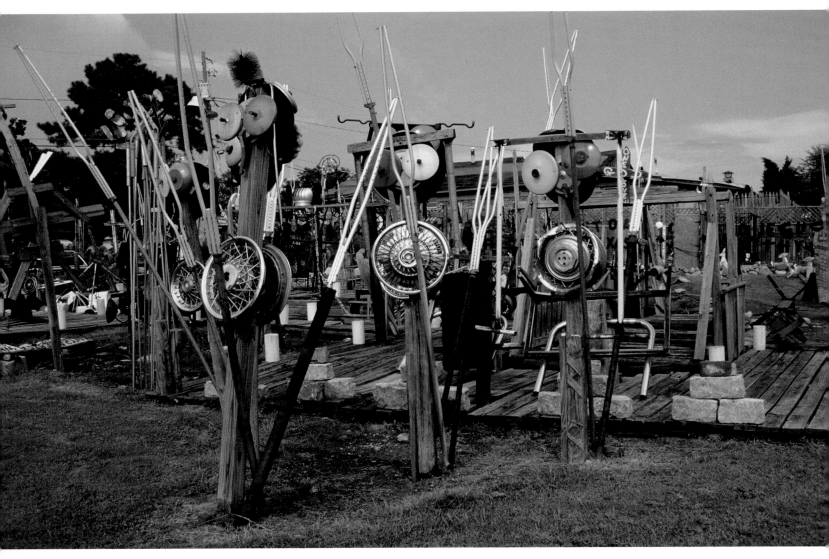

Illus. VI-1
Joe Minter (b. 1943)
African Village in America, 2002
Birmingham, Alabama

A Larger View: Self-Taught Art, The Bible, and Southern Creativity

Charles Reagan Wilson

Flannery O'Connor, the Georgia-born, Roman Catholic writer whose most acclaimed works appeared in the 1950s, saw the South through a lens of faith that would have enabled her to appreciate the region's self-taught artists. She was a storyteller as they have been. The storyteller, for O'Connor, "is concerned with what is," and for a storyteller of faith, "what he sees on the surface will be of interest to him only as he can go through it into an experience of mystery itself." The mystery she speaks of is "the mystery of our position on earth"; she saw the fiction writer as "concerned with ultimate mystery as we find it embodied in the concrete world of sense experience." Sense perceptions are indeed the raw stuff of creative people everywhere, but O'Connor saw clearly that the senses should tie the creative imagination to place, to region. "The things we see, hear, smell, and touch affect us long before we believe anything at all, and the South impresses its image on us from the moment we are able to distinguish one's own from another." The Southern writer discovers "being bound through the senses to a particular society and a particular history, to particular sounds and a particular idiom," and that discovery is the beginning of a realization that puts that writer's work "into real human perspective."[1]

O'Connor's observations about the Southern writer reveal much about the creative context for the imagination and its use of religion in the American South. The region's writers, musicians, and folk artists operate within a cultural context in which a particular form of faith, evangelical Protestantism, has dominated for so long, that it offers an idiom of its own, with images, stories, symbols, rituals, institutions, and experiences that they can explore.

In recounting the importance of the senses to the budding writer, O'Connor mentions first the "things we see," and the visual sense has indeed been a key one in Southern creativity. Much more familiar, though, is the oral sense of the South. The Word has been central to the South's culture, from folk philosophers telling stories on porches and at country stores, to preachers and lawyers using language to win souls and make their legal cases, to professional humorists who make listeners chuckle, and to writers and singers who have epitomized the region's styles for so long. "When one Southern character speaks," O'Connor notes, "regardless of his station in life, an echo of all Southern life is heard." But the South has also presented its observers with a compelling visual landscape as well. The land presents an often lush image, with

flora and fauna that seem exotic to outsiders and that can stimulate a gothic imagination among writers and artists.

The Bible has been central background to the visual culture of the South, with an alchemy of written words, oral delivery, and visual representation making Southerners familiar with images coming out of the Scriptures. Even in a society with relatively high rates of illiteracy, Southerners knew Bible characters and stories. "It takes a story to make a story," O'Connor noted, a story of "mythic dimensions, one which belongs to everybody, one in which everybody is able to recognize the hand of God and its descent." Note that O'Connor uses a compelling story, which presents a dramatic visual image, in explaining why the Bible helped make the South a storytelling place: "Our response to life is different if we have been taught only a definition of faith than if we have trembled with Abraham as he held the knife over Isaac."

O'Connor makes one additional point about the religious imagination in the South. She was highly aware of changes in the South after World War II, changes that meant "every day we are getting more and more like the rest of the country, that we are being forced out not only of our many sins, but of our few virtues." O'Connor felt that the Southern writer needed to "observe our fierce but fading manners in the light of an ultimate concern" and suggests that the writer's gaze should go beyond looking at the surface "until it touches that realm which is the concern of prophets and poet." To do this, the writer had to "descend far enough into himself to reach those underground springs that give life to his work." That descent into self would also be a descent into region.

That complex image of the South given to creative people as part of their Southern birthright includes a sense of loss. For black artists, it has surely been the horrors of slavery and the brutalities of racial segregation (see illus. VI-1). For many Southerners, it has been generations of economic depri-

vation and its threat of spiritual numbness. The writer's "concern with poverty," says O'Connor, "is with a poverty fundamental to man. I believe that the basic experience of everyone is the experience of human limitation." O'Connor mentions as well defeat in the Civil War. "We have gone into the modern world with an inburnt knowledge of human limitations and with a sense of mystery which could not have developed in our first state of innocence—as it has not sufficiently developed in the rest of the country." This sense of human limitation came not only out of specifically Southern history but also out of Scripture. The biblical metaphor for loss that reverberated through Southern culture was the Fall of Man in the Book of Genesis (see plate 93), but other biblical images struck Southern creative people as appropriate as well.

Creative artists in the South have not all had a religious imagination, as O'Connor did, but evangelical Protestantism has been so strongly imprinted on the landscape that they have often had to wrestle with it. Faulkner said, "It's just there," to describe the pervasiveness of religion and his use of it in his fiction. The South produced creative people who were sometimes skeptics and sometimes true believers, but they made use of religious images, characters, and stories as part of their work.

Anyone growing up in the South in the early twentieth century, when Southern creativity began to blossom in new ways among so many writers, musicians, self-taught artists, and others, lived in the shadow of Baptist and Methodist steeples. A religious census in 1905 of the white South showed that 96.6 percent of the population had Protestant affiliations, with 90 percent of church members joining Baptist and Methodist churches. Both had been regionally organized churches since before the Civil War, and the next largest popular denomination, the Presbyterians, was also organized in a separate regional denomination that be-

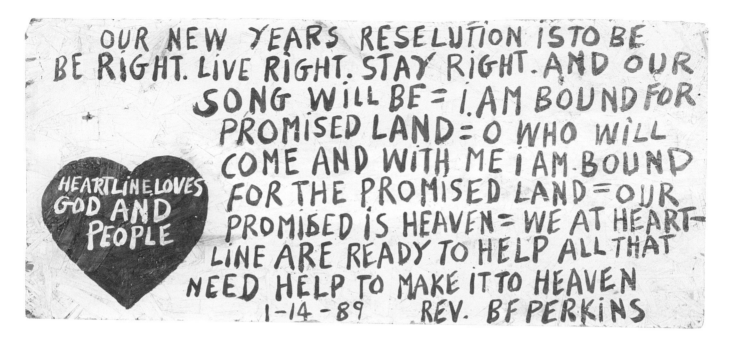

Illus. VI-2
Benjamin "B. F." Perkins (1904–1993)
Heartline Loves God and People, 1989
Paint on chipboard, 15.75 x 30.25
Robert Cargo Folk Art Gallery, Tuscaloosa, Alabama,
and Paoli, Pennsylvania

gan during the war. Black Baptists and Methodists had differing histories and missions from white evangelicals but shared much theology, moralism, and liturgical practice.[2]

Southern evangelicalism insists that religious experience is the essence of faith, a key marker in understanding how creative people could find inspiration in a tradition that was so fixated on orthodoxy as to sometimes discourage the free play of the mind. Calvin was a patron saint of Southern theology, as Southerners took to heart his dim view of human nature. John Wesley was another theological saint, though one who highlighted the centrality of grace. This combination made sin and salvation the dominant style of religion in the South. Evangelicalism does not prioritize theology, however, but the personal relationship with the Redeemer. Sinners have to be born again, seeking God's grace through either patient study or the flash of immediate personal revelation. Justification by faith represents the workings of the supernatural in the life of the wicked, leading to conversion and a new relationship with God. The assurance of redemption then promotes a reformed

lifestyle, with a deliberate effort to overcome the self and serve God. A prime aspect of that service is evangelism, sharing the good news of Christ with others, not as one part of faith but as a driving imperative. The coming millennium and heavenly reward provide future meaning to this vision of human history. Holiness and Pentecostalism emerged around the turn of the twentieth century as sectarian groups outside the mainstream of Southern religious life, but they injected a new infusion of the Holy Spirit into working class evangelicalism (see illus. VI-2), one with profound significance for musical and artistic creativity.[3]

The Bible occupies a position of peculiar religious authority in the South (see plate 33). While other heritages may rely on historical traditions, communal experiences, theological exegesis, the

episcopacy, or combinations of these factors, Southern evangelicalism validates the Bible as the revealed word of God. Fundamentalists and moderates in the region have long disputed the boundaries of interpretation of the Scriptures, but they typically have agreed that the Bible has the answers to life's questions. The Bible took on special meanings in the South's public culture as defenders of slavery and later racial segregation justified those institutions through citations of particular passages of the Scriptures, ignoring others that spoke of more egalitarian impulses.[4]

The Bible and the workings of the Holy Spirit have intertwined in the South, providing a fertile spiritual soil for the creative soul. Both the Bible and the Spirit are matters of everyday concern. One Tennessee Holiness preacher who was recently interviewed conveyed the connection. "I believe that all of the Bible is real. If this book isn't the book of God, you'd better throw in the towel, for there is nothing else that will stand the test like this book." A Baptist minister from Cumberland County, Tennessee, passionately affirms the Scriptures: "I believe with all my heart that the Bible is the holy Word of God, that He inspired men through the Holy Spirit to write the Word in order that they, not only in that bad time, but in the day in which we live, in this instant of time, might be able to receive the Word of God." The Scriptures are not just a historical document, though, but one with continuing meaning through direct contact with Jesus, the central figure of the Christian Scriptures.[5]

One of the formative ethnic groups in the South, African Americans, reflected the mood and style of evangelical Protestantism but added distinctive approaches that provided further inspiration to Southern artists. Laws prevented slaves from learning to read, which denied the Bible to them and gave the Good Book a profound symbolic meaning at the foundation of black spirituality. Some slaves did learn to read and studied the Scriptures, taking away different messages from those that white ministers tried to teach them. They studied the Scriptures for messages of hope, as in the theme of the Promised Land, and reading the Bible became a main incentive for literacy. African Americans especially prized stories from the Old Testament, showing God assisting the oppressed Hebrews and punishing their Egyptian masters. Protestantism validated their searching the Scriptures to find meaning, and slave preachers fastened on passages that told of liberation, not just in heaven but in this world as well. The inheritance of African religions in African American culture added a receptivity to the supernatural, with ancestral spirits, conjure figures, and crossroads devils reverberating through black spirituality. Spirituals became the great musical expression of black creativity under slavery, and they drew from biblical narratives in projecting the hope of deliverance.[6]

For blacks and whites, the 1920s was the decade when creativity seemed to make a quantum leap in the South. The Southern Literary Renaissance brought unheard of production of novels, poetry, fiction, theater, memoir, song lyrics and performance, painting, sculpture, and other forms of creative expression. The stirrings of modernization—economic development, consumerism, urbanization, modern thought—affected Southerners and nurtured a perception of a changing region. At the same time, a deep well of stories, legends, myths, attitudes, and practices continued to provide the cultural context for most Southerners. Popular culture entered a new stage, with Southern entertainers drawing from folk culture for their songs and stories. New technology—radio, recordings, and electronic public address systems—encouraged the popularization of Southern music, while film brought the exploitation of Southern themes and new opportunities for Southerners in the film industry.

Consideration of several writers shows how the

Bible figured in their literary creations. The Scriptures were positioned within a complex religious culture drawing from tradition and innovation, folk culture and modern ways, where Jesus and the Holy Spirit were closely joined with the Bible in the religious imagination. William Faulkner, for example, grew up in a Southern religious culture that made the Bible a centerpiece. His father's family was Methodist and that denomination helped form him, as he attended Sunday School and was baptized at the New Albany Church in Mississippi. Faulkner once noted that he read the Old Testament "once every ten or fifteen years," and on another occasion he admitted how much *Absalom, Absalom!* was indebted to the biblical account of the house of David in Second Samuel.

Faulkner represented the Bible as one of the earliest presences in his fictional Yoknapatawpha County, writing that the earliest settlers there came "roaring with Protestant scripture and boiled whiskey, Bible and jug in one hand and a native tomahawk in the other." In his portrayal of the Civil War, Faulkner tells of Methodist deacon Coldfield in *Absalom, Absalom!*, waiting in his house for Confederate troops marching off to a crusade he did not endorse, reading from the Scriptures "the passages of the old violent vindictive mysticism." In the modern South, Presbyterian minister Gail Hightower, in *Light in August*, confuses the Confederate heroism of his grandfather with the Christian story, with Faulkner writing of his "wild hands and his wild rapt eager voice" evoking images of turbulent evangelical ministry. Hightower realizes that he blends scriptural doctrine with "galloping cavalry and defeat and glory," a judgment on his confusion of biblical and Southern history, with Hightower—and by extension Southern whites—unable to distinguish between the two.[7]

Faulkner's contemporary Zora Neale Hurston wrote that she was "born with God in the house" and soon "tumbled into the Missionary Baptist Church," her father being a Baptist minister in the all-black town of Eatonville, Florida. While she abandoned the church, she embraced the Scriptures for their inspiration of "God's very direct intervention in human affairs." She appreciated "the beautiful language of Luke and Paul," but affirmed that "the New Testament still plays a poor second to the Old Testament for me. The Jews had a God who laid about Him when they needed Him." As far back as slavery, African American religiosity had its sources in Christianity and folk beliefs, and Hurston appreciated both. She drew particularly from voodoo-conjure, a tradition rooted in African religions and derived from the belief that magic can influence behavior.[8]

Hurston's novel, *Moses, A Man of the People*, epitomizes how she used a biblical narrative but adapted its central hero to become a figure who resonated with black folklore. Moses's conjure powers give him the magical ability to influence events in a malevolent world. His servant, Mentu, initiates him into a world of folk beliefs about the creation and about animal stories, and Moses learns that cunning, manipulation, and love for your suffering brethren can achieve indirectly what directness cannot. The Hebrews at the beginning of the novel seem without hope, as Hurston has Jethro tell Moses that they are "down there in Egypt without no god of their own." Moses breaks from the royal house of Egypt through killing an Egyptian, and Hurston's Southern imagination roots the story in regional memory, describing the Egyptian as a "bossman," "foreman," and "overseer," the last term a particularly potent allusion to the slave plantation. Moses becomes his people's liberator through this act, as well as through leading the children of Israel across the Red Sea—an extraordinary act of conjure magic if there ever was one.[9]

Another black writer, Mississippi's Richard Wright, gained early exposure to the church through his grandmother, who was a member of a

millennial denomination, the Seventh-Day Adventist Church. When Wright lived with her as a young man, the household had a strenuous religious regimen, including prayers at dawn, sundown, and meals, followed by each family member reading a Bible verse. Wright heard a gospel of signs and wonders rooted in the Bible, and in particular he absorbed one of the most pronounced themes of Southern religious creativity—millennialism (see plate 76). He "responded to the dramatic vision of life held by the church" and the "religious symbols appealed to my sensibilities," but he did not intellectually embrace the black church. He did learn, though, early lessons in telling a story in compelling imagery and in the power of biblical narratives.[10]

Wright's grandmother and her church believed in a millennial doctrine, rooted in the biblical Book of Revelation. In the last epoch of time, according to conservative interpretations of the Bible, Christ will return to earth to establish his kingship (see plate 118). Protestants have long disagreed over how the millennium will occur. Postmillennialists believe human society will evolve gradually during a thousand years into a kingdom of God on earth, after which Christ will return. Premillennialists, like the Adventists, have a grimmer view, concluding that Christ will return at the beginning of the millennium to lead his legions against those of Satan in a violent Armageddon, after which the wicked will be judged. Both interpretations stress that the millennium will bring "a new heaven and a new earth," with the promise of social justice, a powerful appeal to the disenfranchised. Millennialism highlights the spirit-filled, near mystical dynamic of working class religion in the South.

Wright's book, *Uncle Tom's Children*, uses the biblical theme of millennialism, but combines it with his reading of how political redemption for African Americans might come through an alliance of communism and indigenous black reli-

gion with its belief in millennial justice. Characters in the collection of stories sing spirituals that evoke escape from the Jim Crow South or the perseverance among trials in hopes of a heavenly reward. Biblical figures provide models, as when Deacon Smith is both Satan and Judas to one minister's sacrificial Christ role. A central character is the Reverend Dan Taylor, a black minister who must decide whether to support a demonstration to help his town's poor people. Millennialism reverberates throughout the collection. Wright evokes the fiery Second Coming, such as he heard as a child, as when he writes that one character, Aunt Sue, anticipates a "new and terrible vision of justice" that would come from God-sanctioned social justice.[11]

The music of the South has echoed many of the themes of creativity seen in literature, with the Bible again part of a broader culture that saw folk traditions and modern changes, orthodox biblical interpretations and the turbulent workings of the Holy Spirit in everyday life. The blues at first seems an unlikely genre for religious influences, but blues singers typically grew up in churchgoing households, and their songs conveyed a familiar spirituality that combined Christianity and folk belief. Jon Michael Spencer identifies the biblical Adam and Eve narrative as providing a fundamental explanation for evil in the blues, and consideration of the story in blues lyrics shows how a biblical story can become a key one even in an essentially secular genre. One song from the 1920s blamed "Mudder Eve" for "Daddy Adam's fall," and another blues song implicated "the woman" for causing "po' Adam's fall." Sippie Wallace cowrote "Adam and Eve Had the Blues" after her husband's infidelity, which she blamed on the "forbidden fruit" of Eve: "Eve is the cause of all of us having the blues."[12]

Country music, like gospel music, emerged in the early twentieth century as a commercial genre of mass culture, coming out of the Southern rural

William Edmondson (ca. 1870–1951)

Nashville, Tennessee

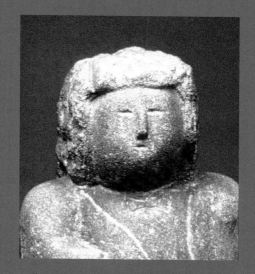

William Edmondson, *Preacher* detail, plate 24

William Edmondson's powerful, iconic sculpture exemplifies the close connection between African American creativity and spirituality. When Edmondson, born on a plantation to former slaves, migrated to Nashville with other members of his family in 1890, he became an active participant in the activities of nearby churches, particularly the Primitive Baptist church, whose tenets inform his life and work. Edmondson's depictions of Adam and Eve, Noah's Ark, and Christ on the Cross illustrate humankind's fall from grace and God's renewed promise of salvation through Christ. Preachers and church ladies, some portrayed as angels with crossed arms and piercing expressions, reveal the belief that all of God's servants are called to use their God-given gifts for the benefit of his church.

Edmondson clearly felt that God had given him a special calling. While as a young boy he had "seen angels in the clouds," it was not until he retired from a lifetime of work that God gave him the gift of carving. "I was out in the driveway with some old pieces of stone when I heard a voice telling me to pick up my tools and start to work on a tombstone. I looked up in the sky and right here in the noon daylight, He hung a tombstone out for me to carve." Edmondson did not doubt that God had called him to serve his community. Using simple tools, including chisels he had crafted from railroad spikes and cast-off or salvaged stone delivered to him by friends, Edmondson began to carve tombstones. His early pieces were rectangular tablets, minimally adorned. Soon, however, he began to try his hand at more ambitious and evocative works, always attributing his developing talent to God: "The Lord told me to cut something once, and I said to myself I didn't believe I could. He talked right back to me: Yes you can."

Cheryl Rivers

Anderson Johnson (1915–1998)

Newport News, Virginia

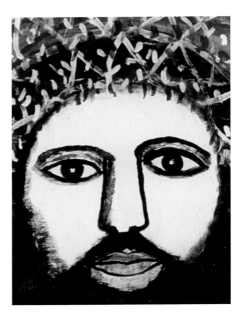

Anderson Johnson, *Jesus: Behold the Man* detail, plate 55

Rev. Anderson Johnson preached the Gospel from the time he was a boy of eight in Lunenburg County, Virginia, and went on to be the "right-hand man" of charismatic preacher Daddy Grace, founder of the United Church of Prayer for All People. Testifying on the streets of New York, Savannah, and Miami, Johnson made sketches of people he met and attracted a crowd by his ability to draw with either hand or even with his toes. Later, back in Newport News, the self-styled evangelist preached and made his own brand of gospel music in a succession of Faith Missions. Johnson's raspy voice, singing the raucous "When I Take My Vacation in Heaven," and accompanied by the random pounding he gave the piano, could whip the faithful into a frenzy.

The original Faith Mission was once a ramshackle store, surrounded by desolate empty lots in the midst of a public housing project. Johnson transformed the frame building into a house of worship with wooden pews, a drum set and piano, a coal-fired heater, and rows of paintings covering every wall from floor to ceiling. Between the drum set and the Heatrola, he placed *Portable Pulpit* (see plate 56), a rough, hand-built lectern. Looking more like a small stepladder than a lectern, the pulpit was light enough to be moved where the preacher could focus his eyes upon the congregation while he read from his Bible. Fashioned from discards, the pulpit incorporates such unlikely materials as egg cartons and ice trays holding candles made from rolled-up sheets of paper. Each assemblage is tied to its shelf with a raveling, striped ribbon. Johnson painted each side of the pulpit with heads of singing angels, like the portraits of women and angels on the mission's walls.

When disability forced Johnson to retire from his traveling ministry, he began making art as a serious endeavor, literally filling his church with paintings—faces drawn with house paint on cardboard, canvas board, doors, and counter tops—faces of Jesus (see *Behold the Man*, plate 55), the United States presidents, and beautiful women. Portraits of George Washington and Abraham Lincoln attracted visitors from around the world to hear Johnson's story and to listen to his music and his preaching, either during a formal (if lengthy) service or as part of a friendly visit.

In Johnson's second-floor living quarters, painted rows of life-sized women in transparent dresses and men in fedoras marched around his bedroom and the stairway hall. When urban development threatened the demolition of the first Faith Mission, a group of concerned citizens halted the government's plans long enough to obtain a HUD grant to remove and conserve Johnson's murals, now located at the Newsome House, an African American history museum in Newport News.

Ann Oppenhimer

folk culture, and religion was a formative influence upon it. It was music of the white working class centered in the hill country and mountain areas of the region but reflecting ethnic influences, especially those of African Americans. The Bible has been a recurrent theme in country music songs. Charlie Tillman recorded the first country Bible song, "My Mother's Bible," in the early twentieth century, but the image of the mother with her Bible was already an old one in the South. This song, like many other sentimental and nostalgic mother/Bible songs, tells of the narrator's mother reading stories of "those mighty men of old," such as Daniel and David, of Satan's temptations, and of Jesus's love.

Another type of country Bible song urges listeners to read the Bible and make it their guide. Karl and Harty recorded "Read the Bible" in 1940 and later recorded "A Bible Lesson," with each verse describing a special problem and offering a specific Bible passage for solace. Even more famous was a bluegrass gospel song, "I'm Using My Bible for a Roadmap," which Don Reno wrote in 1951. Other admonition songs referred listeners to specific Bible passages. The Bailes Brothers recorded "Read Romans Ten and Nine" in the late 1940s, and Molly O'Day near the same time recorded "Matthew 24." "Dust on the Bible" was one of the biggest country hits about the Bible, harkening back to the image of the old, well-used Bible that becomes a symbol of the vanished rural values among a now industrialized working class audience.[13]

The career of the Louvin Brothers reveals how the Bible and evangelical Protestantism shaped country music's creative expression. The Louvins grew up in a remote part of north Alabama, with fiddling contests, dances, and all-day singings a prominent part of the local culture. Their mother sang old British ballads and immersed herself in church singings based around the *Sacred Harp*, a songbook of 1844 by two Georgia Baptist singing teachers that became one of the best known books in the South. It taught singing through the use of notes whose shape, not their position on the staff, determined pitch. This shape note tradition was part of a rural and small town culture that included singing schools and conventions, which were gatherings of an area's singers to sing new songs published in paperback books. Songbook publishing companies became prominent institutions in the early twentieth century, and by the 1920s they were sponsoring professional quartets who sang the new songs on radio to publicize the songbooks but then went on to gain recording contracts. Singing conventions, all-day church or community singings, radio performances, phonograph records—all of these made a vibrant early twentieth-century context for fostering religious music that reworked traditional biblical narratives for a new age.

The Louvin Brothers absorbed these influences and became one of the South's most famous duet, harmony-singing acts. They were not gospel singers but commercial country singers who nonetheless had a religious mission. One brother, Ira, had been told he should be a preacher and always harbored guilt for not assuming his calling. Their music became a ministry for him. One of his songs, "Are You Afraid to Die?," came from Ira hearing Billy Graham preach on the radio. In 1952, they recorded "Insured Beyond the Grave," which Ira's brother Charlie saw as a good example of the role of the Bible in their work. "My brother was a biblical scholar," he said; "a lot of people say he was called to preach. That's why he led such a miserable life, because he refused to accept the calling." Charlie insisted that "basically 'Insured Beyond the Grave' is directly out of the Bible. If somebody steals something, you've got insurance to cover it, but the Book says there's one thing you can't insure here is your soul."[14]

Southern self-taught artists have been intimately related to the writers and musicians of the region, absorbing the biblically informed evangelical

culture. The earliest well-documented artists, such as Bill Traylor and William Edmondson (see plate 23), came to maturity in the late nineteenth and early twentieth centuries, growing up in a region with tangible ties to slavery and the Civil War. More self-taught artists appeared in the years between the two World Wars, at the same time that blues, jazz, gospel, and country musicians began recording careers that converted the South's folk music into popular music. Self-taught artists conveyed the most stunning religious imagination of all of these creative people. One could find doubt about religion among them, but they were not well-educated literary figures struggling with modernist-generated religious skepticism. While self-taught artists sometimes struggled with the temptations of the secular world, they were mostly true believers.

The poverty that O'Connor saw as being fundamental to the human condition and as a source of creativity was a lived experience for many self-taught artists. They often began producing their works not only out of compelling creative spirits but for practical reasons, to supplement jobs and earn money. Mass culture, an important component of modernization, had a profound impact on self-taught artists as a source of images, styles, and stories they set beside the Bible in creating a distinctive aesthetic that nonetheless resonated with that of the region's writers and musicians.

Southern self-taught artists were more likely to be church leaders than the region's writers and musicians, but one needs to understand what they meant in the context of the rural South. Some self-taught artists, like J. L. Hunter (see plate 52), who attended Southern Bible College in the 1930s, became ordained ministers and pastors of local congregations, but many more were "called" preachers, not theologically trained or formally ordained but responding passionately to God's call to spread the gospel. They harked back to an egalitarian evangelical tradition of the frontier, where ministers were not separated from their flocks but held other jobs and vocations while leading their churches. Georgia's R. A. Miller, for example, was a farmer and textile mill worker but also a minister in the Free Will Baptist Church. East Texas's Johnnie Swearingen (see plate 101) grew up the child of migrant workers, attending school and church only periodically. In the early 1960s, at age fifty-three, while working on a farm, he heard and obeyed God's command to preach—and eventually to make art.[15]

Self-taught artists in the South have shown the most primal expression of Southern religiosity—the confidence among many evangelicals in their direct access to the Bible and the Holy Spirit. Self-taught artists testified to their divine inspirations, through recounting their visions, in ways that writers and musicians seldom did. And those visions from their evangelical direct access to the Bible and the Holy Spirit figured in their art as witness as well. Anderson Johnson (see plate 56), born in 1915 and raised in Virginia, had a vision in his father's cornfield at age eight to preach the gospel. He gained little formal schooling, but knew his Bible well—a must for a called preacher. He began preaching at age twelve and left home to become an itinerant street corner preacher at sixteen. After his recovery from a paralyzing disease through God's healing, he converted the first floor of his living space to a mission, which he adorned with colorful biblical and historical painting to attract worshipers. Jesse Aaron, of African American and Seminole Indian ancestry, can date his visitation of the Spirit to the early 1960s (see plate 1). God inspired him to create images of animals.[16]

Perhaps the most compelling stories of visionary inspiration among these artists are those of Elijah Pierce and Minnie Evans. The Mississippi-born carver Pierce created *Vision of Heaven*, a wood relief that portrays God's hand touching him as a young man, when he rejected the Bible to look at a Sears Roebuck catalog. Pierce explains that "the

Elijah Pierce (1892–1984)

Columbus, Ohio

According to Southern folklore, those born with a veil or caul have a special ability to see and interpret the spiritual world. As Gary Davis reports in *The Artist Outsider*, Elijah Pierce's parents interpreted their son's caul within a Christian context, naming him after the Old Testament Prophet Elijah. Fervent Baptists, the Pierces read the Bible every day and encouraged their son to prepare for the ministry. In his youth, Pierce had several experiences of spiritual awakening. When he was ten or eleven, his mother asked him to read the Bible, but the young boy reached for the Sears Roebuck catalog, often the only book besides the Bible in modest homes. He immediately lost consciousness, and, when he failed to awake, his family and neighbors took him for dead. In *Trabelin' On: The Slave Journey to an Afro-Baptist Faith*, Michel Sobel documents that this kind of experience was widely understood as a sign of spiritual rebirth. Later when Pierce, despite his strict Baptist upbringing, was tempted to dance at a party, he received another intimation of his God-given calling. In 1920, he was licensed to preach at Mount Zion Baptist Church in Baldwyn, Mississippi.

Elijah Pierce, *Crucifixion* detail, plate 77

Like many preachers, however, Pierce needed a secular occupation. He became a barber, but did not abandon his ministry, traveling to public gatherings to preach the Gospel. These different strands of Pierce's life define the twofold concept of calling, the inward call to redemption and the summons to a social vocation. Pierce came to understand that his talent for woodcarving was part of his God-given vocation. He illustrated his sermons with didactic tableaux, made from carved figures mounted on cardboard, that he called the *Book of Wood*. He continued this practice after he became assistant pastor of the Gay Street Baptist Church in Columbus. From the pulpit he presented small carvings and wood reliefs to members of the congregation in recognition of achievements and spiritual needs. He also displayed religious works, including the *Crucifixion* (see plate 77) in his barbershop.

Pierce's *Crucifixion* is not a static devotional image but a dynamic account of the very moment of Jesus's crucifixion. The two Marys kneel before the cross and mourn. Soldiers gamble for Jesus's clothes. Frightened disciples come running. Roman soldiers go about their business. At the bottom, soldiers march the Old Testament Prophets out of the picture. The Devil, dressed in a business suit, gloats, mistaking the crucifixion of Jesus for his own triumph. Pierce's artistry, however, reveals that Jesus's earthly death opens the path to heaven. While Jesus's cross stands upon the red and sinful earth of mortal humans and the Devil, Jesus is on his way to the blue sky of heaven to mediate between the world to come, foretold in Revelation, and the world that will pass away.

Cheryl Rivers

good Lord laid his hand on my head, and I fell out of my chair." As a result of his inspiration, "every piece of work I carve is a message, a sermon" (see plate 77). Born in 1892 and raised by her grand-mother in North Carolina, Minnie Evans (see plate 25) powerfully illustrates how her dreams and vi-sions, along with the Bible, mythology, and the natural environment, could touch a creative spirit. She credited her dreams and visions with inspiring her, recalling going to bed once and seeing a beau-tiful light and a wreath. "I didn't see the wreath, but I saw the shadow of the wreath, and behind the shadow of this wreath is where God spoke to me." God promised that "this light that you see now shall shine around all of you." Evans insisted much later that "that's my daily food. He has giv-en me that guarantee." She worked most of her life at an estate in North Carolina filled with extraor-dinary gardens of colorful flowers, birds, animals, trees, and water. She drew from images and charac-ters from the Bible, but the florid colors and jungle of foliage in most of her works created, above all, a modern, unique vision of the Garden of Eden.[17]

Combined with biblical and other religious scenes for many self-taught artists were materials from mass culture reflecting their role in a chang-ing American culture, just as directly accessible to them through radio, television, and film as the Bible and the Holy Spirit had always been. Missis-sippian O. W. "Pappy" Kitchens drew from the Bible but also from photographs, newspapers, mag-azines, television, and a crystal ball. South Louisiana's Prophet Royal Robertson studied the Bible, but one also finds in his art references to girlie magazines, comic strips, and science fiction. Mississippian Mary T. Smith paid homage to God through her yard environment of artworks in the 1980s, but she was watching television as well as reading the Scriptures, and influences from both can be seen in her yard.

Death can be a spur to creative expression in any culture, and that has surely been so in the American South, where evangelical Protestantism sees death as the time of moral judgment and the beginning of the afterlife portrayed in the Bible. Nellie Mae Rowe was a field hand in Georgia, and when her second husband died turned to her art for renewal. Her drawings and paintings did not often portray the stuff of religious life, but her symbols and images conveyed an imaginative spirituality (see plates 86 and 87). "The Lord got me here for something," she once said. "I don't know, a lot of people say I preach." When Rowe learned in 1982 that she had terminal cancer, all of her remaining works portrayed images of death, such as tomb-stones, empty chairs, angels, dying plants, and but-terflies. Rowe constructed an elaborate vision of heavenly redemption, one that drew from biblical inspiration but from her own imagination as well. She had the disinherited believer's sense of a better world to come that infused her art. "They say this world don't stand," she said. "Nobody don't know how long it going to stand. I believe the time's at hand."[18]

No theme of self-taught art is more revealing of Southern religious culture than millennialism, with its ferocious image of the Apocalypse. Artists' experiences using the apocalyptic theme show better than any other the connections be-tween the Bible and the Spirit. Alabama's Myrtice West, for example, has produced two series of Rev-elation paintings, which she began after entering a trance and ending up in the pulpit of a country church. "I'd never been in this church in my life, and there I was, standing up in that pulpit, reading the Bible, and it was open to Revelations." She soon decided God was sending her a message, which she saw related to her natural abilities to paint. West's first Revelation paintings (see illus. I-3, p. 23) required months of Bible study, and her dreams and visions shaped the work as much as her Bible study did. The Book of Revelation was it-self a vision of the biblical John, and "it seemed like John was putting these pictures in my mind,

telling me the colors to use and everything."[19]

Another Alabamian who powerfully used the Book of Revelation was Annie Lucas (see plate 63). She recounted that, "Revelations was the first thing I did. I just started, you know, from the back of the Bible." Revelation talked about "the beasts and the devil, and I could just see in my mind how it was supposed to be, and I just started drawing." A seven-painting sequence portrayed what she had read—seven-headed beasts, locusts devouring everything on the land, angels, and the devil. She read from the Book of Revelation for inspiration before drawing each picture. Speaking of one particular painting, she says, "A lot of people see it, and they don't believe it's in the Bible. So they go to the Bible and then they read about it. So I feel like God's working through me."[20]

Two self-taught artists seem to suggest particularly strong connections with other creative spirits in the South's expressive culture and provide a final view of the range of their work, which balances tradition and innovation, the Bible and the Spirit, and shows the geographical range of self-taught creativity from the Upper South to the Lower South, in a biracial culture. Gertrude Morgan is a good example of an artist in the years between the two World Wars directly tied to the region's religious culture. Born in Lafayette, Alabama, she lived most of her life in New Orleans. Raised in a Baptist family, she later joined a Bible-based, spirit-filled sect whose members dressed only in black and sang and danced to connect with the Holy Spirit. By the 1930s her singing, to the accompaniment of guitar and tambourine, was part of her evangelism at the Everlasting Gospel Mission. Now she dressed only in white and had white furniture and white paint inside the church. Speaking into a megaphone, she preached on the streets of New Orleans and with her paintings set up to illustrate her points. If she represents the evangelical nature of many self-taught artists, she also shows the importance of vi-

sionary inspiration to them. On one of her paintings, *Poem of My Calling* (see plate 68), she recalls when God spoke to her: "My heavenly father called me in 1934 on the 30th day of December or just about thirty-eight years ago. The strong powerful words he said was so touching to me. I'll make thee as a signet for I have chosen thee go ye into yonders world and sing with a loud voice for you are a chosen vessel of mine to call men women boys and girls." As in the later work of Myrtice West, the Book of Revelation was a favorite inspiration for Morgan's sermons and paintings. Although she dressed herself in pure white and adorned her mission church the same way, she used vibrant colors in her art to convey the fiery nature of the apocalypse.[21]

Another artist, Kentucky's Edgar Tolson (see plates 108 and 109), was one of the most revealing self-taught artists in terms of the role of tradition, innovation, and religion in Southern creativity. His father, James Perry Tolson, was a well-known lay preacher in Wolfe County, in eastern Kentucky, who for sixty years preached, prayed for the sick, comforted families of the dead, and laid on hands to heal. In the rural South, congregations of true believers were often unable to maintain full-time ministers or to have weekly worship services, but they met each Sunday to sing hymns and to "listen to a local, nonordained preacher speak on the word of God as shown through the Bible." James Tolson was a Pentecostal, a member of the Church of God, but was part of the Southern interdenominational religious tradition and took part in Baptist, Methodist, and Holiness meetings as well. Common to all was the Scriptures. Young Edgar Tolson rebelled for awhile against the stern moral example of his father, but eventually he, too, began to preach. His private Bible study and evangelism, more than denominational labels, motivated his preaching. Edgar Tolson was conflicted, though, drawn to less holy activities, including drinking and womanizing. Eventually convicted of deser-

Minnie Evans (1892–1987)

Wilmington, North Carolina

As a child growing up in Wilmington, North Carolina, Minnie Evans repeatedly experienced vivid dreams and waking visions. Images of elephants going around the moon and recurrent nightmares of being chased by figures that looked like ancient prophets were so real to the young girl that she assumed that everyone had such visionary episodes. Often distracted from necessary tasks and school work, Minnie took comfort in her grandmother's explanation, consonant with a fundamentalist reading of the Bible, that such visions were not dreams but "signs and wonders" sent from God.

Minnie Evans, *Angel and Demons* detail, plate 26

Though Evan's visionary experiences continued into adulthood, her spirituality, for the most part, took conventional forms. She joined the African Methodist Episcopal Church, sang in the choir, and participated in the African American custom of visiting other congregations. She testified at Methodist and Baptist revival meetings. However, Evan's husband Julius forbade his wife to pursue her interest in the Jehovah's Witnesses and consulted with the pastor before acceding to his wife's intense need to make drawings.

Evans's luminous works, "memoranda" of visionary experiences, resonate with a lifelong delight in nature and faith in a benevolent and accessible God. *A Dream Nov 1968* (see plate 25), a cross-centered wreath supported by smiling, brown-eyed lions and flanked by four blonde angels, gives a glimpse of the visionary process. Evans's customary informal symmetry and balance of warm and cool colors offer a model of a harmonious world that operates according to divine plan, but the ultimate meaning of the work remains elusive. When Evans asked her pastor about the two "beautiful" lions that often recurred in her dreams, he told her " . . . those lions is a sign of the lions of the tribe of Judah," a traditional symbol of the Chosen People. The gentle lions, however, might also be subconscious allusions to lions associated with biblical prophecy. In the Old Testament, Daniel, who won preferment though his adept interpretations of dreams, maintains his faith in the true God even when cast into the lions' den. In Revelation, the lion of Judah breaks the seal on the visionary book that foretells the Fulfillment of Time.

References to biblical prophecy are clearer in *Angel and Demons* (see plate 26), a free translation of imagery from the New Testament Book of Revelation. Here, against a backdrop of crystalline sky, azure water, verdant hills, and clean-swept beach, angels announce the "new heaven and new earth" while unearthly beasts huddle before the "bottomless pit" of perdition (Rev. 21 and 9:20). However, Evans's demons are neither exact renditions of the many-headed, horned and winged beasts described in Revelation nor terrifying harbingers of wrath and destruction. Perhaps her benign vision of God's creation stands in the way of any hell-fire-and-damnation preaching. Moreover, Evans cannot resist foretelling the outcome of the final battle; the rainbow that God sent to Noah as a promise of salvation here signals the imminent fulfillment of that promise in the Second Coming of Christ.

Cheryl Rivers

tion of his children, he served two years in prison and divorced his wife. His preacher father condemned him with biblical passages. "My daddy got on him I don't know how many times," Tolson's brother Elvin said. "He told him, he says, 'The Bible says he that took hold of the plow handle and looked back is not fit for the kingdom of God,' and said, 'He's a dog turned again to his own vomit.'" His brother's judgment was that Edgar "loved the world, the cares of it, better than he did the word of God."[22]

Tolson found his great subject in *The Fall of Man*. Just as the blues and gospel music were drawn to the Adam and Eve story, so was Tolson. Here in eight episodes the Adam and Eve narrative extends from the Garden of Eve through Eve's mourning of her dead son Abel, as his brother Cain departs. Biblical characters, a sense of human history, a tone of moral gravity, and an ultimately tragic vision haunt *The Fall of Man*, an important addition by a self-taught artist to the thematic concerns of the South's writers and musicians, steeped in biblical and regional experience.

One is drawn back to Flannery O'Connor's observation that the great writers in the twentieth-century South discovered they were "bound through the senses to a particular society and a particular history, to particular sounds and a particular idiom," all of which enabled the writer to use the specifics of place to gain broader "human perspective." Southern self-taught artists, like the region's writers and musicians, came out of a regional culture in which evangelical religion provided a dramatic background. Novelist Reynolds Price recalls that Southern culture "provided us with a daily world in which religion played an omnipresent role," which was "immensely important" to those who would later become writers—and one might add to those who would be self-taught artists and musicians as well. Church services, Price says, gave Southerners "a direct possibility of serious encounter with the center of

things—the Creator," a different way to characterize evangelical faith's confidence in direct access to the meaning of the Bible, Jesus, and the Holy Spirit. Price saw that religion was pervasive for generations of Southerners, white and black, referring to "that very complex, bittersweet marination in religion that was available right on down through the 50s and 60s to the standard southern child."[23]

1. Flannery O'Connor, *Mystery and Manners*, ed. Sally and Robert Fitzgerald (New York: Farrar, Straus and Giroux, 1969), 31, 41, 124, 197. Quotations will be cited in the text.

2. Samuel S. Hill, *The South and the North in American Religion* (Athens: University of Georgia Press, 1980), 110.

3. Donald G. Mathews, "Evangelicalism," in *Encyclopedia of Religion in the South*, ed. Samuel S. Hill (Macon: Mercer University Press, 1984), 243–44. See also James Davison Hunter, *American Evangelicalism: Conservative Religion and the Quandry of Modernity* (New York: Holt, Rinehart and Winston, 1967).

4. Mark Noll, "The Bible and Slavery," in *Religion and the American Civil War*, ed. Randall Miller, Harry Stout, Charles Reagan Wilson (New York: Oxford University Press, 1999), 43–73.

5. Loyal Jones, *Faith and Meaning in the Southern Uplands* (Urbana: University of Illinois Press, 1999), 106.

6. Theophus H. Smith, *Conjuring Culture: Biblical Formations of Black America* (New York: Oxford University Press, 1994).

7. William Faulkner, *Requiem for a Nun* (New York: Vintage, 1975), 89; Faulkner, *Absalom, Absalom!* (New York: Vintage, 1972), 82; Faulkner, *Light in August* (New York: Vintage, 1972), 56, 80, 57, 347.

8. Zora Neale Hurston, *Dust Tracks on a Road: An Autobiography* (Philadehia: J. B. Lippincott, 1939), 193, 40. The Hurston and Wright discussions are informed by my reading of Timothy P. Caron, *Struggles over the Word: Race and Religion in O'Connor, Faulkner, Hurston, and Wright* (Macon: Mercer University Press, 2000).

9. Zora Neale Hurston, *Moses, Man of the Mountain* (Philadelphia: J. B. Lippincott, 1939), 156, 93–95.

10. Richard Wright, *Black Boy: A Record of Childhood and Youth* (New York: Harper and Brothers, 1945), 113, 123.

11. Richard Wright, *Uncle Tom's Children* (New York: Harper and Brothers, 1938), 184. Quotations will be cited in the text.

12. Jon Michael Spencer, *Blues and Evil* (Knoxville: University of Tennessee Press, 1993), 2–3.

13. Charles K. Wolfe, "Bible Country: The Good Book in Country Music," in *The Bible and Popular Culture in America*, ed. Allene Stuart Phy (Philadelphia: Fortress Press, 1985), 86, 88, 90, 94, 96–99.

14. Charles K. Wolfe, *In Close Harmony: The Story of the Louvin Brothers* (Jackson: University Press of Mississippi, 1996), 48, 65.

15. Information on the self-taught artists comes from the following sources: Paul Arnett and William Arnett, eds., *Souls Grown Deep: African American Vernacular Art of the South*, Vol. I (Atlanta: Tinwood Books; in association with The Schomburg Center for Research Culture, The New York Public Library, 2000); Joyce Ann Miller, "In the Handiwork of Their Craft Is Their Prayer: African-American Religious Folk Art in the Twentieth-Century South" (M.A. thesis, Southern Studies, University of Mississippi, 1992); Alice Rae Yelen, *Passionate Visions of the American South: Self-Taught Artists from 1940 to the Present* (New Orleans: New Orleans Museum of Art, 1993).

16. Arnett, *Souls Grown Deep*, Vol. 1, 308; Yelen, *Passionate Visions*, 323.

17. Yelen, *Passionate Visions*, 303, 307, 318, 328.

18. Arnett, *Souls Grown Deep*, Vol. 1, 304.

19. Kathy Kemp, *Revelations: Alabama's Visionary Folk Artists* (Birmingham: Crane Hill Publishers), 212–14.

20. Ibid., 114.

21. Jane Livingston and John Beardsley, *Black Folk Art in America, 1930–1980* (Jackson: University Press of Mississippi and the Center for the Study of Southern Culture for the Corcoran Gallery of Art, 1982), 100.

22. Julia S. Ardery, *Temptation: Edgar Tolson and the Genesis of Twentieth-Century Folk Art* (Chapel Hill: University of North Carolina Press, 1998), 12–13, 18–19, 41.

23. Alice Walker, ed., *I Love Myself When I Am Laughing . . . And Then Again When I Am Looking Mean and Impressive: A Zora Neale Hurston Reader* (Old Westbury: Feminist Press, 1979),176; Susan Ketchin, *The Christ-Haunted Landscape: Faith and Doubt in Southern Fiction* (Jackson: University Press of Mississippi, 1994), 86.

Where There Is No Vision the People Perish: Visionary Artists and Religious-Based Environments in the American South

N. J. Girardot

Where there is no vision, the people perish.
—Howard Finster, quoting the Book of Proverbs 29:18

Nothing is impossible to the valiant heart.
—Ferdinand Cheval, maxim inscribed on the Palais Idéal

THE SNAKE IN THE GARDEN

That well-known "Stranger from Another World," Howard Finster, is gone. He would say that he's done gone home—all worn out on our behalf.[1] He has returned to another world not of his making while leaving behind his own Paradise Garden (see illus. VII-1) that came forth from his clotted visions and his gnarled hands, emerged like a slime-covered yet iridescent snake breaking forth from its primordial egg. The trick is that the ethereal garden of cloudy mansions in the sky and Finster's more earthy paradise of glittering junk, winking angels, Elvis, flying saucers, rusting tools, and Co'-Cola bottles lodged within the swampy pine brambles of north Georgia require constant remembrance, conscientious maintenance, and ritual celebration if these worlds are to continue to live for us.

The Truth is that the snake let loose in time brings the terrible tribulations of time with it, the cycles of skin-shedding and family feuding, to all such piously perfect worlds. Throughout the course of his peripatetic career as a small-town *entrepreneurial preacher-tinker-builder-painter, Finster certainly knew the impossibility of perfection.* The full realization of this lesson came during his transformative vision of the tiny-god-head-on-his-finger which came after his Herculean work on several outdoor environments.[2] This divine finger-face ratified all he had done and "called" him to artistically celebrate the messy creativity that flowed from the sacred chaos of images and things that walked through his life and garden. As Finster's career shows us, the creation of these multiple constructed and painted worlds—along with their ongoing growth, decay, and renewal—is linked to the human need for the special kind of intense seeing or healing visualization of worlds within worlds suggested by "visionary" experience. As the boldly superimposed tracings left by the shamans in the Paleolithic caves indicate, the ritually regenerated artistic expression found deep in the grottos of the earth constitutes the realization of vision for the human community. Finster and other self-taught shaman-artists and environment makers would say that, where there is no way to enter into, make real, or remember these

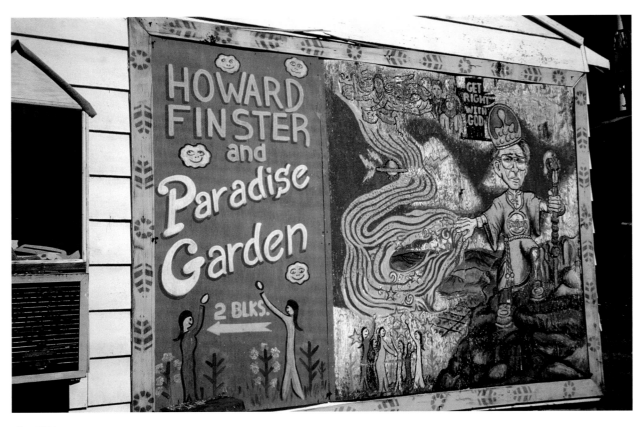

Illus. VII-I
Howard Finster (1915 or 1916–2001)
Paradise Garden Sign, 1997
Summerville, Georgia

painted caves of vision, and when in the twenty-first century there are no more crystal grottos or fantastic environments of visionary experience to explore, then the people perish.

The real genius of Southern evangelical Protestantism is its passionate rejection of religious perfection. More important than some simple and final salvation is the hurt recognition that even the "born again" are "backsliders." Even the environmental work of God's own hand, this world and the Garden of Paradise itself, are flawed and run down. God, it seems, needs the snake and the devil, needs a shaman-savior-Christ who like Finster and Elvis were strangers "from another world," so that we sinners might be saved and saved again, so that we might be fully or even divinely alive. We

need a fallen world to be human. *We are, then, all snake handlers in God's garden of life.* We need the reptilian poison—the visionary ecstasy and aesthetic experience—that is finally a medicine (see plate 92). A snake, a garden environment, biblical words, and painted images in visionary tradition are in this way *signs* of the hidden existence of spirit in human life. They are wholly "made up," but nevertheless point to something extraordinarily human. In more secular terms, the sinuous secret of this kind of "spiritual" or "symbolic" recognition (that is, seeing snakes religiously and artistically as material signs) may be the deep human confluence of visionary and artistic, religious and aesthetic, ecstatic and creative, experience. *Glory! Glory! Hallelujah!*

RELIGION AND ART WORK TOGETHER

The fractured space and place of the quotidian and temporal worlds we live in accounts for the existential necessity of religion and art. The amazing grace that emerges ritually and aesthetically only in time and in the face of individual suffering, moral injustice, and social friction builds and rebuilds meaning for individuals and communities. This is an occurrence that happens best when we can periodically inhabit worlds constructed in ways that refresh our everyday worlds and open us to the promise and hope of spiritual, aesthetic, and moral regeneration. We need to enter into the amazing visionary worlds of shaman-artists so that we can be healed sufficiently to take up again, at least temporarily, the burden of the many "ordinary" and "real" worlds that define our lives.[3] We must explore other marginally or fabulously "unreal" worlds, worlds constructed out of the nostalgically mangled bric-a-brac of religious vision and popular culture, to know how to live gracefully and generously in our ostensibly "given" or "taken for granted" worlds of malls, fast-food restaurants, and MTV "reality" shows.

The existence of the heavenly world in the sky and Finster's maverick Paradise Garden on earth depends on the constructive powers and ecstatic emotions of visionary imagination and artistic expression. Both worlds are, however, inevitably subject to symbolic impoverishment and temporal dissolution. Thus, whether considering the biblical heaven or an earthly paradise we are necessarily dealing with concretely embodied biblical myths, visionary fabulations, or individual "revelations" that become real, become places or "worlds" open to exploration, only when they are actively remembered, artistically expressed, ritually rehearsed, and aesthetically appreciated. Believing is seeing.[4]

Religion and art, as Lynda Sexson has said, come together in special ways in the secularized culture of the modern world. Thus art "comes to be not an aesthetic expression of religious consciousness but a conflation of the two. . . . Religion and art are not precisely equivalent terms but relational perspectives on the importance of imaginary world building."[5] This is, moreover, a building or making that comes forth most powerfully from the fringes of the already mapped worlds of experience—that is, from the activities of artists and visionaries who are to some degree outside of (psychologically, sociologically, or ecstatically "set apart" from) the various official worlds of mainstream culture and who feel compelled to create realms that transcend and subvert the "normal" order of things. Often these are intensely personal worlds that come about because of particular psychological and physical difficulties, but it is precisely the surprising primitive passion and subversive eccentricity of these *worlds* that invite public exploration, wonderment, and joyful celebration.

IN PLACE: AT HOME IN OTHER WORLDS

The truth is that for *this* world (although there is never just *one* world that we live in) to have human meaning and stability we need a specific place within which to live—a hearth, a house, a yard, a garden, a neighborhood, a community, a village, a city.[6] In this sense, these microcosmic places, these multiple worlds, are not exactly "alternative worlds."[7] They help to make *this* world (or our multiple "ordinary" worlds) lively and renewable. They are, even when ironically or aesthetically imagined, places where our hopes, dreams, and fears are constantly mirrored as reflections and refractions. They are places that start with the primordial nostalgia for being "in place" and "at home" in a dark and dangerous world and give our mundane bourgeois worlds a connection with a larger cosmos of imaginative possibility and spiritual meaning. This is why, perhaps, for those

of us who live in worlds largely defined by the civilized grid of concrete, plastic, metal, and neatly trimmed lawns, the unbound and embedded concrete constructions of Finster and Mr. Imagination, the wildly welded and twisted steel critters of Charlie Lucas, or the creatively carved and painted Styrofoam of Lonnie Holley have a special revelatory power. They remind us of something we too easily forget in our comfortable "real" worlds: that finally all human worlds are made from the tissue of the visionary imagination. All our worlds, even the most mundane, were once quite fantastic and unreal.

THE TERROR AND TOLERANCE OF VISION

It is in this sense, also, that we need to be aware of the potential terror of such imaginative constructs, for, as 9/11 has shown us, paradisaical images (for instance, the Koranic heavenly oasis of twenty-one veiled but panting virgins) may become the motivating emotion behind the most despicable of destructive acts perpetrated against hegemonic or "globalized" worlds of economic and technological power that seem to deny the importance of the diversity of culture and spirit in human life (see plate 44). Indeed, it is the apocalyptic fixation on such paradisaical worlds by those who have suffered and who are, in some manner, "outside" the cultural mainstream as defined by Western tradition that is almost always a two-edged sword. The potential is there for the renewal and salvation of spirit, but at the same time there is pent-up tension and anger that can just as well give rise to violence and irrationality. Tolerance and terror, freedom and confinement, creativity and chaos, ecstasy and madness, humor and seriousness, joy and pain are always to some degree joined in the imagination. Certainly they are qualities often confusingly associated with the idealized or concretized images of paradisaical and religious environments. This is, for

example, seen positively in what was Finster's increasingly ameliorative vision and, more dialectically and negatively, in Eddie Owen Martin's (aka St. EOM) suicidal relationship with his created world of Pasaquan, or in the actual apocalypses perpetrated on themselves and others by Jim Jones's People's Temple and Marshall Applewhite's Heaven's Gate. Art (like religion) is surely the "work that is play"— as the joyful productions of so many self-taught world makers show us.[8] But such activity is also subject to the authoritarian distortions of a frighteningly deadly game devoted to the annihilation of infidels.

THE WORK THAT IS PLAY

The evangelical Protestant vision so often connected with self-taught religious environments in the South is typically literalistic in its apocalyptic theology and morally intolerant of those outside the "one true" faith—*W. C. Rice's Miracle Cross Garden being a prominent example of this uncompromising "hell and brimstone" genre.* But some of these artists show us how the visionary expansion and artistic expression of evangelical themes can transform and enlarge the horizons of evangelicalism itself. For example, in Howard Finster's evolving artistic world view, we see a progressive movement away from his earlier apocalyptic damnations to a more ecumenical, even pluralistic and subversive, vision that bravely incorporated various ambiguous "other" worlds—the polymorphously perverse realms of pop culture, non-Christian religions, and elite secular and academic culture. Finster's words remained insistently narrow and theologically intolerant to the end of his days, but his artistic imagery and personal behavior as a "Stranger from Another World" embraced Christians and all kinds of religious, racial, sexual, and cultural outcasts. In fact, it may be said that Finster's mischievous personality and indomitable

good humor, puckish behavior, and fecundity of unexpected artistic imagery unveil yet another pre-Christian religious trait of tinker-shaman-artists—that is, the playful qualities of the mythic trickster/blacksmith figure who is artistically creative precisely because he cannot take the conventional world or religion entirely seriously.[9]

EMBRYONIC WORLD MAKING

With this prologue to religious and artistic world building in mind, it is helpful to turn to a closer typological examination of the overall phenomenon of religiously-based environmental constructions.[10] Finster's multiacre paradise is one of the most famous contemporary examples of these outdoor environments, but the compulsive construction from found and recycled materials of large-scale environmental works, paradisaical realms, and microcosmic worlds of biblical, esoteric, and patriotic symbolism is a common and provocative characteristic of self-taught vernacular art. Such works include, among many possible examples, the spectacular early constructions of Ferdinand Cheval in France (the Palais Idéal), Samuel Dinsmoor's Garden of Eden in Kansas, Simon Rodia's Watts Towers in California, and, more recently, Nek Chand's Rock Garden in India, Tressa Prisbrey's Bottle Village and Leonard Knight's Salvation Mountain in California, Vollis Simpson's Windmill Park in North Carolina, Clyde Jones's Haw River Crossing in North Carolina, and Tom Every's Forevertron in Wisconsin.[11]

All of these works are heroic in ambition and size,[12] but they are also directly akin to smaller and less overwhelming outdoor and indoor constructions (e.g., the Reverend "B. F." Perkins's gourd-bedecked Hartline Assembly Church [see plate 75], Annie Hooper's haunted miniature doll tableaus of Bible stories, LeRoy Bowlin's glittering Rhinestone Cowboy House, and Royal Robertson's

fantastic numerological and misogynistic works). Such productions, whether overtly religious or "visionary" or not, draw upon the prehistoric human drive for healing self-definition and world creation through passionately driven, ritually patterned, and artistically expressive marking and making. This kind of miniature world-making is most basically and sentimentally seen in what some have called the "aesthetics of everyday life," including such widespread activities as Christmas decorations and other forms of everyday cosmetic and decorative behavior, religious and secular shrine construction, and all manner of yard art and the odd-job work of the inveterate tinker- bricoleur.[13]

In a way that anticipates the marginalized intensity, religious idiom, and pop culture sensibility of many larger and more pretentious Southern environments, it is instructive to consider the rough roadside construction of someone like the mostly unknown and partially deaf Tony Hayes, who lives with an ailing wife in a ramshackle trailer along the highway that leads to Summerville, Georgia, and Finster's own Paradise Garden. After almost drowning and then being forced to take up his current life of disability and welfare payments, Hayes started to receive muted messages from God to build, using cast-off debris found along the road, a public altar on the back of a broken-down pickup truck lodged in front of his decrepit trailer. Along with his crudely painted signs and images dedicated to interpreting various biblical secrets and God's cryptic messages, this makeshift though compelling shrine-altar is intended to heal Hayes's broken body and spirit, to warn others of the impending Apocalypse, and to bring sinners back to God's saving grace. Hayes has, of course, heard of his famous neighbor but has never had the time to tour Finster's Garden. Rather, he prefers to work tirelessly and frantically on his own small patchwork assemblage of sacred junk as a way to give meaning and focus to his decaying life.[14]

Hayes and Finster's Christian idiom can be

identified as a particular visual manifestation of "Evangelical Protestantism," a tradition that constitutes the most important religious influence on the visionary world makers in the American South (see plate 36). Such a realization belies the fact that "evangelical" describes a complex religious and cultural phenomenon and has various distinct forms in the South and the North. There are, however, certain common traits that bind the various evangelical communities together, perhaps the most important of these factors being the emphasis on the suffering sinfulness of humankind, the need for a personal "born again" experience, and an insistent concern for the righteous transformation of the individual and community in the light of the immanent "apocalyptic" and "premillennial" coming of the Lord. It is the absolute finality and intense drama of this vision that gives it special urgency and cinematic imagery. From this "dispensationalist" point of view, the world has already entered into the "end time" that leads to a terrible and total destruction of the depraved world and portends the Second Coming of Christ to establish forever his millennial kingdom on earth (see plate 118).[15]

Although a one-sided theological absolutism and a narrow biblical literalism are often defining characteristics of this tradition, it is nevertheless quite possible to recast the particularistic Protestant and Christian aspects of the evangelical persuasion into the broader humanistic context of the comparative history of religions and the universal human drive to construct worlds of saving meaning through oral fabulation (myth making or "vision telling" in the Protestant sense of the recitation of sacred Scripture) and performative/artistic expression (the ritual embodiment and aesthetic re-presentation of the mythic stories). In other words, there is a terrible and pressing need to remake the world in evangelical tradition, a Christian theological principle that is humanistically prefigured and artistically accomplished over and over in the environmental worlds constructed by self-taught artists. In these situations, the finality of the "end" has been relativized. Humanly and imaginatively speaking, therefore, the end is always a new beginning (see plate 38).[16] Furthermore, the characteristic evangelical or Protestant emphasis on intense individual religious experience represents in some interesting ways a dramatic reassertion of a shamanistic concern with direct ecstatic and visionary experience shared with the community through words, music, theatrical performance, and images. Indeed, the jumbled juxtaposition of biblical words and stories with performative, artistic, sculptural, and environmental elements is a strikingly common trait in self-taught tradition.

Another example of the embryonic world making seen in Hayes, although without his explicit Christian symbolism, is the obsessive work of the now deceased Billy Lemming who, after a severe car accident and bouts of alcoholism, retreated reclusively into the Appalachian woods of north Georgia to energize his spirit (quite literally by daily plugging himself directly into 110 volts of electricity) and to create a painted red-white-and-blue cosmos that overflowed his cabin into the surrounding forest.[17] The point is that Hayes and Lemming are each in their own way good examples of the emotionally driven nature of these world-making activities. They also serve to dramatize the fact that such activities are "visionary" in quite different ways—some drawing upon the symbolism of traditional religion and others constituting a much more personal and unconventional idiom of expression and significance. For many of these artists, the initiatory moment for their world making comes out of some kind of personal suffering and despair that is only healed when they embark upon their artistic activity in a way that profoundly affects them. One other issue worth addressing briefly is the question of why the American South figures so prominently in the annals of

George Paul Kornegay (b.1913)

Brent, Alabama

George Paul Kornegay, *Shadrach, Meshach and Abednego* detail, plate 58

Rev. George Kornegay, an African Methodist Episcopal Zion minister, who also worked in Alabama's mills and foundries, began work on his environment in 1981 after a visionary experience. Preparing to carve into a rock he had found on his property, he heard a voice saying, "Upon this rock I will build my Church." Kornegay at once decided to leave the rock as it was and take up his "calling" to create works that would glorify God. Kornegay's environment, which he has named *Hill of Calvary* and *Art Hill*, is a sacred space encoded with the creolized African emblems of the American South and numerous references to biblical stories and sacred music. Kornegay requires that visitors take the time to decode the environment for themselves, warning that some of the symbols he uses are "secrets" between him and God.

Kornegay provides one way into the environment by adopting the traditional African artistic practice: the garden is dotted with wrapped structures that recall the medicated charms known as *minkisi*, bottle trees that attract and trap evil spirits, and large guardian figures and faces. The artist nails large painted roots, thought to be the domain of powerful spirits, to posts that stand next to a depiction of the Crucifixion. Wheels, tires, fans, hubcaps, and cast-off electric fans with four blades all represent the Kongo cosmogram, a circle or diamond divided by two axes that symbolize the four cardinal directions of the universe and the soul's progress from birth, to maturity, to death, and to rebirth. A large assemblage of circular found objects including chrome hubcaps may refer to Ezekiel's "wheels within wheels" and also encodes the belief that shiny surfaces repel evil and embody ashé, the flash of the spirit that denotes the power to make things happen.

These African emblems do not stand in opposition to Kornegay's sacred allusions. Kornegay's *Jacob's Ladder* combines wheels, stairs, and a television antenna with gleaming crossbars to illustrate, in the words of the spiritual, that "every rung goes higher, higher." Another multivalent work, a large sculpture of *Jonah in the Belly of the Whale* attached to a bridgelike structure, alludes to the bridge in nearby Selma where marchers were attacked by police and segregationists and to the promise of a land of milk and honey over Jordan. Likewise, Kornegay's *Last Supper*, a long table topped with stones and crockery and surrounded with chair frames, audaciously juxtaposes the conventional European "last suppers" with African American charms like bottle trees.

Cheryl Rivers

Rev. Kornegay's remarks come from an August 21, 2002, interview with the author. He talks about his environment in *Souls Grown Deep*, Vol. 2, 169–77. Thompson, *Flash of the Spirit*, treats African survivals in contemporary vernacular art.

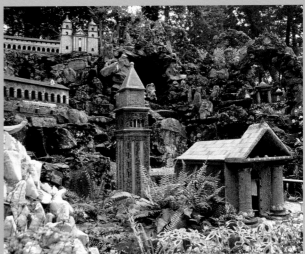

Illus. VII-2, Illus. VII-3, Illus. VII-4
Brother Joseph Zoettl (1878–1961)
Ave Maria Grotto, details, 2003
Cullman, Alabama

Brother Joseph Zoettl (1878–1961)

Cullman, Alabama

When Brother Joseph Zoettl, a German-born Benedictine brother at the Saint Bernard Monastery in Cullman, Alabama, constructed his miniature Holy Land in the late 1910s, he did not intend to create a roadside attraction. Indeed, when tourists asked to see *Little Jerusalem*, the abbot requested that Brother Joseph cease his work. Brother Joseph then spent his spare time fashioning small grottoes to house religious figurines sold in the abbey gift shop. However, the popularity of these shrines, along with reports of grotto shrines built at Midwestern Catholic institutions, soon convinced the abbot that a tourist attraction might bring welcome revenue and inspire religious sentiment.

The grotto shrine, brought to America by European immigrants, has its roots in the ancient belief that caves are sacred dwelling places where one could seek supernatural aid or discharge religious obligations. Incorporated into Christianity through associations with the Nativity and Entombment of Christ, caves took on specifically Catholic connotations through accounts of miraculous apparitions of the Virgin and saints near caves. Thus, the Baroque grotto, an artificial cavern embellished with fragments of glass, stucco stalactites, and seashells, became a conventional setting for the display of religious statuary. With dramatic contrasts of light and dark, grottoes replicated the emotional quality of mystical experience.

Brother Joseph's impressive central grotto, decorated with cement stalactites, shells, broken glass, fragments of white marble, and polished stones, houses imported statues of the Virgin and Saint Benedict and Saint Scholastica, founders of the Benedictine Order. With a full-scale altar, this grotto was blessed as an oratory in 1934.

Brother Joseph's creativity is most fully developed in the miniature tableaux he created from donated materials such as marbles, glass bottles, and costume jewelry. He based his tableaux on postcards, travel brochures, and illustrated encyclopedias. Replicas of Holy Land sites include the Temple in Jerusalem, Herod's Gate, the Cave of the Nativity, Gethsemene, Calvary, and Christ's open tomb. Other biblical scenes include Noah's Ark, the Hanging Gardens of Babylon, and the Tower of Babel, labeled in many languages. An Italian tableau includes St. Peter's Basilica with colonnaded piazza, notable churches, the Coliseum, and the Leaning Tower of Pisa. American tableaux include California missions, St. Bernard Abbey, and the Cathedral of the Immaculate Conception in Mobile. For children, Brother Joseph constructed a fanciful scene titled *Hansel and Gretel Visit the Fortress of the Fairies*. Patriotic scenes include a miniature Statue of Liberty, an American flag, and memorials to St. Bernard alumni who lost their lives in World War II and Korea.

Ave Maria Grotto, named a National Historic Site in 1984, continues to attract visitors who delight in spotting the replicas of well-known buildings. Some visitors, as the abbot hoped, also enjoy the opportunity for quiet contemplation.

Cheryl Rivers

Information about Zoettl's life and grotto can be found in pamphlets and the video *The Ave Maria Grotto* published by St. Bernard Abbey.

contemporary self-taught art. We have already seen that such art and environmental world making can be found throughout the world, but it does appear that there are certain "hot zones" where there is an extraordinary abundance of self-taught or "outsider" artistic activity and visionary construction, the most noted of these zones in the United States during recent decades being the South, the Midwest (especially Wisconsin), and California. No doubt the existence of special regions of self-taught artistic activity is largely an impression of an ongoing romantic fixation with the creative "primitivity" of certain regions in the United States. Be that as it may, it can still be said that the American South is perhaps the most mythic of distinctive regional domains in the United States. The myth and mystery of the American South is, moreover, an extremely attractive fabulation that tends to stress the uniquely passionate and suffering primitiveness of its people and traditions. This is not the place to discuss the complex nature of this mythology of creative marginality, but in general terms it is a powerful fictive construct that is built out of various "real" factors—among them the painful legacy of the Civil War and slavery, the fickleness of the semitropical climactic conditions, the special social and racial implications of the traditional, and often impoverished, agrarian economy, and—most distinctive of all—the special religious heritage of evangelical Protestantism.[18] *This does not mean that there are actually more self-taught artists or visionary environments in the South than in any other particular region, but it does suggest why we think there should be and why, therefore, we have made such mythically nostalgic feelings a self-fulfilling prophecy.*

OTHER RELIGIOUS DISPENSATIONS

The "primitive" religious nature of this kind of compulsive world making is also suggested by a self-taught tradition associated with a region and organized religion distinct from Southern evangelical Protestantism that is, the efflorescence of Roman Catholic grottos and shrines throughout the Midwest and in other parts of the United States during the first part of the twentieth century. The most renowned examples of these simultaneously baroque and rustic structures are Father Paul Dobberstein's elaborate Grotto of the Redemption in Iowa and the similarly obsessive Grotto to the Blessed Virgin in Dickeyville, Wisconsin, built by Father Mathias Wernerus. There are many other examples of such grotto structures in areas affected by Catholic tradition, as well as Brother Joseph Zoettl's Ave Maria Grotto and Shrine located in Cullman, Alabama, the very heart of the Protestant South (see illus. VII-2, VII-3, and VII-4).[19] These structures were modeled on European traditions of shrines associated with saintly apparitions and visionary experience, events most often associated with mountainous caverns and stony outcroppings that recall pagan and Paleolithic traditions of cave sanctuaries and visionary imagery. We witness in this way a deep artistic and symbolic linkage of Protestant visionary world making and the Catholic tradition of grotto construction in relation to various prehistoric and cross-cultural religious traditions and practices. Moreover, it is clear that immigrant Catholic clerics like Dobberstein, Wernerus, and Zoettl were compelled to revive the age-old grotto tradition in the New World because of their personal isolation in the American wilderness and their overpowering need to create a sacred cosmos that visually and experientially renewed and intensified their religious communities with materialized depictions of Christ's life and the special quasi-goddess presence of the Blessed Virgin Mary.[20]

When discussing the fundamental human religiosity of these unconventional activities, we should also call attention to the ubiquity of yard art that on either a small or large scale, often has

H. D. Dennis (b. 1916)

Vicksburg, Mississippi

Illus. VII-5

H. D. Dennis (b. 1916)

Margaret's Grocery and Market, 1997

Vicksburg, Mississippi

When the Reverend H. D. Dennis proposed marriage to widow Margaret Rogers, he promised he would turn her "little old brown plank store into a palace." Mrs. Rogers, who had operated the modest store on Highway 61 north of Vicksburg, Mississippi, for almost thirty years, accepted the proposal, and in 1984 Reverend Dennis began to embellish the simple one-story building, adding columns and an entry gate built from bricks and concrete blocks. Told by God "to keep going higher," Dennis erected an attention-grabbing two-story tower of the Ark of the Covenant with an "Upper Room." When town fathers condemned the tower, Reverend Dennis converted an abandoned school bus into an extravagantly decorated chapel complete with altar and pulpit. The seats of the bus, neatly upholstered, serve as pews. Finally, Dennis ornamented every surface with glossy paint, jig-sawed strips of lumber, glass and plastic Mardi Gras beads, Christmas lights, costume jewelry, artificial flowers, and other recycled materials. Once painted a patriotic red, white, and blue, the environment is now a checkerboard of red, yellow, pink, and white.

Like other yard shows created by African Americans, Dennis's Margaret's Grocery embodies the philosophy and theology of its creator. A close reading of the individual elements reveals two primary themes: fundamental Christianity and a life of discipline and rectitude. Signs placed throughout the environment spell out the fundamentalist theology of this Missionary Baptist preacher. References to the gospel account of Jesus's confrontation with merchants operating in the Temple explain the name of the environment: MATTHEW 21:13: "MY HOUSE SHALL BE CALLED THE HOUSE OF PRAYER, BUT YE HAVE MADE IT A DEN OF THIEVES." Although one sign reads, "ALL IS WELCOME JEWS AND GENTILES," another states, "THE CHURCH OF CHRIST IS THE ONLY ONE." A lengthy notice explains the concept of sanctification, exhorting believers to "BE SET APART FROM THE WORLD." At her husband's insistence, Margaret no longer sells beer at the grocery, and Reverend Dennis often denounces the casino boats that in recent years have attracted visitors to Vicksburg.

Although many fundamentalists denounce Masonic affiliation, Dennis finds that "it can take you a long way." Thus, he employs Masonic devices that derive from the Bible or underscore the values of hard work, self-discipline, brotherhood, and a temperate life. A double-headed eagle, the symbol of the Thirty-Second Degree, tops the entrance gate. The shutters of the grocery bear the Masonic device of square, compass, and the letter G, symbolizing rectitude, restraint, and God or Geometry (divine order). Two columns bearing the initials B and J refer to the columns of Solomon's Temple, Boaz (establishment) and Jachin (strength). Another symbol with both religious and Masonic significance is Dennis's Ark of the Covenant, a highly ornamented chest that contains tablets inscribed with the Ten Commandments. Among other Masonic references are the checkerboard patterning, which denotes the vicissitudes of life, and the masonry architecture of the environment itself.

Cheryl Rivers

Rev. Dennis's environment is discussed in *Souls Grown Deep*, Vol. 1, and in two essays, one by Stephen Young and the other by Frederic Allamel, appearing in the *Southern Quarterly*. For Dennis's fanciful interpretation of the double-headed eagle, consult Moses, *Outsider Art of the South*.

special affinities with African American religious tradition.[21] This tradition, especially in the South but also throughout the diaspora of African Americans, is ostensibly evangelical and Protestant, but more accurately has taken on a distinctive hyphenated life that intensifies the movement of spirit in soul and body. It is also the case that, despite legitimate suspicions about the unconscious importation of certain "Africanisms" from remnants of West African religious traditions and symbolism, there is a syncretistic religious form and aesthetic style to African American evangelical religion that is broadly "tribal" and non-Christian.[22] That is not to say that there is something pejoratively "primitive" about such African American transformations of conventional white Protestantism; rather, the point is that African American tradition has dynamically expanded the evangelical cosmos in more universally religious, morally sensitive, and artistically expressive ways.[23] This kind of expansive and transfiguring vision is especially seen in the self-taught world making of Southern African Americans coming out of evangelical tradition, such as the Reverend H. D. Dennis's roadside Margaret's Grocery and Market (see illus. VII-5) and the Reverend George Kornegay's House of the Apocalypse (see plate 59). But it is also seen in the less conventionally evangelical and Protestant, though no less "religious," work of Charlie Lucas (whose tin critter environment is more tricksterish and shamanistic than Christian), Royal Roberson (whose esoteric paranoia is both religiously eclectic and sexually tortured), Purvis Young (who periodically transforms parts of his urban landscape into impressionistic painted evocations of spirit), and Lonnie Holley (whose several yards always have a way of turning into creative fantasies of redeemed junk and revived spirit).

We should underscore the fact that the American South, in keeping with the rest of the United States, has at the beginning of the twenty-first century become an incredibly pluralistic culture with regard to the active presence of organized religions and emergent, and often syncretistic, religious cult movements. It is no longer possible when discussing the history of American religions to fall back on the formula of Protestant, Catholic, and Jew. The recent influx of Latin Americans means that we can expect to see "Latin" forms of religion throughout the United States and not only in the traditional areas of the Southwest. Equally important is the increasing presence of American Muslims and Asian Americans. Often these immigrant populations are socially, culturally, and economically marginalized in relation to mainstream American culture and are ripe for the healing activities of self-taught world making. The question remains as to what these worlds will look like aesthetically and religiously and how they will transform, reform, and appropriate the existing worlds of meaning in America.[24]

CONCLUSION: EMBODIED PRECARIOUSNESS

We end this essay by recalling what we noted at the outset—that Howard Finster has gone home now to that glowing mansion in the sky. His earthly environment, his garden, and the world that he gave to us do go on, but it is fragile and is now, despite the efforts of Finster's daughter, rather dilapidated and depressing (see illus. VII-6).[25] Finster certainly wanted his garden to continue to live, but at the same time, he recognized the *snaky* decay that was creeping over his body, his family, and his garden. Most of all, he believed in the need to build new worlds and never to accept the permanence and perfection of anything on this earth. Only spirit, revealed in matter through the alchemical making of the imagination, has the permanence of constant change and movement. To believe in the truth of spirit is to believe evangelically in the absolute need for the repeated revival of spirit, something only accomplished by remak-

Illus. VII-6

Howard Finster (1915 or 1916–2001)

World's Folk Art Church, 1997

Summerville, Georgia

ing those worlds that we have started to take for granted. In time, there comes a reformation time when old worlds must be destroyed and entirely new worlds constructed if spirit is to be made visible and active again in human life. Roger Cardinal tells us that one of the most "compelling" and "haunting" aspects of self-taught environmental art "is its tendency to embody precariousness."[26] This is not so much an evil, but the hard truth of the snakelike and skin-shedding spirit that always exists within the multiple gardens that define hu-

man life. Unlike human beings, environments can, in fact, be resurrected. Healing comes from the recognition that all existing gardens, worlds, and communities need periodically to be refreshed and rebuilt. Then through the special spontaneous efforts of those who have the eyes to see and the art to make their visions real, unexpected and seemingly fantastic worlds will be produced for public exploration and habitation. Otherwise, as Finster incessantly reminded us, "the people perish."

1. For some commentary on the implications of Finster's death, see N. J. Girardot, "Envisioning Howard," *Folk Art Messenger*, 14 (2001/2002): 7.

2. The recent memoirs of Thelma Finster Bradshaw are important for their portrait of Finster's early environmental works. See her *Howard Finster, The Early Years: A Private Portrait of America's Premier Folk Artist* (Birmingham: Crane Hill Publishers, 2001).

3. Art in a shamanistic context, says the anthropologist Joan Halifax, is not art for art's sake, "rather it is art for survival, for it gives structure and coherence to the unfathomable and intangible." The shaman in traditional tribal societies may be considered an "artist and performer" who "utilizes the imagination to give form to a cosmos that is unpredictable. Even in the course of wild initiatory trances, the mythological rendering of a chaotic psyche is essential. Order is imposed on chaos; form is given to psychic confusion; the journey finds its direction. The shaman also provides a diseased person with a language, by means of which unexpressed and otherwise inexpressible psychic states can be immediately expressed." The shaman is therefore "a master of play, dancing, and chanting in the field of human suffering. And through these acts, the people are awakened from the nightmare of sickness to the dream of paradise." See Halifax, *Shaman, The Wounded Healer* (London: Thames and Hudson, 1982), 11, 18, 26. For the classic statement of the relation between shamanism and artistic world making, see Andreas Lommel, *Shamanism: The Beginnings of Art* (New York: McGraw-Hill, 1967). And for the contemporary critical discussion of shamanism as a problematic academic construct (influenced primarily by Mircea Eliade's work), see Jeremy Narby and Francis Huxley, eds., *Shamans Through Time: 500 Years on the Path to Knowledge* (New York: Jeremy P. Tarcher/Putnam, 2001); Alice Beck Kehoe, *Shamans and Religion: An Anthropological Exploration in Critical Thinking* (Prospect Heights: Waveland Press,

2000); and (the best of the three studies) Ronald Hutton, *Shamans: Siberian Spirituality and the Western Imagination* (London: Hambledon and London, 2001).

4. On the theme "believing is seeing," see Mary Anne Staniszewski, *Believing Is Seeing: Creating the Culture of Art* (New York: Penguin Books, 1995).

5. See Lynda Sexson, *Ordinarily Sacred* (Charlottesville: University Press of Virginia, 1992), 69. Art, as Sexson says, "creates the reality it lives in."

6. As William Paden has said, "the notion of world formation supplies a basis for comparative analysis because it constitutes a common, human activity against which differences may also be discerned. The world-making model identifies both common forms of world fashioning behaviors and historically different socio-cultural contents of world expressions." See his article "World," in *Guide to the Study of Religion*, ed. Willi Braun and Russell T. McCutcheon (London: Cassell, 2000), 334–50. The classic understanding of religion as "world construction" is found in Peter Berger's *The Sacred Canopy: Elements of a Sociological Theory of Religion* (Garden City: Doubleday, 1969). As Berger says, "Religion is the human enterprise by which a sacred cosmos is established. Put differently, religion is cosmization in a sacred mode. By sacred is meant here a quality of mysterious and awesome power, other than man and yet related to him, which is believed to reside in certain objects of experience." To this, I might add that art is the expressive medium of cosmization for both religion and culture. On world construction as it specifically relates to visual culture, see David Morgan, *Visual Piety: A History and Theory of Popular Religious Images* (Berkeley: University of California Press, 1998), 2–20. Another interesting study dealing with imaginary "world making" (having relations with shamanism, mysticism, visionary experience and, in a more contemporary vein, "near death" experiences) is Carol Zaleski, *Otherworld Journeys: Accounts of Near-Death Experience in Medieval and Modern Times* (New York: Oxford University Press, 1987). As Zaleski says (and much of what she says applies to self-taught visionary environments):

> Otherworld visions are products of the same imaginative power that is active in our ordinary ways of visualizing death; our tendency to portray ideas in concrete, embodied, and dramatic forms; the capacity of our inner states to transfigure our perception of outer landscapes; our need to internalize the cultural map of the physical universe; and our drive to experience that universe as a moral and spiritual cosmos in which we belong and have a purpose [205].

7. See Randall Morris's interesting attack on the idea that outsider art is necessarily concerned with the creation of "alternative universes." As Morris says, the continuum between trained artists and self-taught artists may be found in "man's relationship to home-ground." Morris is never very clear as to what he means by "home-ground," but I would interpret it to mean something along the lines of my idea of artistic "world making," which is always linked to the establishing, centering or renewing of a particular cultural place or "home." See Randall Morris, "The One and the Many: Manifest Destiny and the Internal Landscape," in *Self-Taught Art: The Culture and Aesthetics of American Vernacular Art*, ed., Charles Russell (Jackson: University Press of Mississippi, 2001), 117–28.

8. On the idea that art and religion are the "work that is play," see Sexson, *Ordinarily Sacred*, 84.

9. The connection between shamanism and trickster mythology and symbolism is established in the work of M. L. Ricketts, "The Structure and Religious Significance of the Trickster-Transformer-Culture Hero in the Mythology of the North American Indians." (Ph.D. dissertation, University of Chicago, 1974). See also the study of African trickster tradition by Robert D. Pelton, *The Trickster in West Africa: A Study of Mythic Irony and Sacred Delight* (Berkeley: University of California Press, 1980).

10. Roger Cardinal provides us with a general definition of "outsider" environments/architecture: It is "that mode of ambitious, handmade material construction which typically involves recycling, assemblage, and display within an autonomous and bounded space, and which, based upon no blueprint and essentially the work of an unaided, self-taught individual, strikes an unmistakable note of singularity." See his essay "The Vulnerability of Outsider Architecture," *Southern Quarterly* 39, 1–2 (Fall–Winter 2000–2001), 169–86.

11. For pictorial inventories and descriptions of many of these environments see, for example, Roger Manley and Mark Sloan, *Self-Made Worlds: Visionary Folk Art Environments* (New York: Aperture, 1997); Deidi Von Schaewen and John Maizels, *Fantasy Worlds* (Koln: Taschen, 1999); and John Maizels, *Raw Creation: Outsider Art and Beyond* (London: Phaidon Press, 1996). Manley's essays are always worth reading, but the most sustained and impressive interpretation of these works is found in John Beardsley's *Gardens of Revelation: Environments by Visionary Artists* (New York: Abbeville, 1995).

12. The heroic world-making and "cabinet of curiosities" aspects of many of these environments are epitomized by Howard Finster's description of his work on the early version of Paradise Garden called the Plant Farm Museum (the following is a transcription of a sign Finster placed in his garden):

> It took me about seven years to clear out this jungle killing over one hundred snakes and cutting thousands of trees, bushes, vines, and thorns, filling ditchs, leveling, clearing out garbage throughout, labor all by hand tools, standing on mud palets, raking out water ways for three spring branches. It was said by Mrs. C. L. Lowery that this

place once was a lake where men hunted ducks from small rowe boats, Mr. C. L. Lowery former owner of this land dug into a clay pot of indian arrow heads, if he found other things its unknown, since that time I found one small piece of yellow gold shining from the mud where I was digging, not too far from the clay pot, Mr. Lowery was a music teacher wrote, the words to the song lifes evening sun, allso studied and worked on prepitual machine 40 years, I now have remains of his machine. Many years ago I know God spoke to my soul that there was something for me in Pennville after 40 years of preaching the gospel with out charge, I then felt led to build a paradise garden in which I will open print the holy bible verse by verse throughout. Please respect for Christ's sage. W. H. F.

13. On the prehistoric and ethological nature of art as a (quasi-ritualized) form of "making special" or world making, see Ellen Dissanayake, *Homo Aestheticus: Where Art Comes From and Why* (New York: Free Press, 1992). In a more impressionistic vein, see Lucy Lippard, *Overlay: Contemporary Art and the Art of Prehistory* (New York: The New Press, 1983). And on the mundane decorative activities that constitute a form of authentic folk-aesthetic behavior, see Michael Owen Jones, "The Aesthetics of Everyday Life," in *Self-Taught Art*, 47–60; David Morgan's discussion in *Visual Piety*, 12–17; and Colleen McDannell, *Material Christianity: Religion and Popular Culture in America* (New Haven: Yale University Press, 1995).

14. This discussion about Tony Hayes is based on personal fieldwork in Georgia in 1998. At that time, I conducted several taped interviews and took numerous photographs of Hayes and his work. I am indebted to Larry and Jane Schlacter for introducing me to Hayes.

15. On evangelical "dispensationalist" theology in self-taught art, see especially Carol Crown, "The Revelations Series: Divinely Inspired, Evangelically Conceived," in *Wonders to Behold: The Visionary Art of Myrtice West*, ed. Carol Crown (Memphis: Mustang Publishing, 1999), 18–43.

16. See the discussion of these themes in N. J. Girardot's curator's statement in the exhibition catalog, *Four Outsider Artists: The End Is a New Beginning* (Bethlehem: Lehigh University Art Galleries, 2001).

17. For a short discussion of Billy Lemming, see *Self-Made Worlds*, 52–53.

18. On these issues, see especially Charles Reagan Wilson's "Flashes of the Spirit: Creativity and Southern Religion" in *Image* 24 (1999), 72–86 and George B. Tindall, "Mythic South," in *Encyclopedia of Southern Culture*, ed. Charles Reagan Wilson and William Ferris (Chapel Hill: University of North Carolina Press, 1989), 1097–99. Finally, it is worth consulting V. S. Naipaul's quirky, but evocative, study of the mythic tradition of the South (the "past that is a wound") in his *A Turn in the South* (New York: Alfred A. Knopf, 1989).

19. On the grotto tradition, see especially Beardsley's *Gardens of Revelation*, 101–32; Lisa Stone and Jim Zanzi, *Sacred Spaces and Other Places* (Chicago: School of the Art Institute of Chicago Press, 1993); Barbara Brackman and Cathy Dwigans, eds., *Backyard Visionaries: Grassroots Art in the Midwest* (Lawrence: University Press of Kansas, 1999); and Susan Niles, *Dickeyville Grotto: The Vision of Father Mathias Wernerus* (Jackson: University Press of Mississippi, 1997).

20. On the mythic and "primitive" implications of the Blessed Virgin tradition in Roman Catholicism, see Marina Warner, *Alone of All Her Sex: The Myth and Cult of the Virgin Mary* (London: Weidenfeld and Nicolson, 1976).

21. See, among other works, Richard Westmacott, *African-American Gardens and Yards in the Rural South* (Knoxville: University of Tennessee Press, 1992); Maude Southwell Wahlman, "African Charm Traditions Remembered in the Arts of the Americas," *Self-Taught Art*, 145–65; Beardsley, *Gardens of Revelation*.

22. On the problems with the premature detection of "Africanisms" in self-taught African American art see the acerbic comments by Bill Swislow in *The Outsider* 6, 2 (Winter 2002), 9–11 (reviewing *Testimony: Vernacular Art of the African-American South*).

23. Concerning the vexed issues connected with "primitivism," "primitivity" or the "primitive" in the history of art, see the balanced study by Colin Rhodes, *Primitivism and Modern Art* (New York: Thames and Hudson, 1994). For the relation to self-taught art, see Rhodes, *Outsider Art: Spontaneous Alternatives* (New York: Thames and Hudson, 2000), 24–26.

24. On some of the visual culture associated with these new religious dispensations in contemporary American culture, see David Morgan and Sally M. Promey, eds., *The Visual Culture of American Religions* (Berkeley: University of California Press, 2001), and their *Exhibiting the Visual Culture of American Religions* (Valparaiso: Brauer Museum of Art, Valparaiso University, 2000).

25. On the decrepitude of Paradise Garden, see Tom Patterson, "Paradise Before and After the Fall," *Raw Vision* 35 (2001), 42–51; and Carol Crown, "Paradise Revisited: The Desecration and Reclamation of Howard Finster's Paradise Garden," *Number* 39 (Summer 2001), 28–33. See also my discussion of Finster's waning years, "Howard Finster," *Self-Taught Artists of the Twentieth Century: An American Anthology* (New York: Museum of American Folk Art, 1998), 164–69.

26. Cardinal, "The Vulnerability of Outsider Architecture," 170.

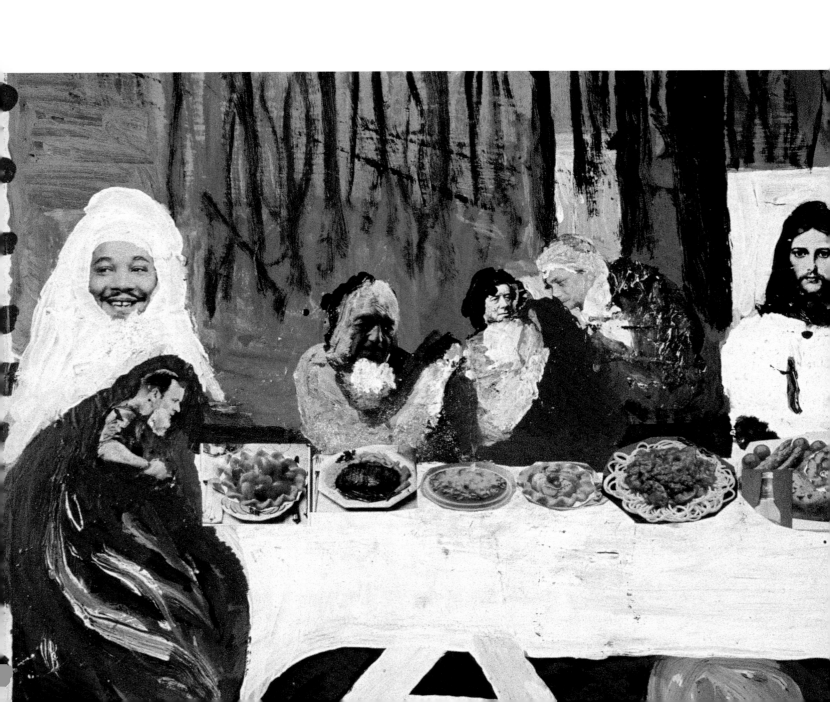

Plates

Unless otherwise indicated, all dimensions (height, width, depth) are in inches.

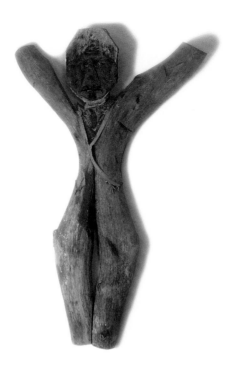

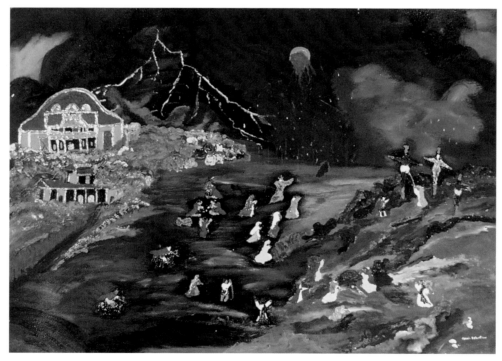

PLATE 1 Jesse Aaron (1887–1979)
Crucifixion, n.d.
Wood and cloth, 84 x 54 x 8
Collection of Josh Feldstein

PLATE 2 Sarah Albritton (b. 1936)
Crucifixion, 1996–1997
Acrylic on paper, 22 x 30
Collection of A. Brooks Cronan, Jr., M.D., and Jo Cronan

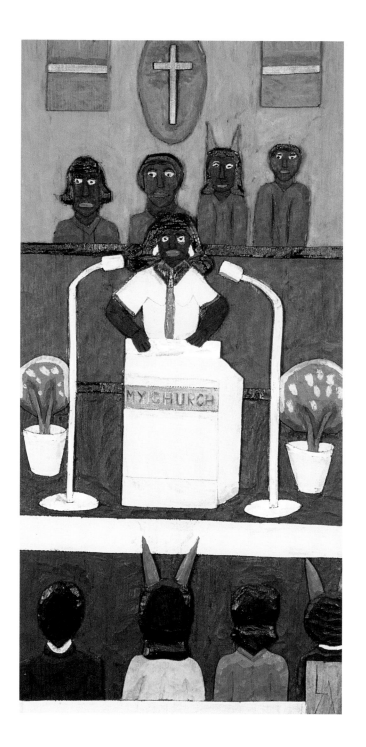

PLATE 3 Leroy Almon, Sr. (1938–1997)
My Church, 1987
Paint on wood relief, 24 x 11.25
Collection of Dan and Kristi Cleary

PLATE 4 Leroy Almon, Sr. (1938–1997)
The Preacher and Satan, 1985
Paint on wood relief, 14 x 10.75
Robert Cargo Folk Art Gallery, Tuscaloosa, Alabama,
and Paoli, Pennsylvania

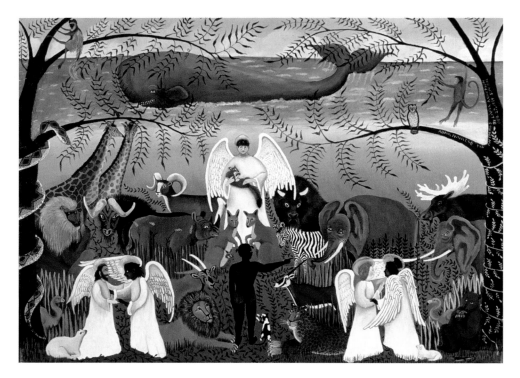

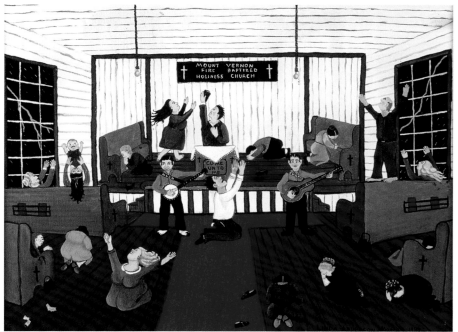

PLATE 5 Linda Anderson (b. 1941)
Adam Naming the Animals, 1994
Oil on linen canvas, 18 x 24
American Folk Art Museum, New York;
Gift of Rebecca Alexander, 2001.08.001

PLATE 6 Linda Anderson (b. 1941)
Mt. Vernon Fire Baptized Pentecostal Holiness Church, 1984
Oil on canvas, 17.75 x 23.75
Collection of the Artist

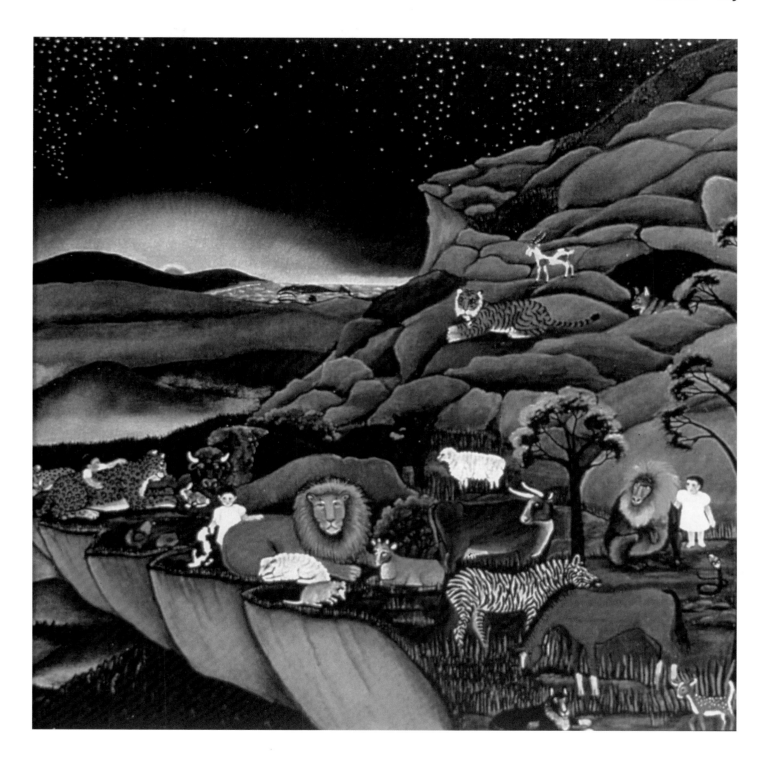

PLATE 7 Linda Anderson (b. 1941)
Sunrise on the Peaceable Kingdom, 2001
Oil on canvas, 25 x 25
Collection of Lewis Regenstein

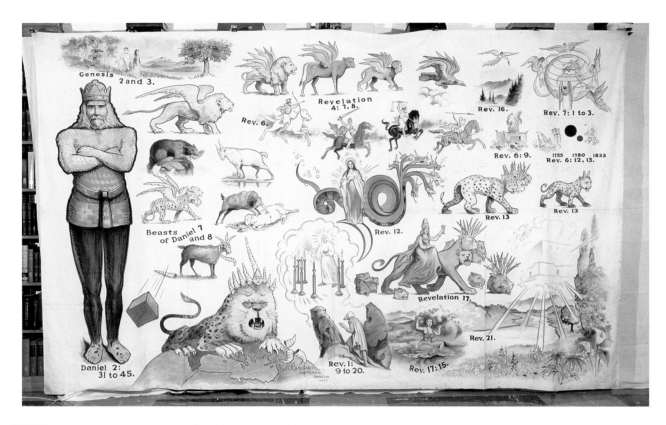

PLATE 8 George E. Bingham (1884–1957)
Bingham Prophecy Chart, 1927
Tempera and ink on muslin, 89 x 140.5
Jenks Memorial Collection of Adventual Materials,
Aurora University Library

PLATE 9 Henrietta Black (1900–1971)
Daniel 2 and 7, 1935
Paint on canvas, 59.5 x 128.75
Jenks Memorial Collection of Adventual Materials,
Aurora University Library

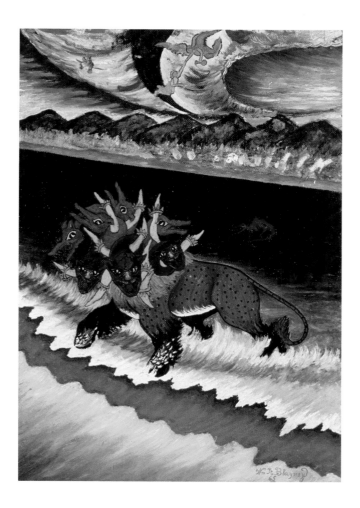

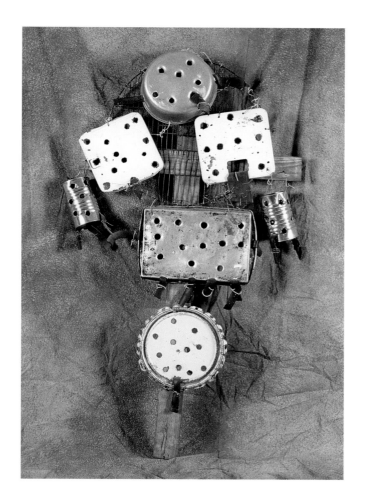

PLATE 10 William Alvin Blayney (1917–1986)
Red Beast, 1965
Oil on canvas board, 29 x 19
Collection of Audrey B. Heckler

PLATE 11 Hawkins Bolden (b. 1914)
Untitled (Crucifixion), 1994
Mixed media, wire, wood, found metal, and rubber, 63 x 36 x 10
Collection of Bruce and Julie Webb

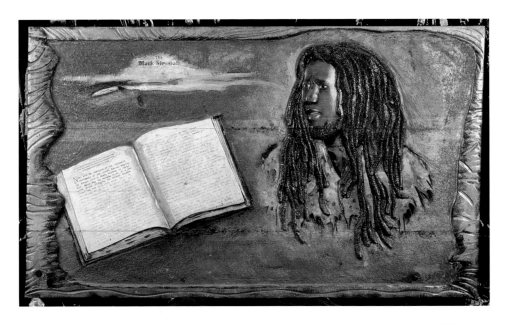

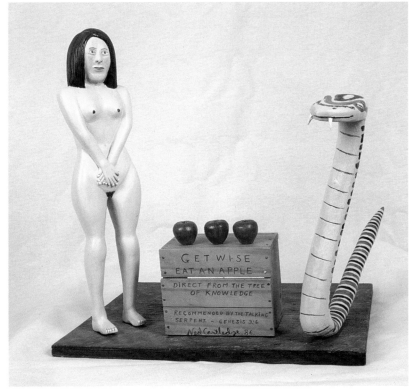

PLATE 12 Edward Butler (b. 1941)
Black Messiah, n.d.
Carved and painted wood with glitter, 30 x 48
Collection of Craig Wiener

PLATE 13 William "Ned" Cartledge (1916–2001)
Get Wise, Eat an Apple, 1986
Carved and painted wood, 16.87 x 16 x 14
Collection of Lynne and Jim Browne

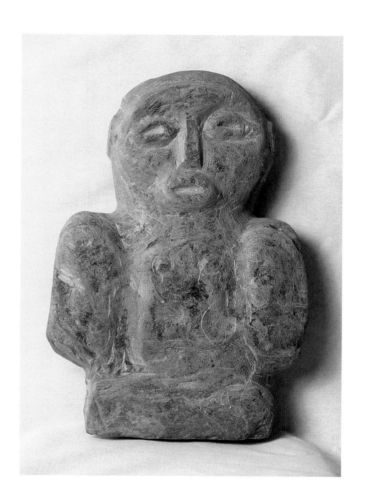

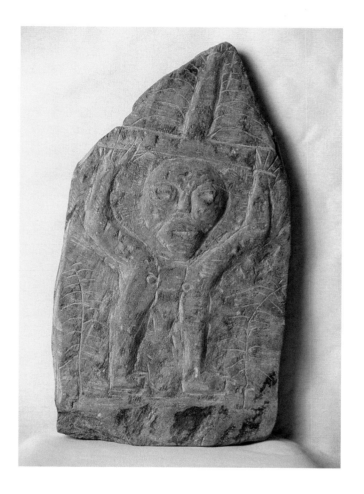

PLATE 14 Raymond Coins (1904–1998)
Angel, ca. 1988
Carved stone, 16.5 x 11 x 3.5
Robert Cargo Folk Art Gallery, Tuscaloosa, Alabama,
and Paoli, Pennsylvania

PLATE 15 Raymond Coins (1904–1998)
Crucifixion, ca. 1988
Carved stone, 20.5 x 10.5 x 2.5
Collection of Randall Lott and Nancy McCall

PLATE 16 Jessie Cooper (b. 1932) and Ronald Cooper (b. 1931)
Brother John, 1996
Wood, foam, glue, steel wool, clothing, and shoes, 70 x 21 x 17
Collection of the Artists

PLATE 17 Jessie Cooper (b. 1932) and Ronald Cooper (b. 1931)
Heaven and Hell Pulpit (for *Brother John*), 2000
Wood, paint, electrical wiring, foam insulation,
and metal, 48 x 48 x 24
Collection of Cal Kowal and Anita Douthat

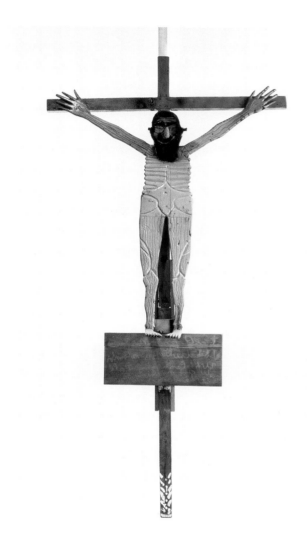

PLATE 18 Ronald Cooper (b. 1931)
Television Evangelist, 1988
Painted wood, 22 x 8 x 5
Kentucky Folk Art Center, 1989.4.20

PLATE 19 Chester Cornett (1912–1981)
Crucifix, ca. 1968
Paint on wood with human hair, 96 x 48 x 12.25
American Folk Art Museum, New York;
Gift of Pam and James Benedict, 1983.28.001

PLATE 20 Carl Dixon (b. 1960)
Crucifixion of Jesus Christ, 1996
Polychromed wood, 17.75 x 24
Collection of Stephanie and John Smither

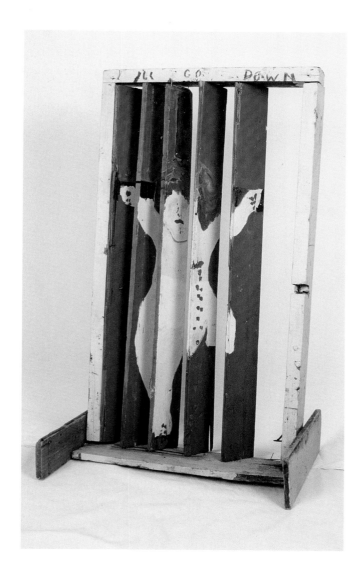

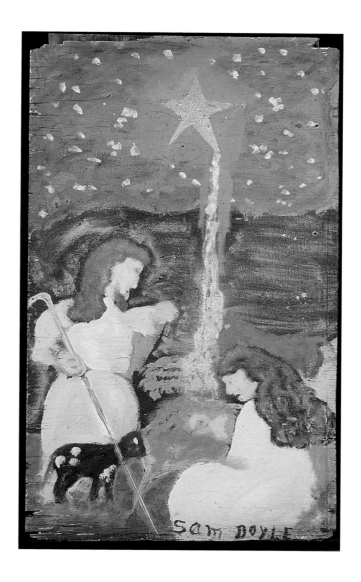

PLATE 21 Sam Doyle (1906–1985)
I'll Go Down, ca. 1979
Paint on wood louvers, 45.75 x 26 x 23.25
Collection of Robert A. Roth

PLATE 22 Sam Doyle (1906–1985)
Untitled (Nativity), n.d.
Paint on board, 48 x 28.5
Collection of Randall Lott and Nancy McCall

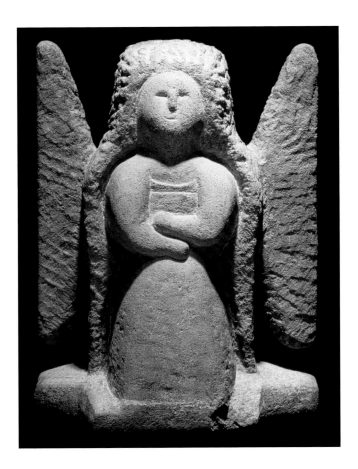

PLATE 23 William Edmondson (ca. 1870–1951)
Angel, 1937–1939
Carved limestone, 18.5 x 13 x 5.5
Collection of Robert A. Roth

PLATE 24 William Edmondson (ca. 1870–1951)
Preacher, ca. 1938
Carved limestone, 18 x 8 x 7.5
Frank H. McClung Museum, University of Tennessee, Knoxville

PLATE 25 Minnie Evans (1892–1987)
A Dream Nov 1968, 1980
Mixed media on cardboard, 16 x 20
Collection of Carl and Marian Mullis

PLATE 26 Minnie Evans (1892–1987)
Angel and Demons, ca. 1975
Oil on canvas board, 11 x 13.75
Collection of Susann Craig

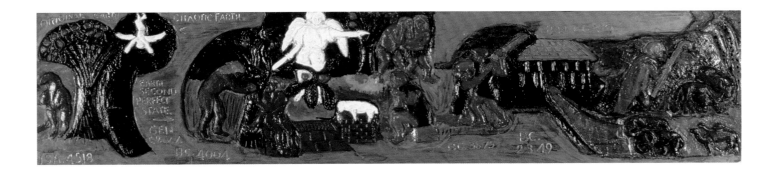

PLATE 27 Josephus Farmer (1894–1989)
Genesis, ca. 1970
Carved and painted wood relief, 11.87 x 52.5
Milwaukee Art Museum; Gift of WITI-TV,
Channel 6, Milwaukee, M1986.3

PLATE 28 Josephus Farmer (1894–1989)
The Great Exodus, 1970s
Carved and painted wood, 13.62 x 47.37 x 1.5
Collection of Robert A. Roth

PLATE 29 Howard Finster (1915 or 1916–2001)
A Feeling of Darkness #2358, 1982
Enamel on wood, 20.75 x 34.25
Arient Family Collection

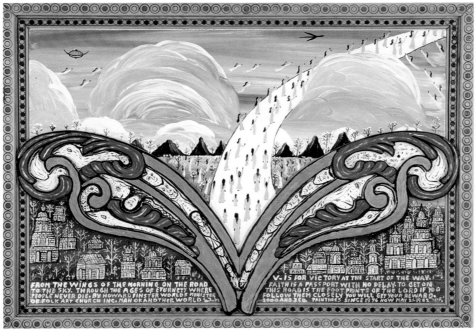

PLATE 30 Howard Finster (1915 or 1916–2001)
Days of Creation, ca. 1976
Enamel on wood, 21 x 24
Collection of Chuck and Jan Rosenak

PLATE 31 Howard Finster (1915 or 1916–2001)
From the Wings of the Morning #2354, 1982
Enamel on wood, 19.37 x 26.87
Arient Family Collection

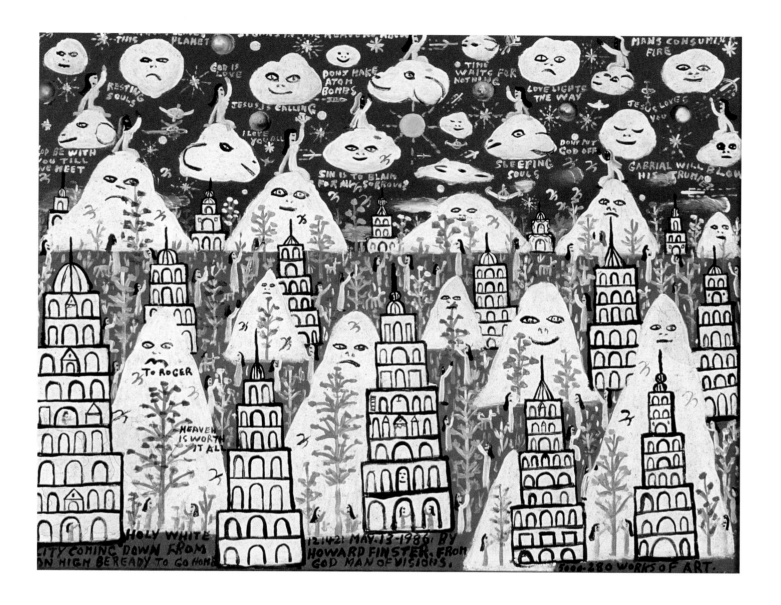

PLATE 32 Howard Finster (1915 or 1916–2001)
Holy White City Coming Down #5000.280, 1986
Enamel on wood, 15.87 x 20.12
Collection of Roger Manley

PLATE 33 Howard Finster (1915 or 1916–2001)
I Am the Angel Flying Low #3398, 1984
Paint on plywood cutout, 20.75 x 41.12
Collection of Matthew J. Arient

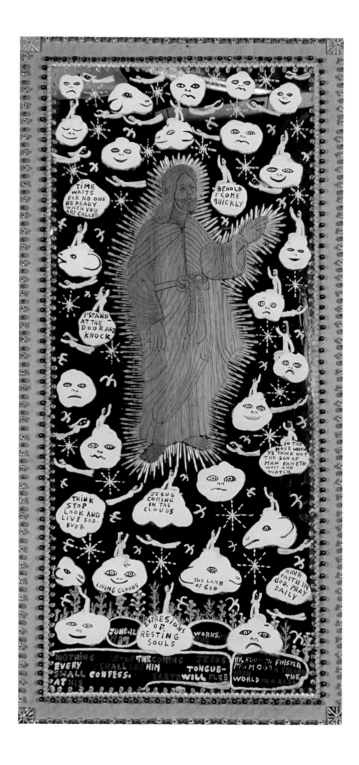

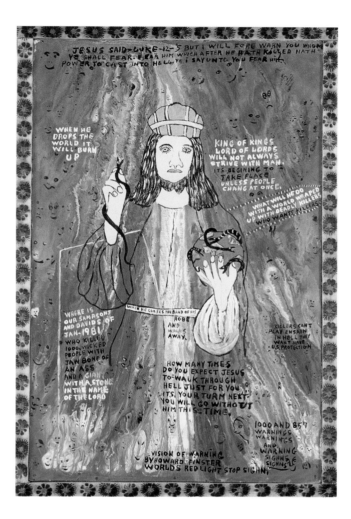

PLATE 34 Howard Finster (1915 or 1916–2001)
Jesus Coming in the Clouds #6000.653, 1987
Wood-burned cutout on mirrored plexiglass, beads,
and tractor enamel on plywood, 43.12 x 19.87
Collection of John Denton

PLATE 35 Howard Finster (1915 or 1916–2001)
King of Kings #1857, 1981
Enamel on wood, 23.5 x 15.5
Arient Family Collection

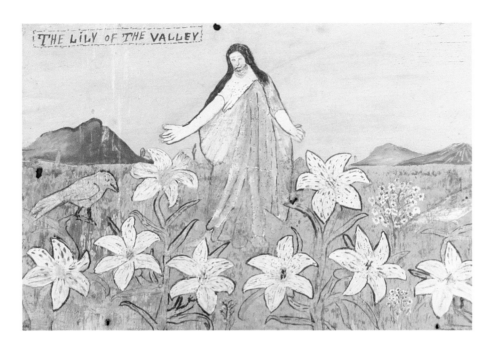

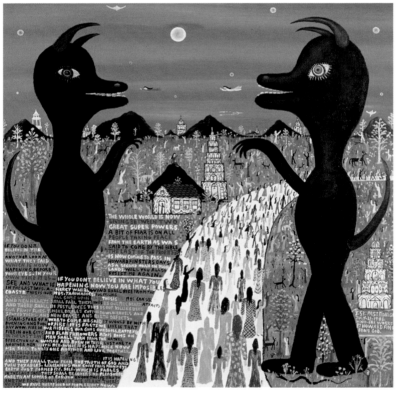

PLATE 36 Howard Finster (1915 or 1916–2001)
The Lily of the Valley, pre-1976
Acrylic and mixed media on wood, 12 x 17
City of Orlando Public Program,
The Mennello Museum of American Folk Art

PLATE 37 Howard Finster (1915 or 1916–2001)
The World Is Now Living Between Two Great Superpowers
#4000.581, 1985
Enamel on wood, 48 x 48
Collection of John Denton

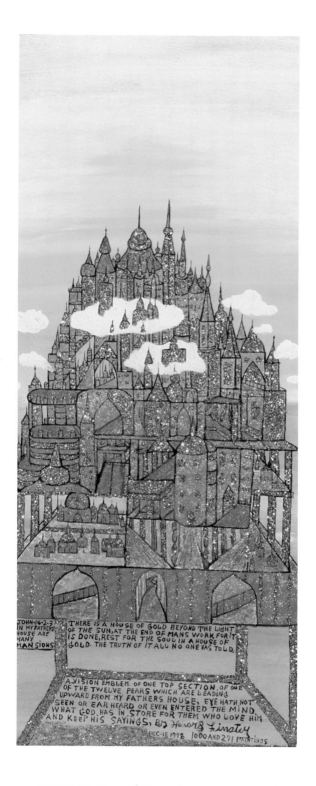

PLATE 38 Howard Finster (1915 or 1916–2001)
There Is a House of Gold #1000.271, 1978
Enamel and glitter on Masonite, 16 x 35.5
Collection of John Turner

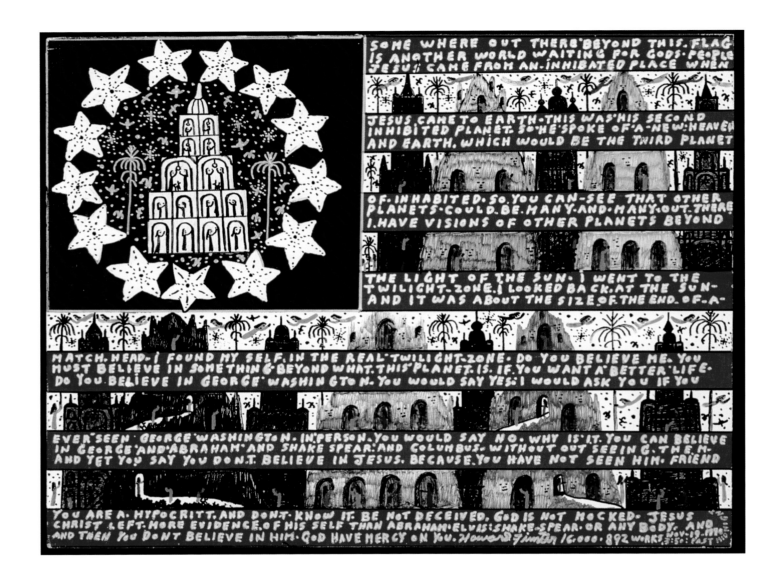

PLATE 39 Howard Finster (1915 or 1916–2001)
Visions of Other Planets #16000.892, 1990
Enamel on wood, 18.75 x 24
Collection of William C. Paley

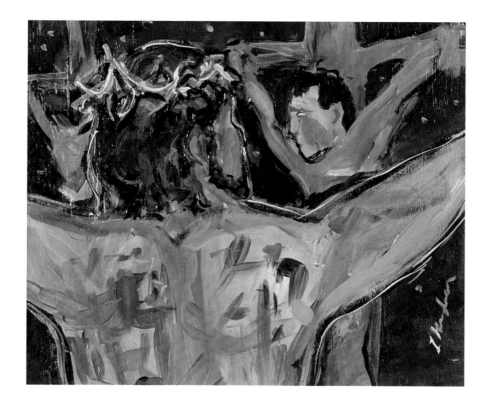

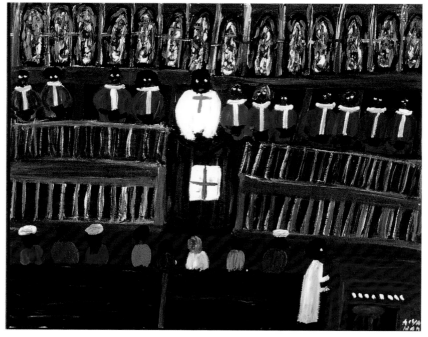

PLATE 40 Lorraine Gendron (b. 1938)

Crucifixion, 1999

Paint on wood, 14 x 16

Collection of the Artist

PLATE 41 Alyne Harris (b. 1942)

Choir of Church People—Baptist Church in the 1960s, 1994

Acrylic on canvas, 48 x 66

Collection of Mr. Donald N. Cavanaugh and Mr. Edward G. Blue

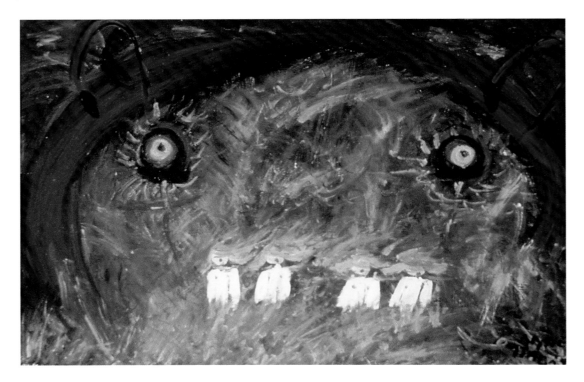

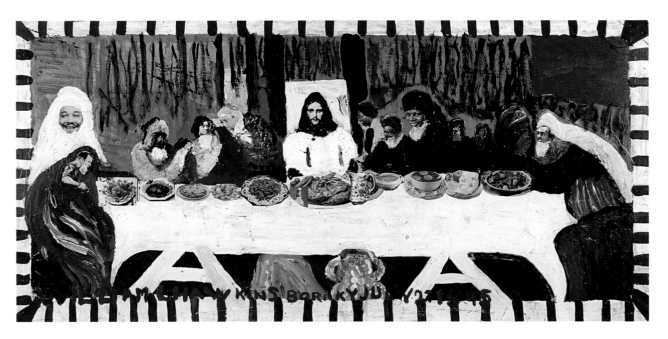

PLATE 42 Alyne Harris (b. 1942)
Devil Devouring Angels, 1987–1988
Acrylic on canvas, 24 x 36
Collection of Mr. Donald N. Cavanaugh and Mr. Edward G. Blue

PLATE 43 William Hawkins (1895–1990)
Last Supper #6, 1986
Paint with collage on plywood, 23.93 x 48
Collection of Robert A. Roth

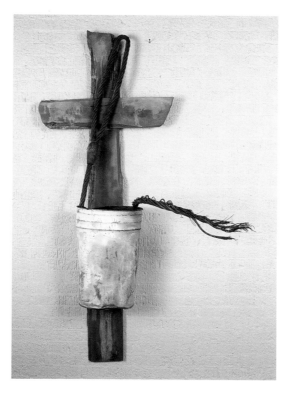

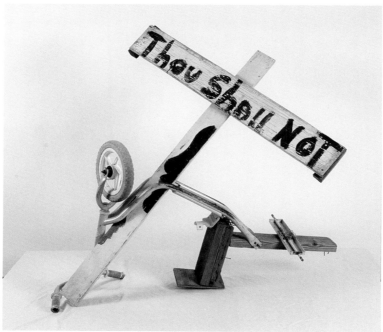

PLATE 44 Lonnie Holley (b. 1950)
9-11, The Cable That Snapped Before They Saved Me, 2001
Metal, wood, cable, and paint, 74 x 46 x 18.5
Collection of Carl and Marian Mullis

PLATE 45 Lonnie Holley (b. 1950)
Thou Shall Not, 1993
Child's scooter, wood, wire, and paint, 45 x 27 x 49
Collection of William Arnett

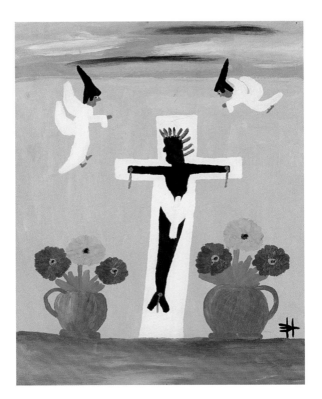

PLATE 46 Clementine Hunter (1886 or 1887–1988)
Crucifixion with Red Zinnias, 1965
Oil on canvas, 24 x 18
Collection of Jack and Ann W. Brittain and Their Children

PLATE 47 Clementine Hunter (1886 or 1887–1988)
Frenchie Goin' to Heaven, mid 1970s
Oil on board, 18 x 24
Collection of Thomas N. Whitehead

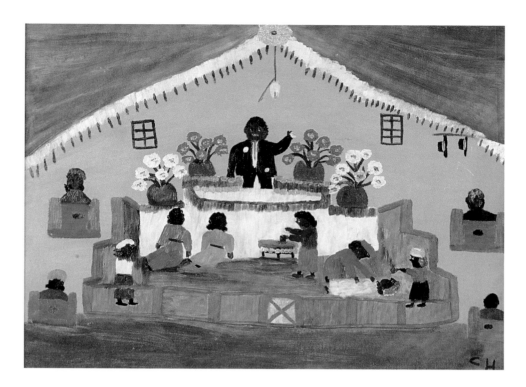

PLATE 48 Clementine Hunter, (1886 or 1887–1988)
Tent Revival, 1950s
Oil on paperboard, 18 x 24
Collection of Jack and Ann W. Brittain and Their Children

PLATE 49 Clementine Hunter (1886 or 1887–1988)
The Moon and the Stars, ca. 1980
Oil on board, 8 x 10
Collection of Thomas N. Whitehead

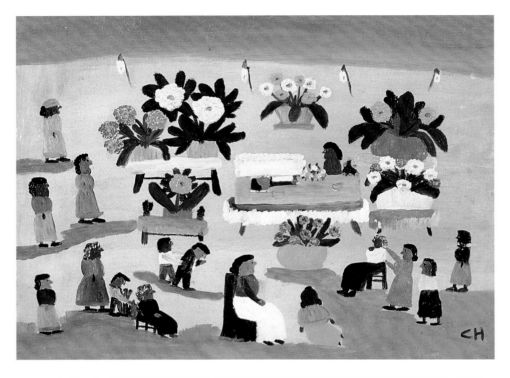

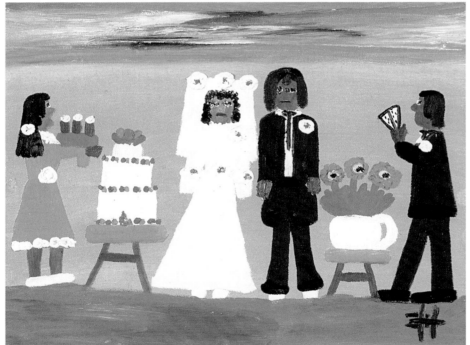

PLATE 50 Clementine Hunter (1886 or 1887–1988)
Wake, 1950
Oil on paperboard, 18 x 24
Collection of Jack and Ann W. Brittain and Their Children

PLATE 51 Clementine Hunter (1886 or 1887–1988)
Wedding, early 1970s
Oil on canvas board, 14 x 18
Collection of Thomas N. Whitehead

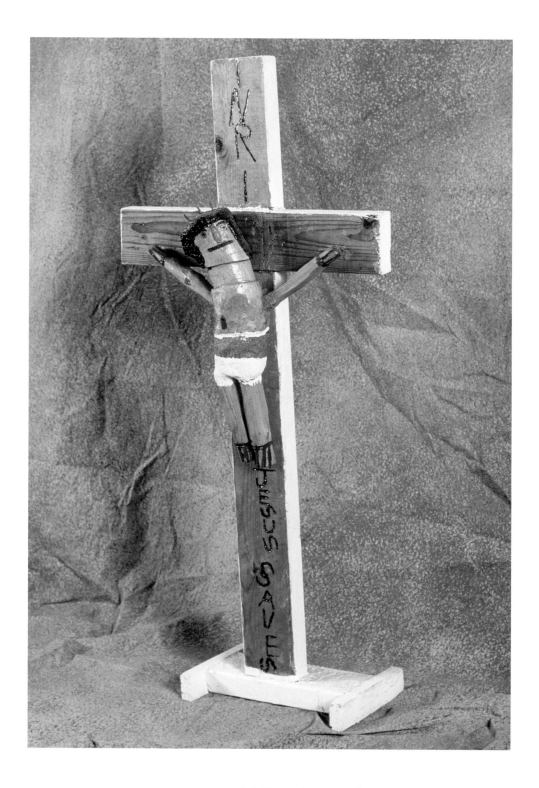

PLATE 52 J. L. Hunter (1905–1997)
Crucifixion INRI Jesus Saves, 1992
Wood, paint, nails, and glue, 38 x 16.5 x 8
Webb Gallery, Waxahachie, Texas

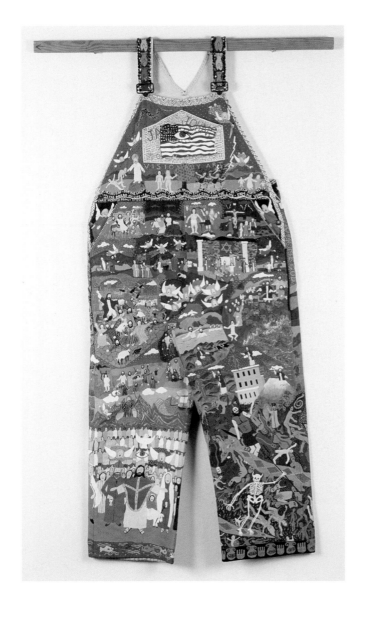

PLATE 53 J. F. Hurlbut (b. 1893–)
Tree of Life, 1935
Oil on canvas, 71 x 54.5
Jenks Memorial Collection of Adventual Materials,
Aurora University Library

PLATE 54 Jas Johns (1941–2003)
Heaven and Hell Britches, 2000–2002
Acrylic paint on overalls, 65 x 27
Collection of the Artist's Estate

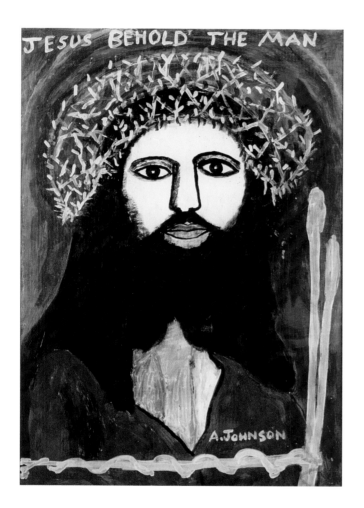

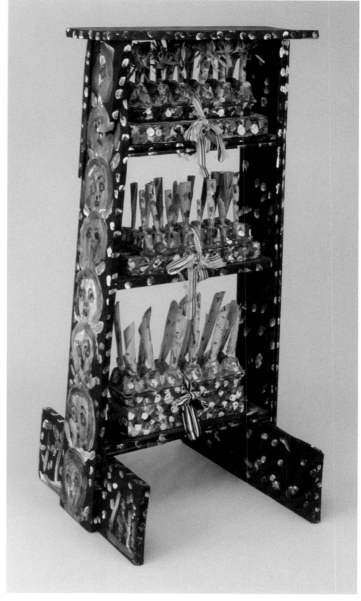

PLATE 55 Anderson Johnson (1915–1998)
Jesus: Behold the Man, 1980s
Paint on cardboard, 36 x 24
Collection of Carl and Marian Mullis

PLATE 56 Anderson Johnson (1915–1998)
Portable Pulpit, 1989
Wood, paper, plastic, rayon, metal, and house paint, 41 x 18 x 18
Collection of William and Ann Oppenhimer

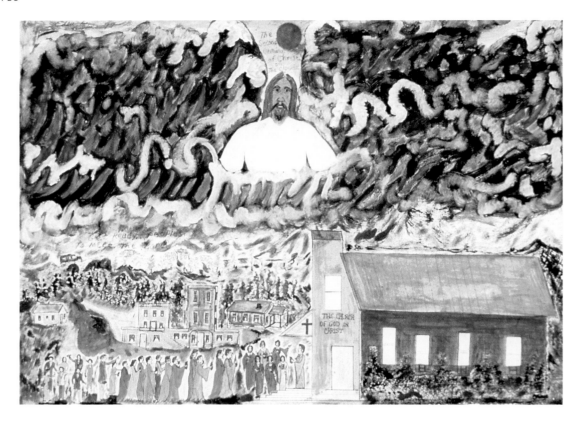

PLATE 57 Eddie Lee Kendrick (1928–1992)
The Second Coming of Christ! On the Clouds! 1977
Acrylic, ballpoint pen, colored pencil, and pencil on paper, 17.5 x 24
Collection of Joseph H. and Susan Turner Purvis

PLATE 58 George Paul Kornegay (b. 1913)
Shadrach, Meshach and Abednego, n.d.
Wood and tin, 49 x 38.5 x 2.5
Collection of Bruce and Julie Webb

PLATE 59 C. M. Laster (b. 1963) and Grace Kelly Laster (b. 1966)
There Is Only One King, 2002
Acrylic on wood, 31.72 x 21.31
Collection of Katherine and Thomas LoBianco

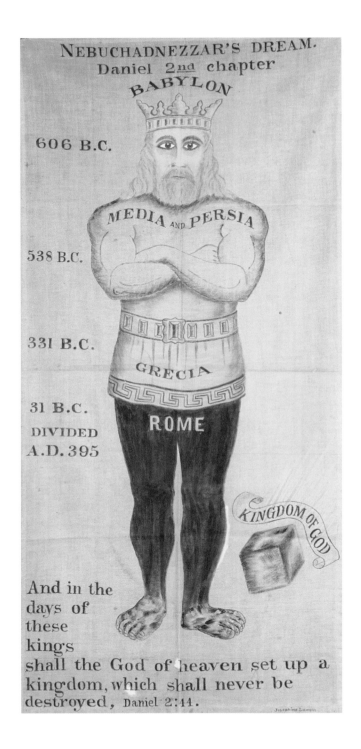

PLATE 60 Josephine Lawson (1866–1963)
Prophecy Chart, Colossus of Daniel 2, 1917
Oil, tempera, and ink on cotton muslin, 42.5 x 20
Jenks Memorial Collection of Adventual Materials,
Aurora University Library

PLATE 61 Tim Lewis (b. 1952)
Garden of Eden, after 1988
Carved stone, 19 x 20.5 x 7.25
Collection of John and Teenuh Foster

PLATE 62 Joe Light (b. 1934)
The God of Israel, Abraham and Moses, 1997
Paint on door, 32 x 89
Collection of Craig Wiener

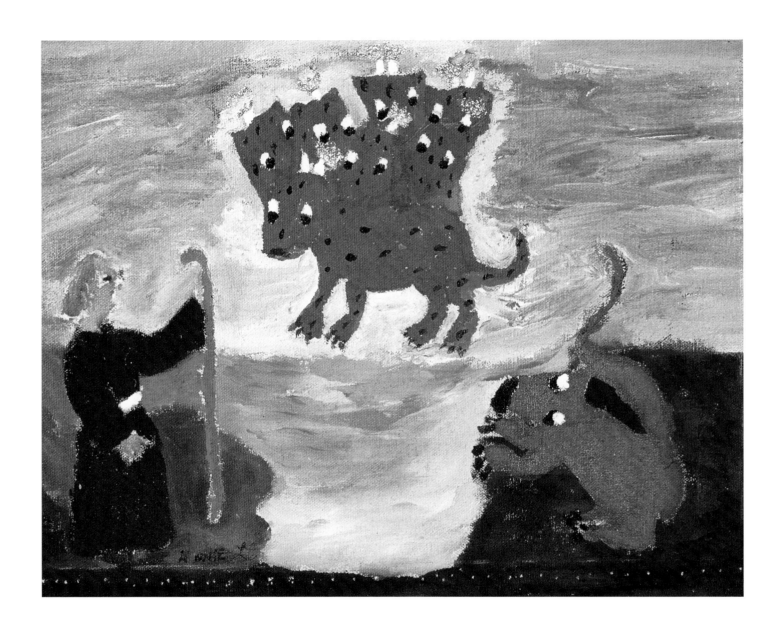

PLATE 63 Annie Lucas (b. 1954)
Beast Out of the Sea, n.d.
Acrylic and glitter on canvas, 12.5 x 15.5
Private Collection

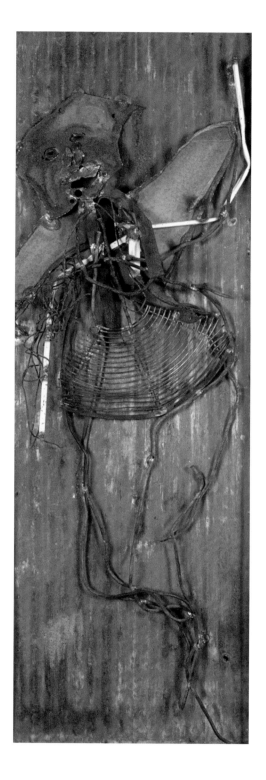

PLATE 64 Charlie Lucas (b. 1951)
Green Angel, ca. 1980 or early 1990s
Metal and wood, 72 x 28 x 9
Collection of Carl and Marian Mullis

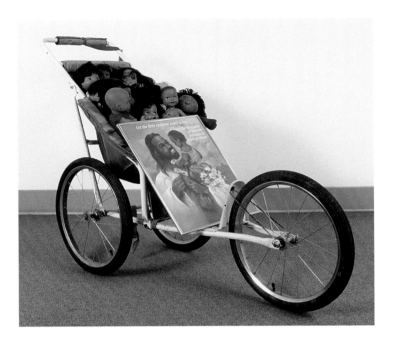

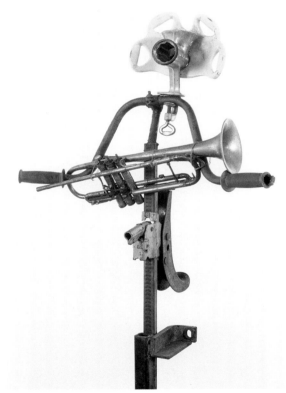

PLATE 65 Joe Minter (b. 1943)
Jesus Loves the Little Children, 2000
Baby stroller, dolls, lithograph of Jesus,
and other found objects, 40 x 22 x 62
Collection of the Artist

PLATE 66 Joe Minter (b. 1943)
The Last Trumpet detail, 2001
Found objects, dimensions variable (3 pieces), 70 x 99.5 x 24
Collection of the Artist

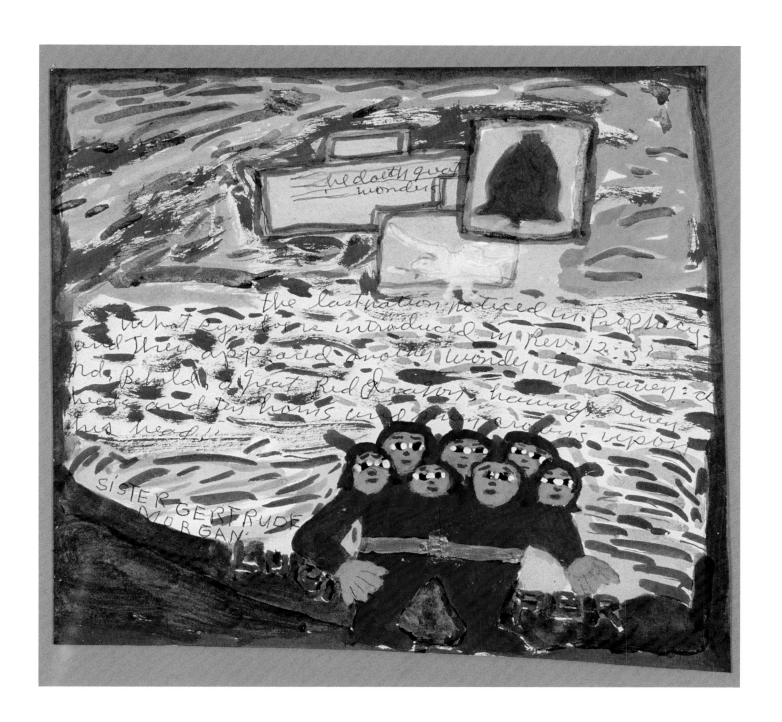

PLATE 67 Sister Gertrude Morgan (1900–1980)
He Doth Great Wonders, ca. 1970
Pen, watercolor, and gouache on paper, 11 x 12
Collection of Robert A. Roth

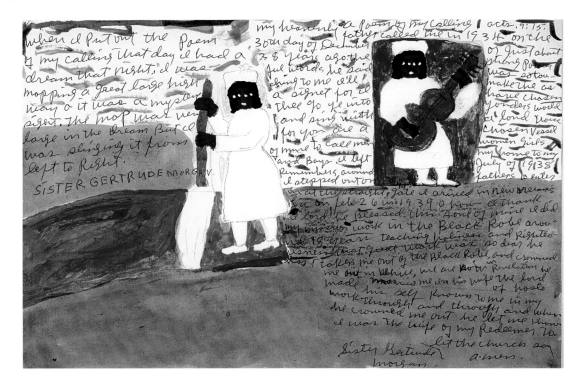

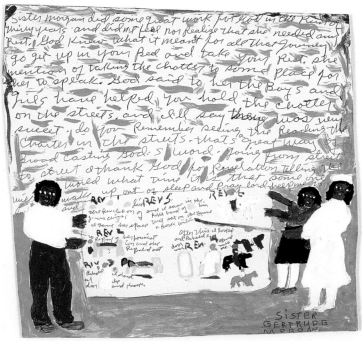

PLATE 68 Sister Gertrude Morgan (1900–1980)
Poem of My Calling, 1972
Acrylic and ink, 10 x 15
Collection of Susann Craig

PLATE 69 Sister Gertrude Morgan (1900–1980)
Sister Morgan Did Some Great Work, ca. 1970
Gouache and ballpoint pen on cardboard, 12 x 11.75
Collection of Robert A. Roth

PLATE 70 John "J. B." Murray (1905–1988)
Untitled (Purple and Green), 1987
Acrylic paint stick on paper, 24 x 18
Collection of Dan and Kristi Cleary

PLATE 71 John "J. B." Murray (1905–1988)
Untitled (Cross), 1987
Acrylic paint stick on paper, 24.87 x 17.87
Collection of Dan and Kristi Cleary

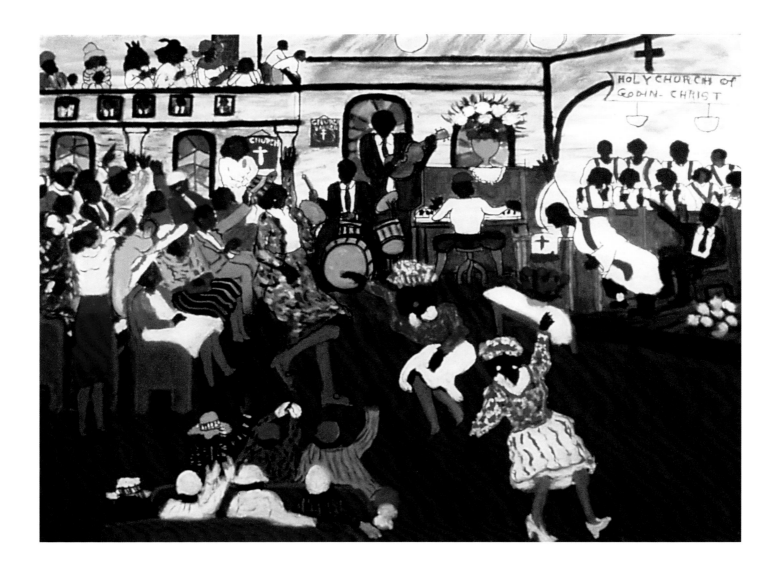

PLATE 72 Charlie A. Owens (1922–1997)
Holy Church of God-in-Christ, n.d.
Tempera and marker on Masonite panel, 36 x 48
Columbus Museum of Art, Ohio; Gift of Lindsay Gallery
and Austin T. Miller American Antiques, Inc.

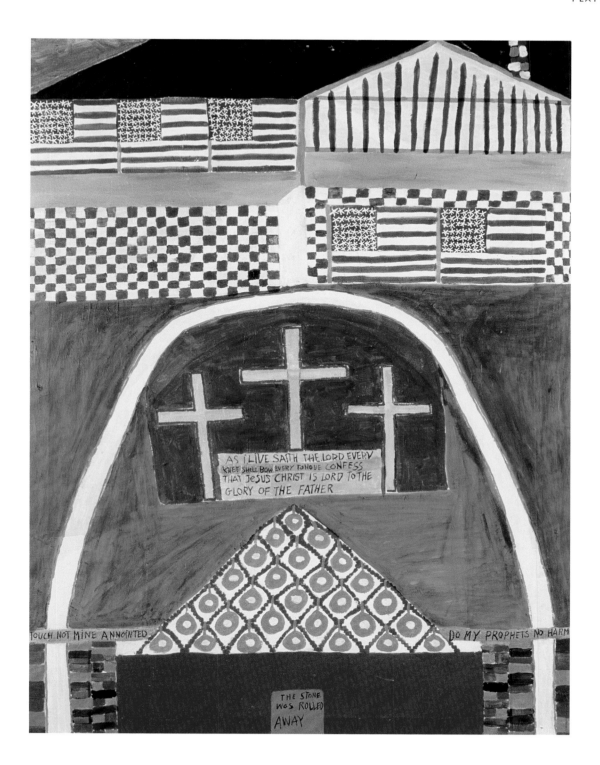

PLATE 73 Benjamin "B. F." Perkins (1904–1993)
Homeplace, ca. 1985
Paint on canvas, 48.5 x 36.12
Collection of Carl and Marian Mullis

PLATE 74 Benjamin "B. F." Perkins (1904–1993)
Jesus Is the Light of the World, n.d.
Paint on canvas, 22 x 34
Collection of Dan and Kristi Cleary

PLATE 75 Benjamin "B. F." Perkins (1904–1993)
May We All Let Jesus Come into Our Harts, before 1987
Paint on plywood panel, 24.25 x 47.75
Robert Cargo Folk Art Gallery, Tuscaloosa,
Alabama, and Paoli, Pennsylvania

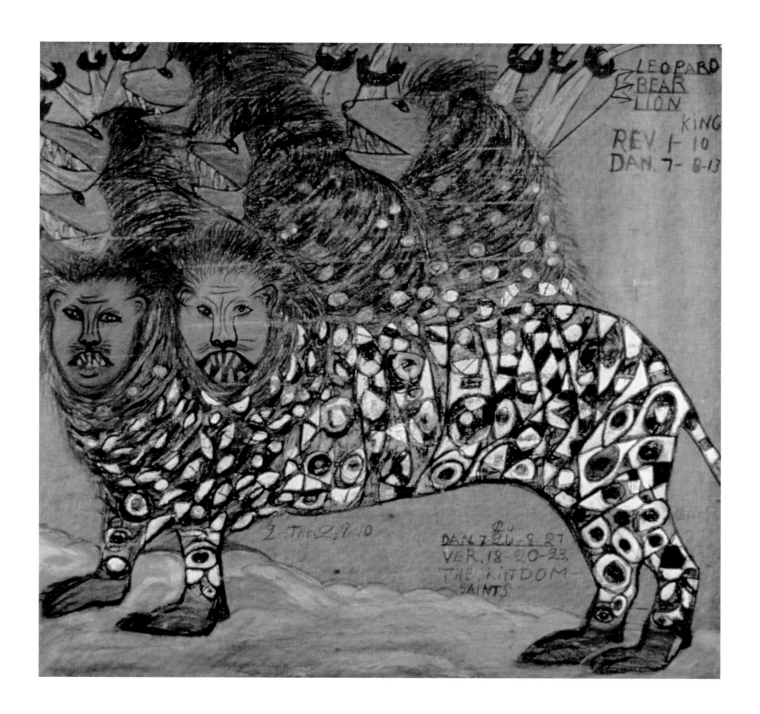

PLATE 76 Samuel David Phillips (1890–1973)
Beast of the Sea (Rev. 13:1–2), ca. 1950
Pencil, crayon, and water-based paint on oilcloth, 45 x 47
Collection of Jan Petry

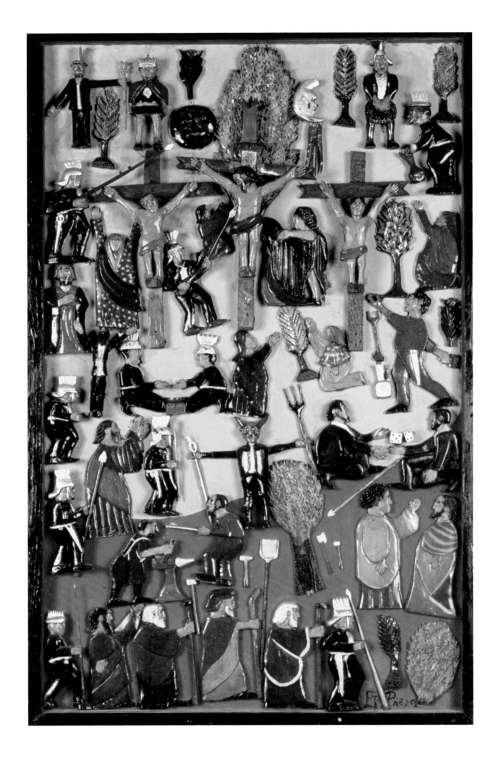

PLATE 77 Elijah Pierce (1892–1984)
Crucifixion, mid-1930s
Carved and painted wood with glitter, mounted on painted panel, 47.5 x 30.5
Columbus Museum of Art, Ohio; Museum Purchase, 1985.003.001

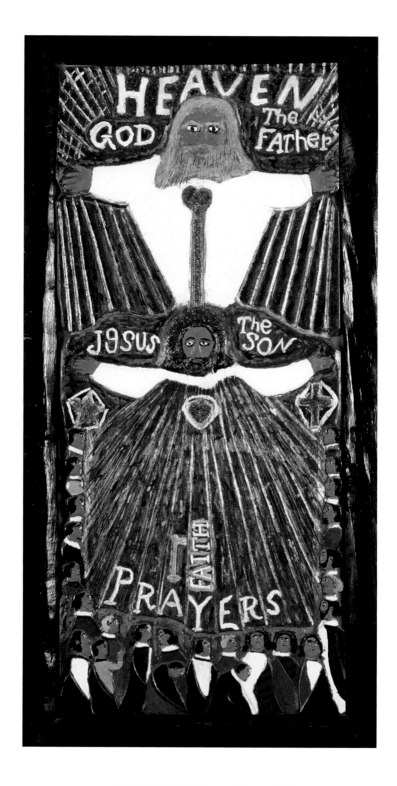

PLATE 78 Elijah Pierce (1892–1984)
The Power of Praying, 1960
Carved and painted wood relief with glitter, 40.5 x 19.5
Collection of John and Teenuh Foster

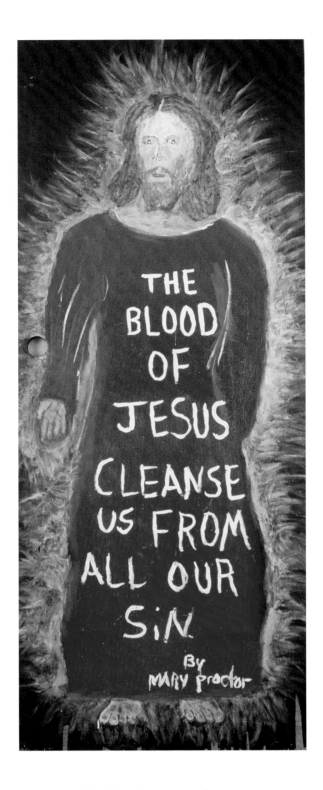

PLATE 79 Mary Proctor (b. 1960)
The Blood of Christ, n.d.
Paint on door, 79.75 x 31.75
Collection of Gunny Yawn

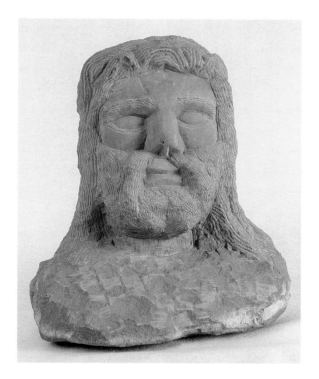

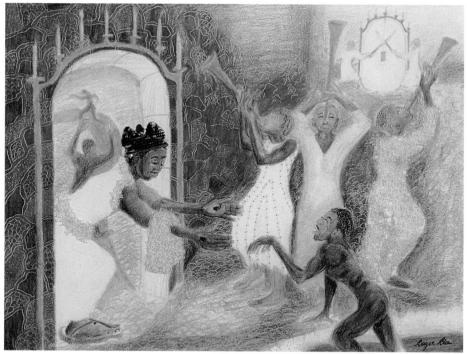

PLATE 80 Ernest "Popeye" Reed (1916–1985)
Bust of Christ, ca. 1980
Carved sandstone, 11 x 9 x 6.5
Collection of Randall Lott and Nancy McCall

PLATE 81 Roger Rice (b. 1958)
Homecoming, 1995
Colored pencil on paper, 11 x 14
Robert Cargo Folk Art Gallery, Tuscaloosa,
Alabama, and Paoli, Pennsylvania

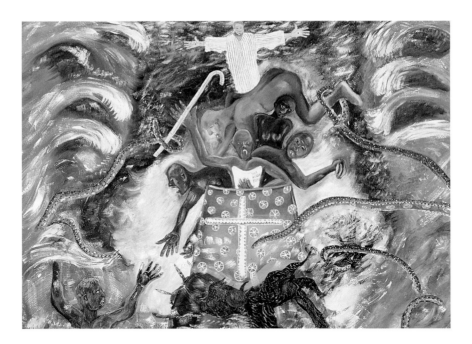

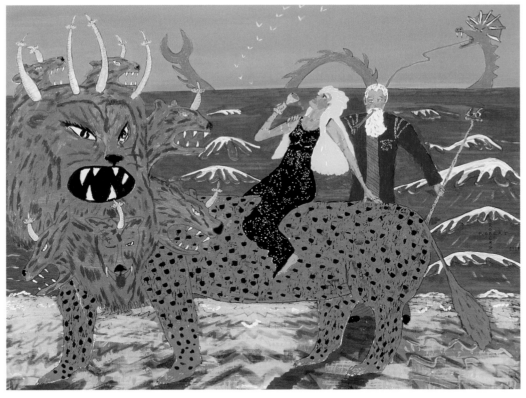

PLATE 82 Roger Rice (b. 1958)
Gospel Train, ca. 1988
Oil on canvas, 29.75 x 39. 87
Robert Cargo Folk Art Gallery, Tuscaloosa, Alabama,
and Paoli, Pennsylvania

PLATE 83 Robert Roberg (b. 1943)
*The Whore of Babylon Riding on a Beast
with Seven Heads*, ca. 1991
Acrylic and glitter on canvas, 30 x 40
Collection of Chuck and Jan Rosenak

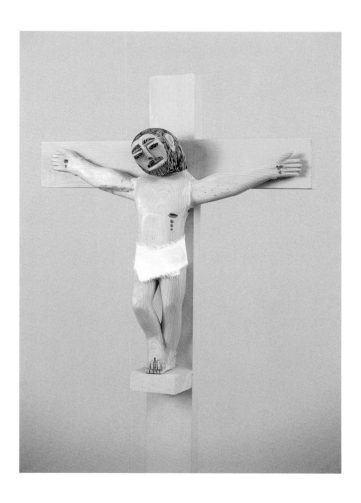

PLATE 84 Sultan Rogers (1922–2003)
Crucifixion, n.d.
Paint on wood, 52 x 12.5
Collection of John and Teenuh Foster

PLATE 85 Sultan Rogers (1922–2003)
Preacher, 2001
Paint on wood, 12.5 x 5.12 x 7.12
Arient Family Collection

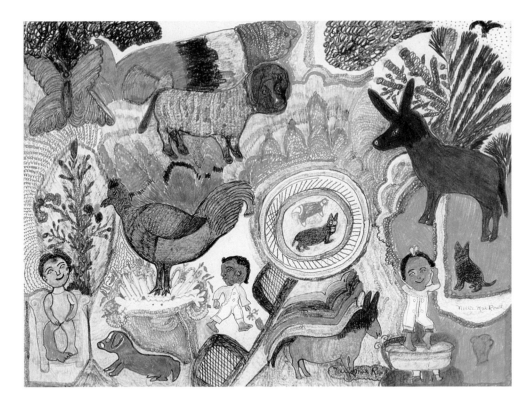

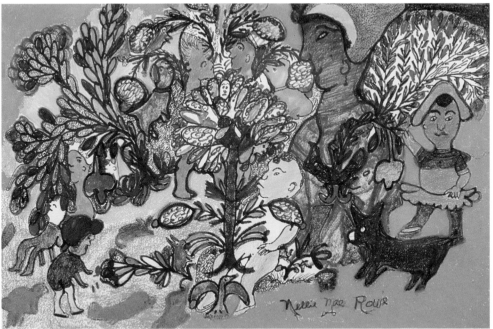

PLATE 86 Nellie Mae Rowe (1900–1982)
Untitled (Creation), 1979
Felt tip pen, ballpoint pen, and colored pencils
on paper, 27.5 x 32.25
Collection of Sally and Paul Hawkins

PLATE 87 Nellie Mae Rowe (1900–1982)
Tree of Life, 1979
Crayon, felt tip pen, and watercolor on paper, 14.12 x 20
Collection of Marianne and Richard Lambert

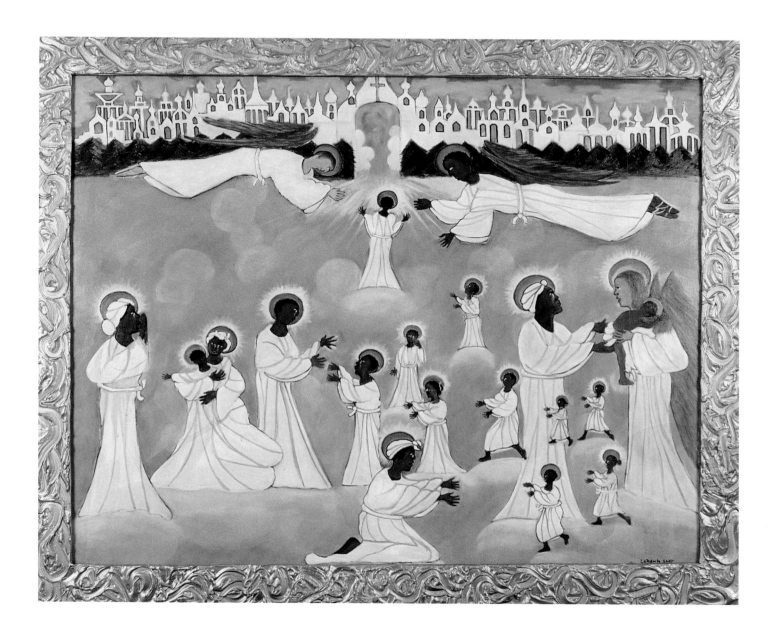

PLATE 88 Lorenzo Scott (b. 1922)
Reunion in Heaven (of the "House of Prayer Children"), 2001–2002
Oil on canvas in artist decorated frame, 55.5 x 66.5
Collection of Jim Farmer and Scott Fields

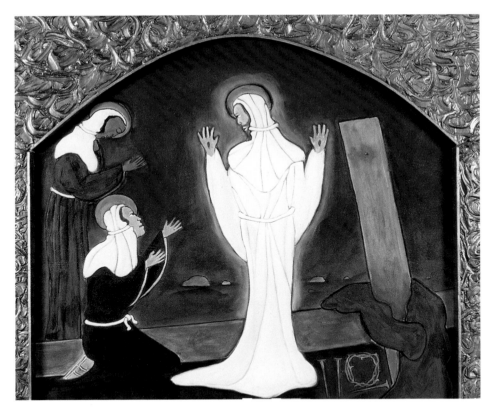

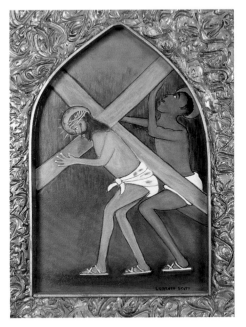

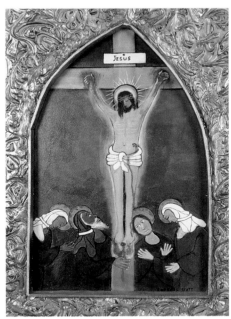

PLATES 89A, 89B, 89C Lorenzo Scott (b. 1922)
Triptych with Christ Carrying the Cross, Resurrection, Crucifixion, ca. 1997
Oil on canvas in artist decorated frames, 34 x 23.5; 47 x 48; 34 x 23.5
Collection of Jim Farmer and Scott Fields

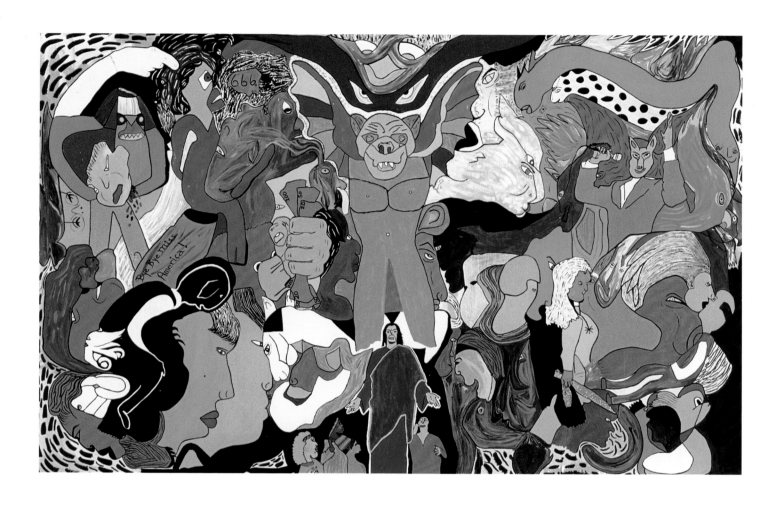

PLATE 90 Cherry ShaEla'ReEl (b. 1956)
Beast 666, 1998
Acrylic paint with poly coating on wood glittered frame, 29 x 41
Webb Gallery, Waxahachie, Texas

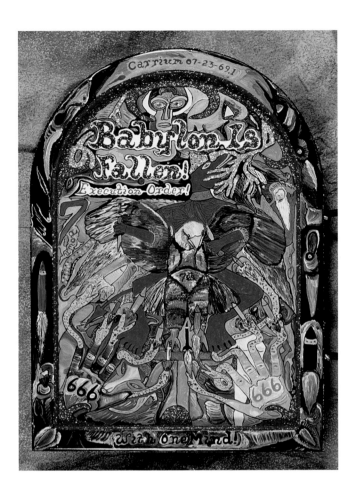

PLATE 91 Xmeah ShaEla'ReEl (b. 1943)
Babylon Is Fallen!, ca. 1996
Acrylic, polyurethane, and glitter on wood, 40.5 x 28
Webb Gallery, Waxahachie, Texas

PLATE 92 Jim Shores (b. 1952)
Taking up Serpents, Speaking in Tongues,
Singing God's Praises, 2003
Found objects, 76 x 24 x 40
Collection of Carl and Marian Mullis

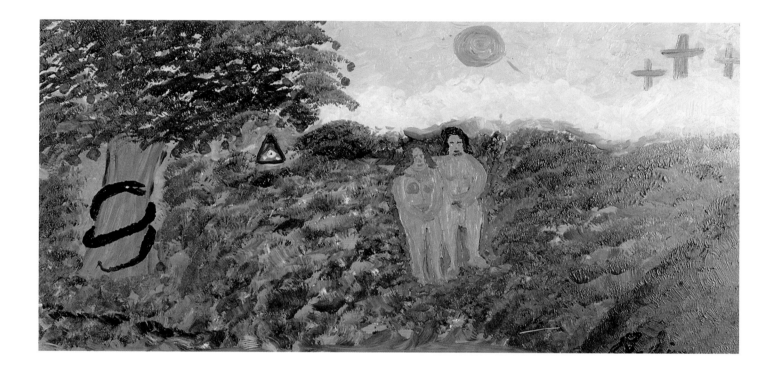

PLATE 93 Bernice Sims (b. 1926)
Adam and Eve, 1992
Oil on wallboard, 15.25 x 30.25
Robert Cargo Folk Art Gallery, Tuscaloosa, Alabama,
and Paoli, Pennsylvania

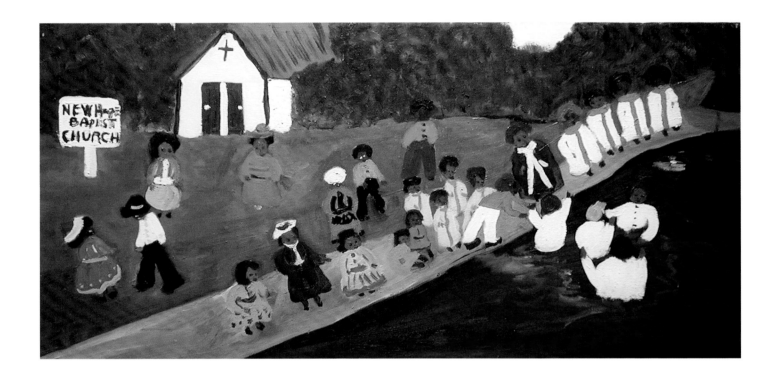

PLATE 94 Bernice Sims (b. 1926)
New Hope Baptist Church Baptism, ca. 1988
Oil on canvas, 15 x 30
Robert Cargo Folk Art Gallery, Tuscaloosa, Alabama,
and Paoli Pennsylvania

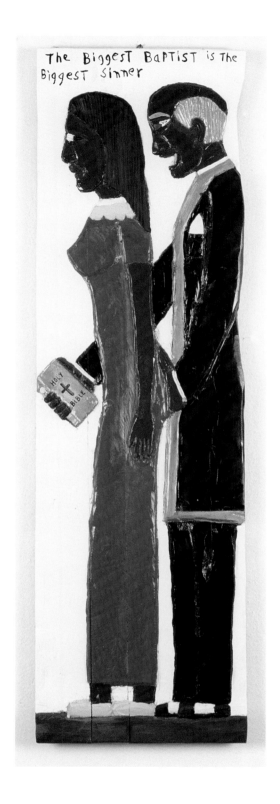

PLATE 95 Herbert Singleton (b. 1945)
The Biggest Baptist Is the Biggest Sinner, 1998
Carved and painted wood relief, 53 x 15.5 x 1.62
Collection of Robert A. Roth

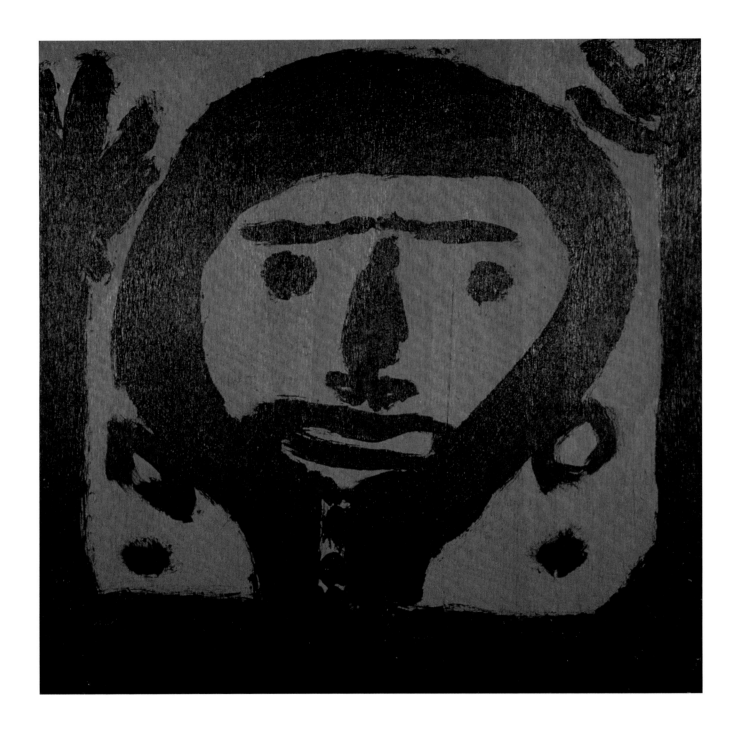

PLATE 96 Mary T. Smith (1904 or 1905–1995)
Hallelujah Lady, 1987
Paint on plywood, 23.25 x 24
Collection of Dan and Kristi Cleary

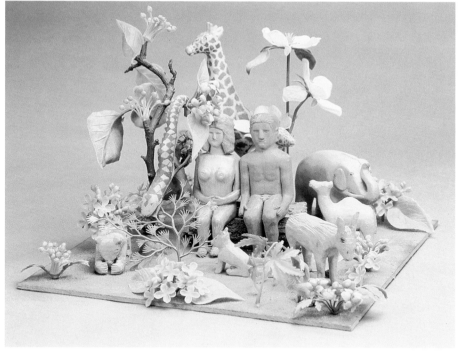

PLATE 97 Hugo Sperger (1922–1996)
Creation, 1977
Acrylic on board, 72 x 48
Collection of George and Sue Viener

PLATE 98 Lawrence Stinson (1906–1998)
Garden of Eden, 1975
Plywood, driftwood, plastic flowers, and paint, 9.5 x 13 x 14
Collection of Chuck and Jan Rosenak

PLATE 99 Jimmy Lee Sudduth (b. 1910)
Christ, 1986
House paint and earth pigments on plywood panel, 43.5 x 12.25
Robert Cargo Folk Art Gallery, Tuscaloosa, Alabama,
and Paoli, Pennsylvania

PLATE 100 Jimmy Lee Sudduth (b. 1910)
Devil, 1986
Earth pigments and chalk on plywood panel, 19.5 x 18.25
Robert Cargo Folk Art Gallery, Tuscaloosa, Alabama,
and Paoli, Pennsylvania

PLATE 101 Johnnie Swearingen (1908–1993)
God Loves You, 1991
Oil on canvas, 33 x 41.5
Collection of Stephanie and John Smither

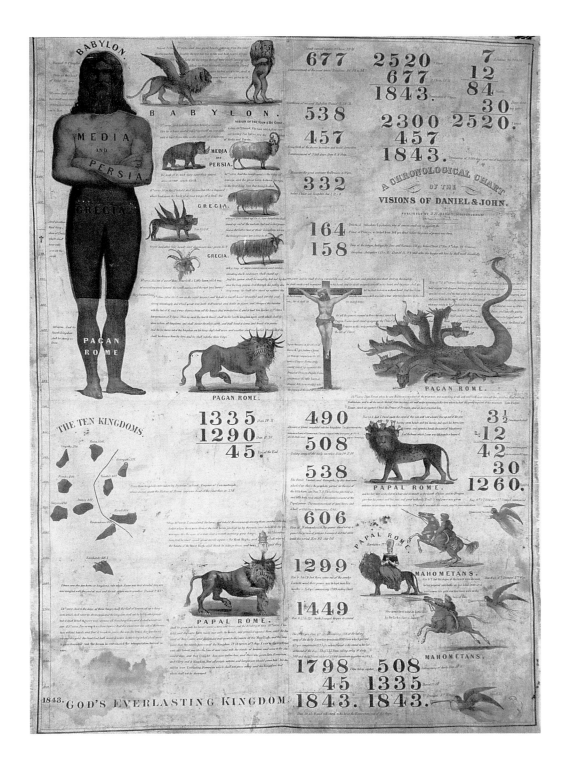

PLATE 102 B. W. Thayer & Company

Millerite Chart of 1843, 1842

Ink on canvas, 55.5 x 38.5

Jenks Memorial Collection of Adventual Materials,

Aurora University Library

PLATE 103 William Thomas Thompson (b. 1935)
Faithful and True (Christ of the Second Coming), 2001
Acrylic on linen, 48 x 36
Collection of the Artist

PLATE 104 William Thomas Thompson (b. 1935)
Whore of Babylon, 2003
Acrylic on linen, 24 x 18
Collection of Mary M. Stiritz

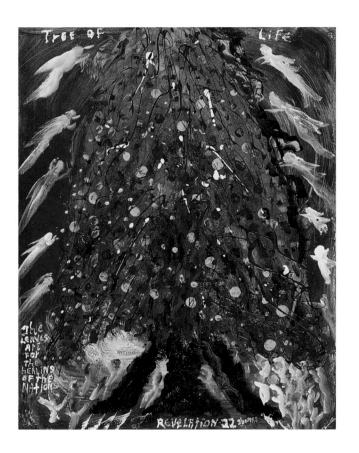

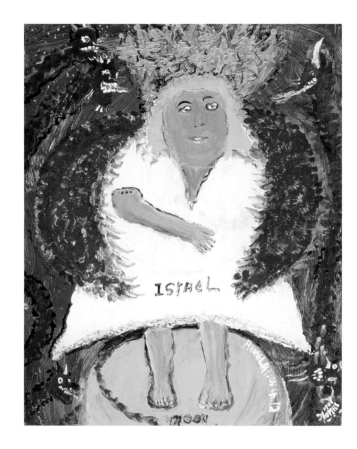

PLATE 105 William Thomas Thompson (b. 1935)
Tree of Life, 2001
Acrylic on linen, 48 x 36
Collection of the Artist

PLATE 106 William Thomas Thompson (b. 1935)
Woman Standing on the Moon, 2001
Acrylic on linen, 48 x 36
Collection of the Artist

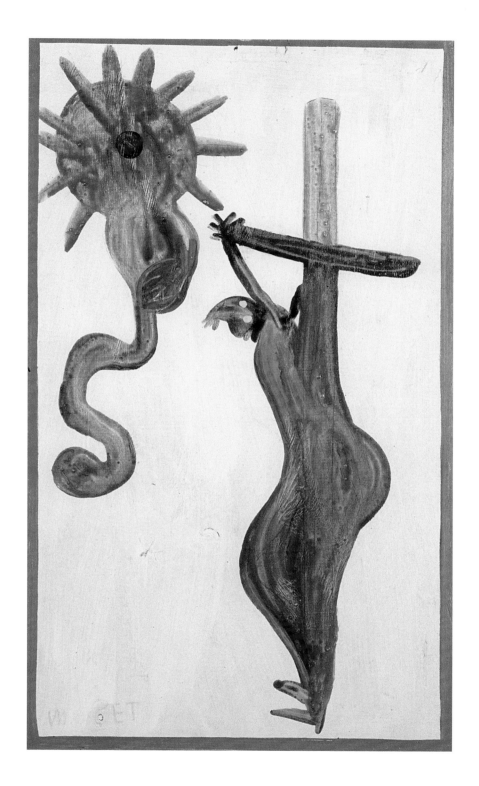

PLATE 107 Mose Tolliver (b. ca. 1919)
Crucifixion, 1985
House paint on plywood panel, 24.25 x 14.25
Robert Cargo Folk Art Gallery, Tuscaloosa, Alabama,
and Paoli, Pennsylvania

PLATE 108 Edgar Tolson (1904–1984)
Crucifixion, 1969
Carved and assembled wood, 19.5 x 17
Milwaukee Art Museum; The Michael and Julie Hall Collection
of American Folk Art, M1989.321

PLATE 109 Edgar Tolson (1904–1984)
Temptation, ca. 1970
Wood and paint, 13 x 9.25 x 7.25
Kentucky Folk Art Center, 1993.5.3

PLATE 110 Unknown Artist
Bible Pedestal, n.d.
Carved wood, 13 x 15.37 x 12.75 (dimensions with cover)
Collection of John and Teenuh Foster

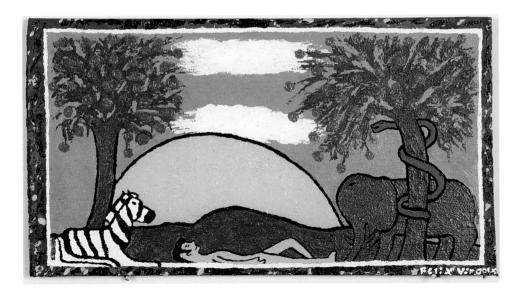

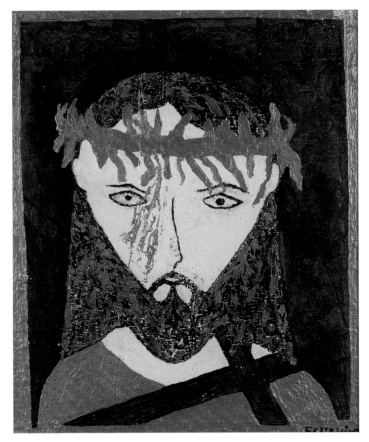

PLATE 111 Felix Virgous (b. 1948)
Adam in Paradise, n.d.
Acrylic on panel, 11.87 x 20.75
Robert Cargo Folk Art Gallery, Tuscaloosa, Alabama,
and Paoli, Pennsylvania

PLATE 112 Felix Virgous (b. 1948)
Head of Christ, 1993
Acrylic on plywood, 18 x 14.5
Robert Cargo Folk Art Gallery, Tuscaloosa, Alabama,
and Paoli, Pennsylvania

PLATE 113 Fred Webster (1911–1998)
Adam Please Take This Fruit, ca. 1985
Carved and painted wood, 12 x 9 x 7.5
Robert Cargo Folk Art Gallery, Tuscaloosa, Alabama,
and Paoli, Pennsylvania

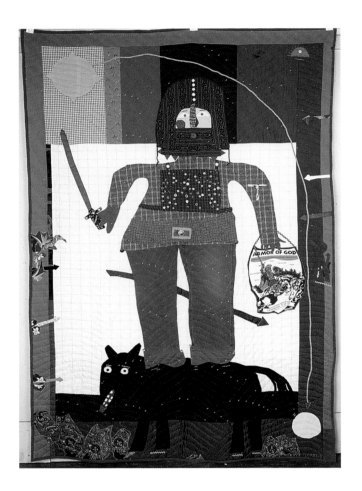

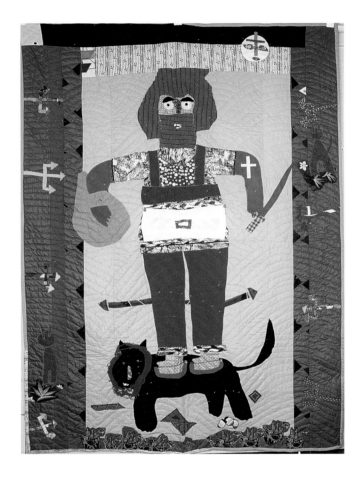

PLATE 114 Yvonne Wells (b. 1939)
The Whole Armor of God I, 1995
Cotton, cotton blend, metallic fabric, yarn,
and buttons, 100 x 71.25
Robert Cargo Folk Art Gallery, Tuscaloosa, Alabama, and Paoli,
Pennsylvania, and courtesy of the Artist

PLATE 115 Yvonne Wells (b. 1939)
The Whole Armor of God III, 1997
Cotton, cotton blend, and iron-on appliqué, 101 x 68
Robert Cargo Folk Art Gallery, Tuscaloosa, Alabama,
and Paoli, Pennsylvania, and courtesy of the Artist

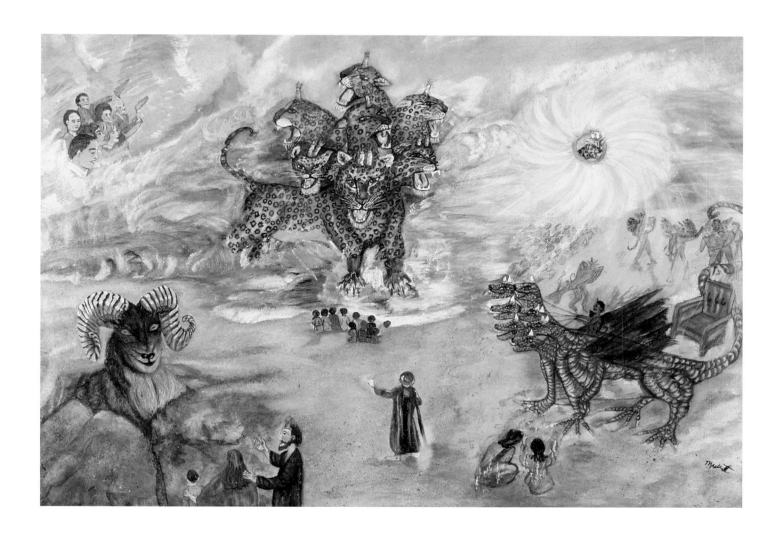

PLATE 116 Myrtice West (b. 1923)
Beast Out of the Sea (#7 in the Revelations Series), 1980s
Oil on wood, 27.5 x 39.5
Collection of Robert A. Roth

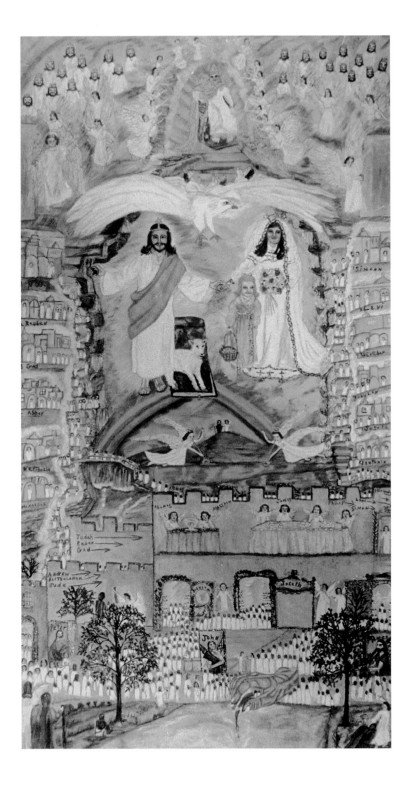

PLATE 117 Myrtice West (b. 1923)
Christ and Bride Coming into Wedding
(#13 in the Revelations Series), 1980s
Oil on canvas, 33 x 64.5
Collection of Tamara and Rollin Riggs

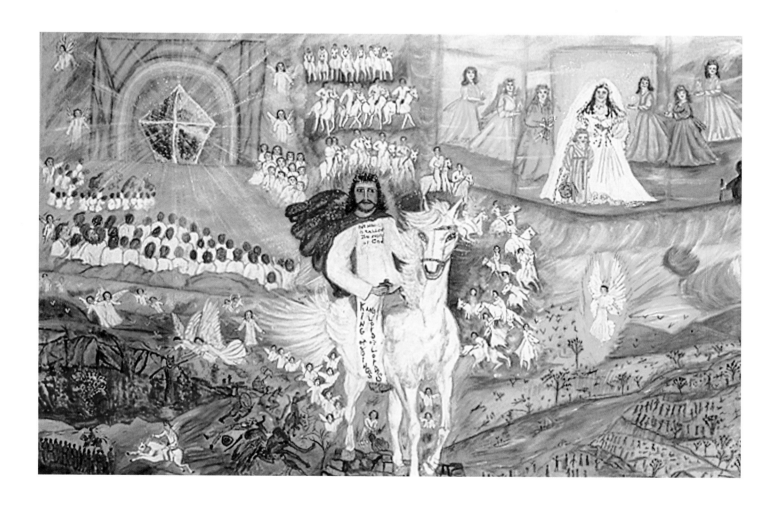

PLATE 118 Myrtice West (b. 1923)
Christ Returns as Church Gets Ready;
King of Kings and Lord of Lords (#11 in the Revelations Series), 1980s
Oil on canvas, 50.5 x 34.25
Collection of Tamara and Rollin Riggs

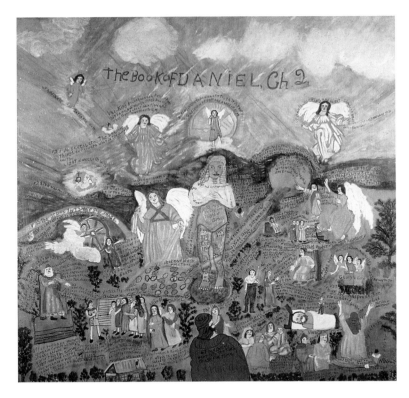

PLATE 119 Myrtice West (b. 1923)
Daniel: Chapter 2, 1997
Oil on wood, 49.75 x 49.5
Collection of Tamara and Rollin Riggs

PLATE 120 Myrtice West (b. 1923)
Satan Takes Over (#8 in the Revelations Series), 1980s
Oil on wood, 27.5 x 39.5
Collection of Robert A. Roth

PLATE 121 "Artist Chuckie" Williams (1957–1999)
Our Savior Lord Christ, 1985–1990
Paint on poster board, 22 x 28
Robert Cargo Folk Art Gallery, Tuscaloosa, Alabama,
and Paoli, Pennsylvania

PLATE 122 Purvis Young (b. 1943)
Black Jesus, 1974
Paint on wood, 31 x 40
Skot Foreman Fine Art, Atlanta, Georgia

Notes on the Artists

Information in these notes derives from interviews with the artists and/or family members or close friends, unpublished sources, especially the files in the Jenks Collection of Adventual Materials at Aurora University in Aurora, Illinois, and published sources or general encyclopedias, such as Chuck and Jan Rosenak's *Encyclopedia of Twentieth-Century American Folk Art and Artists* or Betty-Carol Sellen's *Self-Taught, Outsider, and Folk Art*. Wherever possible, religious affiliations have been stated.

Jesse Aaron
1887–1979
Active: Gainesville, Florida
Evangelical Protestant. Unaffiliated
Jesse Aaron, who at one time attended the Church of God in Christ, preferred not to affiliate with one denomination. The son of a former slave, he had black, white, and Seminole forebears. At the age of eighty-one, when he lost his business and turned to God for help, " . . . the Spirit woke me up and said, 'carve wood.'" Using chainsaws, Aaron roughed out the human or animal forms he saw within the wood (preferably cedar or cypress). While his pieces, like *Crucifixion*, often have an unfinished appearance, they express a powerful spiritual presence. C. C.

Sarah Albritton
b. 1936
Active: Ruston, Louisiana
Baptist
Sarah Albritton's memory paintings of Southern rural life comment on social and political ills and deal with painful childhood incidents. She also represents religious subjects, such as her somber *Crucifixion*. It illustrates Matt. 27:51, which recounts the tearing of the curtain of the Temple when Jesus died in the midst of a violent storm and earthquake. Albritton, who grew up in a Missionary Baptist church and holds a theology degree, equates the Crucifixion story with her own experience of being saved. (Roach, *On My Way*, 88.) C. C.

Leroy Almon, Sr.
1938–1997
Active: Talapoosa, Georgia
Evangelical Protestant. Unaffiliated
Leroy Almon, Sr., was born in Tallapoosa, Georgia. He met the great self-taught artist Elijah Pierce in Columbus, Ohio, when he moved there to work for Coca-Cola. Almon became Pierce's apprentice, first collaborating and then making his own works of art. Returning to Georgia, he worked as a police radio dispatcher and became a nondenomina-tional evangelical preacher. Like Pierce, Almon is famous for his painted bas-relief depictions of African American life and religious imagery. C. C.

Linda Anderson
b. 1941
Active: Clarksville, Georgia
Presbyterian
Now a Presbyterian, Linda Anderson attended the Fire-Baptized Holiness Church as a child. Founded in 1895, this denomination, which later merged with the Pentecostal Holiness Church, International, believed that the conversion experience is followed by a "Second Blessing," signifying a state of perfect love and a "Third Blessing," or "baptism by fire," evidenced by speaking in tongues. This is the subject of Anderson's *Mount Vernon Fire Baptized Holiness Church*. Anderson believes that God inspires her to paint biblical subjects, such as the Garden of Eden and Paradise, and her memories of everyday life in the Appalachian countryside. J. B.

George E. Bingham
1884–1957
Active: Portland, Oregon
Advent Christian
Born in Worcester, Massachusetts,

George Bingham studied art in New York City and taught drawing at the YMCA. He later moved to Portland, Oregon, where he owned a frame shop and worked as a freelance artist, designing cartoons and drawings for book illustrations. He also made prophecy charts like the one featured in *Coming Home!* Although Bingham was neither a Southerner nor a self-trained artist, his art belongs to the same religious tradition that sparked the prophecy art of many Southerners. His work, which is densely packed with apocalyptic motifs, demonstrates the continuity and widespread use of such imagery. C. C.

Henrietta Black

1900–1971
Active: Kansas City, Kansas
Advent Christian

Henrietta Black took classes at the Kansas City Art Institute and worked at Hallmark Cards as a professional artist. She also made banners illustrating biblical prophecies for A. P. Ferrell, a pastor in the Advent Christian Church and a traveling evangelist. Like the works of self-taught artists in *Coming Home!*, Black's banner belongs to a long tradition of prophecy charts initiated in the nineteenth century by the Millerites. Her banners, however, are far less diagrammatic than traditional banners and demonstrate such learned artistic techniques as modeling and perspective. C. C.

William Alvin Blayney

1917–1986
Active: Thomas, Oklahoma
Pentecostal

William Blayney grew up in Pennsylvania near the West Kentucky border, moving to Pittsburgh as an adolescent. The son of a strict Methodist father, he began to study the Bible and make religious paintings in the late 1950s. In 1966, he set out for Oklahoma, where he lived for the next twenty years, becoming an ordained Pentecostal minister and using his paintings to preach the Gospel. Although Oklahoma is not always claimed as being Southern, Blayney's art holds much in common with the work of Southern artists, such as Samuel David Phillips and Gertrude Morgan, demonstrating a strong grounding in Bible prophecy and drawing upon a religious tradition of didactic imagery going back to the mid-nineteenth century. C. C.

Hawkins Bolden

b. 1914
Active: Memphis, Tennessee
Baptist

Hawkins Bolden, blind since the age of five, creates mixed-media works made of cast-off materials: garbage cans, hub caps, license plates, rug remnants, plastic hoses, and leather straps. Intended to serve as scarecrows for his garden, such pieces are admired for their abstract forms and evocative shapes. A member of the Eastern Star Baptist Church in Memphis, Bolden believes his talent is a gift from God. Although there is no obvious religious function to his art, the works, which have been likened to the assemblage pieces of contemporary trained artists, are clearly rooted in his deep spirituality. C. C.

Edward Butler

b. 1941
Active: Baton Rouge, Louisiana
Unknown

Born in Louisiana, Edward Butler makes bas-relief carvings that demonstrate in their depictions of important black heroes, such as Malcolm X, Rodney King, and Martin Luther King, a deep pride in African American culture and a desire to celebrate its heritage. *The Black Messiah* featured in *Coming Home!*, which imagines Jesus in dreadlocks, includes an image of an open book whose text begins, "For nearly 500 years the illusion that Jesus was white dominated the world only because white Europeans dominated the world." These are the opening lines of Albert B. Cleage, Jr.'s influential book *The Black Messiah*, published in 1968. C. C.

William "Ned" Cartledge

1916–2001
Active: Atlanta, Georgia
Unitarian Universalist

Ned Cartledge was a third-generation member of the Unitarian Universalists, a religious group that believes the Bible is not the sole source of religious knowledge. In 1985, his Atlanta congregation featured an exhibition of thirty-nine of his bas-relief carvings. Cartledge used his creativity through woodcarving to call attention to hypocrisy, injustice, and intolerance. He also attacked the excesses of the New Puritans, specifically, televangelists, whom he called the "Church of the Gullible." In the catalogue, *Let It Shine, Self-Taught Art from the T. Marshall Hahn Collection*, Susan Mitchell Crawley writes, "Cartledge was inspired by the passage from the Sermon on the Mount: 'Let your light shine before men,'" an idea reflected in the cover piece, *Don't Hide Your Light Under a Bushel*, 1986. L. B.

Raymond Coins

1904–1998
Active: Winston Salem, North Carolina
Primitive Baptist

Raymond Coins was a devout member of the Rock House Primitive Baptist Church in Pilot Mountain, North Carolina, where he served as deacon. He is best known for rough, simple carvings of animal and human forms, which he made of found materials, including white river stone, sandstone, soapstone, and cedar, their shapes often suggesting the subject of his carvings. Coins was a deeply reli-

gious man, believing that his task was to free the spirit within the material he used. K. L.

Jessie Cooper
b. 1932
Ronald Cooper
b. 1931
Active: Flemingsburg, Kentucky
Christian Holiness

Like missionaries, the Coopers use their art to present the tenets of their faith. Just as they share their faith, the two artists share their artmaking. Using cast-off materials—shoes, kerosene heaters, toy wagons—or sometimes constructing forms like the pulpit in *Coming Home!*, Ronald Cooper fashions the three-dimensional elements of their artworks. The two then divide the task of painting: Jessie representing the joys of heaven and Ronald depicting the horrors of hell. C. R.

Chester Cornett
1912–1981
Active: Dwarf, Kentucky
Evangelical Protestant

Described as a "Mountain Man," Chester Cornett had little formal education, yet became known for his ingenious hand-crafted chairs that look more like sculptural works of art than utilitarian pieces of furniture. Working with his grandfather and uncle in the back country near Dwarf, he learned how to make finely crafted chairs of buckeye and white oak. Except for a short period during World War II, when he had joined the army and was stationed in the Aleutian Islands, he supported himself by chair making. His *Crucifix* is a rare essay into figural imagery. C. C.

Carl Dixon
b. 1960
Active: Houston, Texas, now Jackson, Mississippi
Baptist

After living more than twenty years in Houston, Texas, Carl Dixon returned to Jackson, Mississippi, where he was born. A deeply religious man devoted to Bible study, Dixon, who was once diagnosed with cancer, puts significant emphasis on the regenerative role of faith. To make his incised reliefs, Dixon first draws his subject on paper, then, if the subject is biblical, he prays. He next incises the image, using such woodworking tools as chisels, jigsaws, drills, and routers. After adding color with acrylic or oil-based paints, he finishes the carving with a protective coating of lacquer. D. B.

Sam Doyle
1906–1985
Active: St. Helena Island, South Carolina
Baptist

Sam Doyle was born on St. Helena Island, off the coast of South Carolina, where the African *Gullah* culture flourishes today. In most of his work, Doyle painted with enamel on materials such as corrugated board, wooden panels, and discarded roofing tin. His images are colorful, painterly, and flat in style, and his works frequently incorporate handwritten text. His Bible paintings often focus on the figure of Christ, representing, for example, his birth, death, and resurrection. Doyle was an active member of St. Joseph Baptist Church, where he served as sexton and trustee. K. L.

William Edmondson
ca. 1870–1951
Active: Nashville, Tennessee
Primitive Baptist

William Edmondson believed he received the gift of carving from God. The first black man and the first self-taught artist to be featured in an exhibition at the Museum of Modern Art, he has been celebrated as one of the twentieth century's great sculptors. His statuary demon-

strates a keen observation of pose, gesture, attitude, and dress, a simple bold reduction of organic form to abstract shape and a clean, pristine line coupled with superbly wrought textures. Never large in scale yet monumental in presence, Edmondson's work demonstrates a keen appreciation of nature, a deep pride in the African American community, a strong sense of humor, and a devout belief in God. C. C.

Minnie Evans
1892–1987
Active: Wilmington, North Carolina
African Methodist Episcopal Church

Minnie Evans, a native of North Carolina, was brought up by her grandmother in a poor, black family and had only a sixth grade education. She worked thirty years as a domestic at a wealthy estate and then as a gatekeeper at Airlie Gardens. Having experienced vivid dreams and waking visions from childhood, she began drawing in the 1940s, saying that the idea came to her in a dream. Using ink, graphite, wax crayon, and later oil paint, she created lyrical depictions of lush gardens bedecked with verdant plants and colorful flowers and often inhabited by strange mythical or angelic beings. Her art draws imagery from the Book of Revelation and the Bible's visions of Paradise, suggesting the mysterious fecundity and benevolent innocence of Eden. C. R.

Josephus Farmer
1894–1989
Active: Milwaukee, Wisconsin
Pentecostal

Born in Tennessee, Rev. Josephus Farmer, a Pentecostal preacher, moved to St. Louis, Missouri, around 1945 but shortly thereafter settled in Milwaukee, Wisconsin. The son of a former slave, Farmer was a street preacher, who composed songs, taught himself the guitar, made

painted banners, and carved wood reliefs and dioramas. The banners, which Farmer used in his street preaching, derive from a didactic tradition that goes back to the mid-nineteenth century. His brightly painted reliefs often represent biblical events or celebrate political leaders like Theodore Roosevelt or John F. Kennedy, while his dioramas recall scenes of rural Tennessee. C. R.

Howard Finster

1915 or 1916–2001
Active: Summerville, Georgia
Baptist

Rev. Howard Finster was first and foremost a Baptist preacher. He believed God meant him to make "sacred art" in order to win souls to Christ. His most celebrated constructions are Paradise Garden and the World's Folk Art Church, located in northwest Georgia. Finster produced thousands of other works, including mixed-media pieces, a densely illustrated book relaying two Christian families' two-thousand-year voyage to heaven, album cover designs, and whimsical inventions. His art demonstrates an ingenious use of materials and a common sense but conservative approach to religion. C. C.

Lorraine Gendron

b. 1938
Active: Hahnville, Louisiana
Evangelical Protestant. Unaffiliated

Lorraine Gendron is a painter and a sculptor who uses Mississippi mud or makes cut-outs of wood, which she paints. A devout Christian, she is often inspired to make religious imagery and is especially enthralled with the Book of Revelation. Gendron is best known, however, for lively scenes of Louisiana life, especially vignettes from the French Quarter, depicting its colorful personalities and New Orleans jazz funeral bands. C. C.

Alyne Harris

b. 1942
Active: Gainesville, Florida
Evangelical Protestant. Unaffiliated

Alyne Harris, who attends Williams Temple Sanctified Church in Gainesville, Florida, still retains childhood memories of the angels who visited her when she was young and inspired her art. Over a span of twenty years Harris has painted on wood, Masonite, canvas board, and metal, using bold colors to create scenes from everyday life and nature, depictions rooted in the African American experience and images inspired by church life and religion. K. L.

William Hawkins

1895–1990
Active: Columbus, Ohio
Unknown

William Hawkins, who was born near Lexington, Kentucky, later moved to Columbus, Ohio, where he produced most of his art. Not much is known about his religious upbringing or beliefs, although Frank Maresca of Ricco-Maresca Gallery says that Hawkins told him outright that he did not attend church. A prolific painter, Hawkins collected illustrations from magazines, books, and newspapers, which he used as sources for his work. Employing a highly dramatic style, Hawkins generally chose to represent animals or architectural forms but did draw some subjects from the Bible, such as his Last Supper series. C. R.

Lonnie Holley

b. 1950
Active: Birmingham and Harpersville, Alabama
"Universal Believer"

Lonnie Holley, who was baptized in the African Methodist Episcopal Church, says his grandmother wanted him to be a minister. Although he never became a

preacher, Holley believes he ministers through his art. Invested with a broad knowledge of Christianity, Islam, and spiritualism (*Souls Grown Deep*, Vol. 1, 43), he now considers himself to be a "universal believer," that is, someone who respects the beliefs that others hold and seeks to build on all humanity's ideas, experiences, and hopes. "I make prophecy art," Holley says, meaning not the kind of art that looks forward to the apocalyptic end of history but an art that acts much like the prophets of the Old Testament, who sought to remedy the evils of human life. C. C.

Clementine Hunter

1886 or 1887–1988
Active: vicinity of Nachitoches, Louisiana
Catholic

Working in rural Louisiana on Melrose Plantation, Clementine Hunter was a prolific maker of memory paintings that capture the special religious character of the region. Her work depicts both Protestant and Catholic religious traditions and accurately records the religious life of African Americans who lived near Natchitoches, a town situated at the border between Protestant northern Louisiana and the Catholic-dominated south. Hunter, who was a lifelong member of St. Augustine Catholic Church in Isle Breville, created paintings that draw upon her experience as a Catholic, depict religious events of special importance to African Americans of all faith, and also represent tent revivals and worship services associated with evangelical traditions. C. R.

J. L. Hunter

1905–1997
Active: Dallas, Texas
Baptist

Senior minister of the True Light Baptist Church in Dallas, Texas, for more than

thirty years, Rev. J. L. Hunter took up woodcarving as a hobby. Despite his theological training at Austin's Southern Bible College and other institutions, Hunter rarely depicted religious subjects. Instead, he preferred to carve animals, subjects drawn from everyday life, Santa Claus figures, and the Statue of Liberty. Hunter typically carved his works from found pieces of wood whose shape suggested the final form, assembled the work by attaching appendages using nails and a "secret sauce" of his own glue, and finished by painting the figures with enamel or house paint. C. C.

J. F. Hurlbut

b. 1893–
Active: Villisca, Iowa
Advent Christian

Little is known about J. F. Hurlbut beyond the fact that he was pastor of a small Advent Christian church in Villisca, Iowa, and presumably a self-taught maker of prophecy charts. The Tree of Life chart featured in *Coming Home!* was collected by Rev. A. P. Ferrell, an itinerant evangelist for the Advent Christian Church, who also collected the piece by Henrietta Black in the exhibition. C. C.

Jas Johns

1941–2003
Active: Cartersville, Georgia
Episcopal

Jas Johns was a communicant of Ascension Episcopal Church in Cartersville, Georgia, where he served as senior warden and Lay Eucharistic Minister. He had a master's degree in technology education, and he taught technology, drafting, and woodworking at the secondary level. Johns created acrylic paintings that were often religious in nature, hoping to make the "one sublime message to the masses about the love of God and his Trinity." He hoped his art would "minister unto" others and often relied on humor to cap-

ture attention and soften the message, a tactic evident in *Heaven and Hell Britches*, which Johns wore to art fairs and festivals. K. L.

Anderson Johnson

1915–1998
Active: Newport News, Virginia
Evangelical Protestant

Rev. Anderson Johnson, at one time the "right-hand man" of charismatic preacher Daddy Grace, founder of the United Church of Prayer for All People, established his own church in Newport News. There, at a succession of Faith Missions, he made his own brand of gospel music and preached from the *Portable Pulpit*, featured in *Coming Home!* When Johnson retired, he began making art as a serious endeavor, filling his church with paintings of faces drawn with house paint on cardboard, canvas board, doors, and counter tops and representing Jesus (*Behold the Man*), the U.S. presidents, and beautiful women. His art can be seen today at the Newsome House, an African American history museum in Newport News. A. O.

Eddie Lee Kendrick

1928–1992
Active: Little Rock, Arkansas
Church of God in Christ

Scripture, church, and gospel singing inspired the art of Eddie Lee Kendrick, who was born in Stephens, Arkansas, near Little Rock, where he attended the Bethel African Methodist Episcopal Church. Later when he moved to Higgins, a suburb of the capitol, he joined the Woods Temple Church of God in Christ, serving as a choir soloist and participating in several gospel groups. Using a wide range of media—tempera, watercolor, crayon, acrylics, oils, pen, pencil, ink, and glitter—he made paintings of church life and Bible prophecy. S. P.

George Paul Kornegay

b. 1913
Active: Brent, Alabama
African Methodist Episcopal Zion

Rev. George Kornegay, an African Methodist Episcopal Zion minister, is the creator of a huge visionary environment located on a hill near his house. His yard show, like others created by African American self-taught artists, blends African American aesthetic traditions, political commentary, and a Christian message. In addition to religious tableaux, including the Last Supper and many depictions of the Crucifixion, Kornegay has created katsina figures that represent his Native American forebears and a bridge structure that refers to his participation in civil rights movement events like the March on Selma. Kornegay, who worked for many years in Alabama's foundries, includes many metallic elements in his work. C. R.

C. M. Laster

b. 1963

Grace Kelly Laster

b. 1966
Active: Hopkinsville, Kentucky
Baptist/Pentecostal

C. M. Laster and Grace Kelly Laster consider themselves to be missionary ministers for Howard Finster's World's Folk Art Church. Their Rockin' Holy Roller Artcar, transformed into a rolling sermon, is the mobile church that reveals their message of God's love. They believe the art they create, which centers on their spiritual struggles, has healing potential for others. The Lasters experiment with unusual found materials and often portray Elvis and Jesus. Both were raised in religious homes and Grace Kelly attended Catholic school for a short period. It was Finster's spiritual inspiration and their love of Elvis that pulled the couple together, driving them to "get on the altar" and create art. K. L.

Josephine Lawson

1866–1963
Active: Pasadena, California
Advent Christian

Confined to a wheelchair, Josephine Lawson was born in Sweden, came as a young woman to America, learned English well enough to write her autobiography in her adopted language, traveled extensively, and settled in California. Lawson employed her artistic talents in the service of her faith. A fervent Advent Christian, she painted Scripture on the glass windows of her house and along the roadside on rocks, fences, bridges, fallen trees, adobe walls, and stumps. She also made and illustrated prophecy charts, like the example shown in *Coming Home!* (and kept a similar one tacked on the outside of her house). C. C.

Tim Lewis

b. 1952
Active: Isonville, Kentucky
Baptist

Tim Lewis, who began his carving career by making walking sticks, soon turned to sandstone and limestone, materials indigenous to the Kentucky hills where he lives. Currently at work on a six-foot *Crucifixion*, Lewis usually carves smaller pieces, including animals, as well as motifs and scenes from popular culture and religion. Raised a Baptist and the grandson of the minister of Newcomb Valley Baptist Church in Isonville, Lewis attended Sunday school as a child and occasionally attends church today. K. L.

Joe Lewis Light

b. 1934
Active: Memphis, Tennessee
Jewish

Joe Light, who converted to Judaism in prison, describes himself as an "American Jew." However, the form of Judaism Light practices is highly eccentric and nontraditional. Light is especially well known for his hand-lettered signs that speak about current events, religious topics, and racial issues, themes he also addresses in his vivid paintings that abstract natural forms into planes of bright flat colors. Although he does not endorse Christianity, that religion's influence permeates his work, particularly in his choice of themes, which emphasize salvation and personal transformation (*Souls Grown Deep*, Vol. 2, 283). C. C.

Annie Lucas

b. 1954
Active: Pink Lily, Alabama
Baptist

Annie Lucas attends the New Nazareth Baptist Church in Deatsville, near her home in Pink Lily, Alabama. The Book of Revelation is possibly Lucas's favorite reading. Believing that God is the source of her talent, Lucas often chooses to portray the Bible's apocalyptic visions. When she reads the Bible's prophetic passages, Lucas says, "I can just see what those visions look like, and I want to paint them." Combining paint and needlework on stretched canvas, Lucas hopes that her art brings joy to others, and she believes that it serves a didactic function, teaching others about the Bible. C. C.

Charlie Lucas

b. 1951
Active: Pink Lily and Selma, Alabama
Unaffiliated

Charlie Lucas, whose family includes at least seven generations of crafts persons, says learning about God was a natural part of growing up. He remembers his mother telling him, when he once complained at dinner, to go out to "meet Jesus." Only later did he realize that she was sending him to the Baptist church behind their home, where the family attended services. Today, Lucas, who creates from automobile and machine parts monumental metal sculptures of fantastic creatures and also makes paintings, describes himself simply as a child of God. C. C.

Joe Minter

b. 1943
Active: Birmingham, Alabama
Baptist

Joe Minter's *African Village in America*, which calls to mind a tropical garden of dazzling flowers and leafy plants, is located in southwest Birmingham, Alabama. Embellished with brightly colored tin and wood constructions, huge silhouettes of abstract metal and wooden shapes, and placards painted with statements from Scripture and the civil rights movement, the garden is a tribute to the history, culture, and courage of African Americans. C. C.

Sister Gertrude Morgan

1900–1980
Active: New Orleans, Louisiana
Baptist/Holiness tradition

Raised a Baptist, Morgan affiliated with a Holiness group in New Orleans, where she worked as a street preacher, singing gospel and making art to preach salvation. She used crayons, poster paint, acrylics, watercolor, and ballpoint pens on any kind of material—cardboard, paper fans, window shades, even toilet paper rolls. She appears in her paintings dressed completely in white garb inspired by her belief that she was the Bride of Christ. C. R.

John "J. B." Murray

1905–1988
Active: Glascock County, Texas
Baptist

Illiterate and uneducated, John "J. B." Murray became the maker of breathtakingly beautiful calligraphic designs,

which he believed represented the word of God. Murray was a member of a Southern Baptist church that practiced glossolalia, or speaking in tongues; his glossographia were the visual embodiment of his personal religious beliefs: painted prophecies of good and evil; visually elaborate incantations of a deeply private faith. E. D.

Charlie A. Owens
1922–1997
Active: Columbus, Ohio
Baptist

Born in Maysville, Kentucky, Charlie A. Owens moved to Columbus, Ohio, in 1942, where he worked a number of jobs, ranging from construction worker to mechanic. He also served in the U.S. Marines. Owens always loved art, and it is reported that he especially " . . . liked to paint history and the Bible." *Holy Church of God-in-Christ* represents an ecstatic worship service with preacher, choir and band, and its congregation, mostly of jubilant women dressed in their Sunday best, caught up in the spirit. The Church of God in Christ, founded in 1897 in Memphis, Tennessee, is now the largest Pentecostal denomination in the world. C. C.

Benjamin "B. F." Perkins
1904–1993
Active: Bankston, Alabama
Pentecostal

A former marine, Alabama artist Rev. "B. F." Perkins served as a minister in the Assembly of God Church and then as a bishop in the Church of God. He established his own church Hartline Assembly Church of God near Bankston, Alabama. Perkins's art weds his strong religious beliefs to a staunch patriotism. Perkins began painting after his retirement in 1979, even taking an art course at a local junior college. He used watercolor and acrylic on canvas and also acrylics on large gourds to make brightly decorated depictions of Bible stories, the Statue of Liberty, and motifs inspired by magazine illustrations of objects from King Tut's tomb. C. C.

Samuel David Phillips
1890–1973
Active: Chicago, Illinois
Pentecostal

Rev. Samuel David Philips grew up in Georgia and was ordained in 1934 by the Association of Pentecostal Assemblies of Atlanta. He later moved to Chicago, where he served at the Progressive Pentecostal Mission on Chicago's South Side and became its pastor. Convinced that human history would soon come to an end, Reverend Phillips made portable charts depicting the visionary imagery of the prophetic Books of Daniel and Revelation to illustrate his sermons. Rendered in pencil, crayon, and water-based paint on the backs of oilcloth table cloths, the charts demonstrate that Phillips was clearly aware of an Adventist religious and pictorial tradition that goes back to the mid-nineteenth century. C. R.

Elijah Pierce
1892–1984
Active: Columbus, Ohio
Baptist

Born in Baldwyn, Mississippi, Elijah Pierce moved to Columbus, Ohio, in 1923, where he worked as a barber and served as associate pastor at the Gay Tabernacle Baptist Church. Pierce, who had learned to carve as a child, believed that God called him to preach the Bible's message of salvation through his art. He is best known for his "sermons in wood," carved and painted low reliefs, such as the masterful *Crucifixion*, 1933. His much later *Power of Praying* is not only meditative in its symmetrical design but also didactic, stressing the centrality of prayer in Christian life. C. C.

Mary Proctor
b. 1960
Active: Tallahassee, Florida
Evangelical Protestant. Unaffiliated

Mary Proctor, versed in Scripture and folklore tales she learned from her grandmother as a child, received divine instruction in 1995 to "get a door and paint." One such door is *Coming Home!*'s *The Blood of Christ*, portraying a large figure of Christ with the message, "The Blood of Jesus Cleanse Us From All Our Sin," which once adorned Proctor's outdoor garden. Proctor constructs her images by assembling broken pottery, watches, beads, fabric, and even green stamps, and then attaching them to found objects such as doors, furniture, and wooden panels. Proctor considers herself the "missionary" and her collectors, the "deliverers." She often signs her work "Missionary Mary." K. L.

Ernest "Popeye" Reed
1916–1985
Active: Columbus, Ohio
Unaffiliated

According to Stanley Greer, Ernest "Popeye" Reed's apprentice, "Popeye was a deeply spiritual man but skeptical about organized religion." Born in rural southern Ohio, Popeye, who was part Native American, became an expert at carving wood and stone. He often peddled his art in Columbus, where Charlie A. Owens and Elijah Pierce worked. Greek mythology, the Bible, and Native American lore fascinated him and inspired much of his art. Reed's religious figures include angels, Adam and Eve, and Jesus, such as the *Bust of Christ* in *Coming Home!* K. L.

Roger Rice

b. 1958

Active: Parchman Prison, Mississippi

Evangelical Protestant

Roger Rice is a prison inmate who holds master's degrees in art and pastoral theology. Although is he not self-taught, his work has been associated with contemporary folk art, because it is categorized as Prison Art, which is perceived as being—like self-taught art—outside the mainstream of the contemporary art world. Rice's interest in using art to proselytize also contributes to the marginalization of his work. An ordained minister, he is active in prison ministry. Although his use of modeling and perspective separates his work from the other art in *Coming Home!*, his religious focus and expressive voice are much the same. C. C.

Robert Roberg

b. 1943

Active: Gainesville, Florida

Evangelical Protestant. Unaffiliated

An evangelical preacher, Robert Roberg conducts a unique street ministry. "For fifteen years I have been going out on street corners with biblical paintings and it draws people like a magnet. I do not preach in the traditional sense of the word, but rather dialogue with people, which entails a lot of listening." Making his paintings as people watch, Roberg witnesses to his beliefs and ministers to those in need. Like many self-taught artists, he is especially fascinated with the Book of Revelation. So far, he has completed nearly a hundred paintings on the Apocalypse, which he is hoping will travel as a series. C. C.

Sultan Rogers

1922–2003

Active: Taylor, Mississippi

Missionary Baptist

Sultan Rogers attended North Hopewell Missionary Baptist Church in Taylor, Mississippi. Although he did not follow his father into the ministry, much of the elder Rogers's preaching served as inspiration when the son later took up his father's hobby of whittling. Rogers is a favorite among collectors because of the unusual characters he carved—two-headed women, devils with multiple appendages, animal-headed humans, and demons with long, snaky tongues. He also made preachers (sometimes suggesting their duplicity), women singers with microphones, snakes, and figures in coffins. He preferred to carve in sweet pine, creating pieces that average up to twelve inches in height, and varnished or painted them sparingly. D. B.

Nellie Mae Rowe

1900–1982

Active: Vinings, Georgia

African Methodist Episcopal Church

Deeply spiritual throughout her life, Nellie Mae Rowe was a member of the African Methodist Episcopal Church and also attended the local Baptist church in Vinings, Georgia. She often engaged God in daily conversation and reasoned that he had blessed her with the gift of artistic talent. Church, prayer, and gospel music inspired many of her drawings, which she made using felt markers and sometimes acrylic paint. Rowe also made dolls, quilts, and gum-sculpture, employing chewing gum to create fantastic creatures, then decorating them with found objects and painting them with vivid colors. L. K.

Lorenzo Scott

b. 1922

Active: Atlanta, Georgia

Baptist

Lorenzo Scott admits that as a child he did not do well in school because he was always drawing. A committed Baptist who has experienced visions from God, Scott often paints religious subject matter. After visiting New York's Metropolitan Museum of Art, he returned to Atlanta to study the "Old Masters" at the High Museum and decided to imitate their art. In consequence, Scott's oil paintings often display traditional themes that look more Catholic than Protestant, his style and technique emulate the work of Renaissance painters and his ornate, gold frames made of wood and decorated in Bondo, a car filler, replicate the elaborate frames he admires. R. M.

Cherry ShaEla'ReEl

b. 1956

Xmeah ShaEla'ReEl

b. 1943

Active: East Texas

Evangelical Protestant

Xmeah and Cherry ShaEla'ReEl have made their art integral to their ministry. Xmeah, who was born David Jones, established his own church, The Children of Christ of America, sometime after 1976, when he believes God appointed him to be a messenger to humankind. A second vision commanded David to adopt the name of Xmeah ShaEla'ReEl, meaning, "Warrior Divine Angel of God." Xmeah believes his art is inspired by God and must be shared with others. The imagery that he and Cherry employ is often derived from the Book of Revelation. Their paintings frequently convey God's displeasure with human immorality and his ultimate victory over evil. Sometimes serving an instructional purpose, sometimes constituting a sharp rebuke, their paintings utilize intense colors, glitter, beads, and rhinestones and include written messages, which often explicate the imagery but also play a strong decorative role. C. C.

Jim Shores

b. 1952

Active: Rome, Georgia. Unaffiliated

Jim Shores, who was born in New Hampshire but settled in Georgia, dropped out of high school in the twelfth grade. With

a religious background steeped in the liturgical church—Episcopal, Catholic, and Lutheran—he describes himself as unaffiliated with organized religion, although he considers himself a spiritual person. His work demonstrates a fascination with things Southern and his love of junk stores and metal scrap yards. C. C.

Bernice Sims

b. 1926
Active: Brewton, Alabama
Baptist

Bernice Sims is a memory painter best known for her scenes of rural life in southern Alabama. She paints vivid, energetic scenes of farming, church activities, cotton picking, and sugar production as well as compelling images documenting her memories of the civil rights struggle. Less common are scenes like those in *Adam and Eve*, which reveal an understanding of the theology that leads from the snake's temptation of Eve, to the fall of the First Parents, to the promise of salvation in Jesus. D. C.

Herbert Singleton

b. 1945
Active: New Orleans, Louisiana
Unaffiliated

Although the woodcarver Herbert Singleton has led a checkered life and even spent thirteen years in Angola Penitentiary, the imagery he employs often consists of religious subject matter. Sometimes his low relief carvings point out the hypocrisy of church life, yet other times his depictions, especially those of Christ, can be poignantly beautiful and meditative. Asked about his religious beliefs, Singleton points out that African Americans have been schooled in Christianity and admits that "You have to go with the God you know." C. C.

Mary T. Smith

1904 or 1905–1995
Active: Brookhaven, Mississippi
Evangelical Protestant

Mary T. Smith's funeral services took place at Chapel Hill Baptist Methodist Church, but whether she was a member of that congregation is uncertain. William Arnett reports that Smith told him she did not often attend church services because of her hearing problems, but her art and recorded comments point to a strong familiarity with the teachings of evangelical Christianity. She is best known for the brightly colored abstract figures painted for her yard, which was located on the highway into Hazlehurst, Mississippi. Smith's yard signs included such messages as "The Lord No Me," "The Lord my Hart," "I Was in a Wrake. The Lord Was for Me," and "The Lord is Head of the World." C. R.

Hugo Sperger

1922–1996
Active: Salyersville, Kentucky
Unaffiliated

Born in Italy, Sperger immigrated to the United States with his German parents in 1940, settling in upstate New York. After serving in the army, he moved to rural Kentucky. Painted in oil on Masonite, Sperger's work typically portrays spacious landscapes inhabited by small figures of people and animals, which are sometimes labeled or carry white balloons with written messages. Adding to the surreal effect of such scenes, these figures often walk, float, and fly in the air. Although Sperger claimed not to be an especially religious man, his paintings show a strong knowledge of the Bible and a profound interest in the human condition. C. R.

Lawrence Stinson

1906–1998
Active: Washington, D.C.
Baptist

Born in the Shenandoah Valley in Virginia, where Appalachian craft traditions thrive, Lawrence Stinson learned woodcarving as a child. Brought up a Baptist, he later moved to Washington, D.C., where for fifty years he was the engineer/custodian of the National Cathedral, an Episcopalian church. There he began making religious carvings, many being displayed in the Cathedral's nave. Stinson died in 1998 after retiring to Cashmere, Washington, where his family lives. C. C.

Jimmy Lee Sudduth

b. 1910
Active: Fayette, Alabama
Church of Christ

Jimmy Lee Sudduth, who has little formal education, became a folk art celebrity when he was invited to participate in the Smithsonian Festival of American Folklife in 1976. Known for his mud paintings of Alabama architecture and life, he typically paints on plywood, beginning his work by drawing the outline of the image he wants to make. Sudduth uses a mixture of sugar, mud, and water to paint the subject's broad areas, later adding color by using natural pigments. Sudduth usually paints scenes of people, animals, and architecture, sometimes producing series that focus on one theme, his dog Toto, for example. Less common are depictions of religious figures, such as his paintings in *Coming Home!*
C. C.

Johnnie Swearingen

1908–1993
Active: Chappell Hill, Texas
Missionary Baptist

Although he claimed he was called to preach as a child, Johnnie Swearingen was not ordained until age seventy-five. He grew up in the black community of Campground Church near Chappell Hill, Texas, left the area in the Great Depression but ultimately returned to nearby Brenham, where he farmed. He completed a correspondence course from the Lone Star Bible School in 1965. Celebrat-

ed for his memory paintings of early twentieth-century Texas, Swearingen also represented church services and sometimes used paintings to illustrate his sermons. He preferred to paint in oils on Masonite. Because he rarely cleaned his paintbrushes, his colors vary from crisp and clear to dark and muddy. C. C.

B. W. Thayer & Company

Boston, Massachusetts

John Henry Bufford (1810–1870), chief artist and general manager of B. W. Thayer & Company, a well-known Boston printing firm, was apparently in charge of lithographing the famous Millerite chart of 1843 (Tatham, "John Henry Bufford," 55). Adapted from a larger hand-painted two-part original (now lost) made by two nineteenth-century ministers, Charles Fitch and Apollos Hale, the chart was published by J. V. Himes, a Boston minister. A talented publicist, Himes promoted the end-time teachings of William Miller, who preached Christ's Second Coming. The chart's distinguishing feature is a large statue that appears in the dreams of King Nebuchadnezzar (Dan. 2). Sometimes called the Colossus, the statue played an important role in Miller's theories and is still a constant fixture in the prophecy teachings of many evangelical Christians. C. C.

William Thomas Thompson

b. 1935
Active: Greenville, South Carolina
Pentecostal Holiness

William Thomas Thompson lives in Greenville, South Carolina, at the historic Gassaway Mansion, where his studio occupies its third floor. A fervent Pentecostal, Thompson is best known for his three-hundred-foot-long painting, Revelation Revealed, which represents the apocalyptic vision of St. John. The canvas paintings shown in Coming Home! feature themes pictured in Thompson's monumental version. The

imagery reveals a strong evangelical faith in the Bible's authority, a premillennialist's understanding of end-time events and a powerfully expressive style. C. C.

Mose Tolliver

b. ca. 1919
Active: Montgomery, Alabama
Unaffiliated

Born near Montgomery, Alabama, Mose Tolliver began painting in the 1970s, at first working with paint on plywood, Masonite, and paneling but moving to found materials, including gourds and old furniture. One of the most popular and widely collected contemporary black Southern folk artists, Tolliver makes paintings that are easily recognizable by their strong central figures set against flat areas of contrasting background colors, which are subdued in hue. He is best known for his lively sexual figures, whimsical animals, vehicles, and self-portraits, although he occasionally produces religious figures or a Crucifixion. D. B.

Edgar Tolson

1904–1984
Active: Campton, Kentucky
Evangelical Protestant

A key figure in the history of contemporary self-taught art, Edgar Tolson is Kentucky's most famous woodcarver. His sculpture demonstrates the survival of folk craft traditions, the impact of outside forces, and a strong creative originality. The idea for representing the Temptation, which he carved more than seventy times, was suggested by a collector. Perhaps it was not only the hope of financial award but also the artist's religious zeal that prompted his enthusiasm for the subject. Ardery (Temptation, 18) suggests that Tolson, who called himself a Baptist preacher, was not especially concerned with affiliating with one denomination but more devoted to his own brand of Bible study. C. C.

Unknown Artist

Although the maker and origin of this covered Bible holder are unknown, such objects are not uncommon in the South and are especially well known in Appalachia (God, Man, and the Devil). Bible holders, Bible covers, and even carvings of the Bible itself were often made for domestic use. Consisting of a base and cover, Coming Home!'s example calls to mind the simplified form of an ark with a low roof, bow, and stern. The ark traditionally symbolizes the Church, and its use to enshrine the Bible may have been intended to convey the centrality of God's Word in the church and the importance of religion in family life. C. C.

Felix Virgous

b. 1948
Active: Memphis, Tennessee
Holiness-Sanctified Tradition

Born in northern Mississippi, Felix Virgous most associates himself with the Holiness-Sanctified tradition, an evangelical movement that originated in the late nineteenth century and ultimately led to the flourishing movement known as Pentecostalism. Virgous often makes paintings of Old and New Testament subjects, sometimes situating such imagery in contemporary, urban settings yet investing them with a sense of timelessness. Virgous uses a bright palette—bold pinks, turquoise, intense reds, greens, and yellow—and designs highly balanced and symmetrical compositions. Human forms and other objects are simplified, space becomes two dimensional and the overall effect is highly ornamental. C. C.

Fred Webster

1911–1998
Active: Berry, Alabama
Methodist

Fred Webster was a retired high school principal when he took up a longtime interest in carving. His enthusiasm was sparked when he enrolled in courses at

the John C. Campbell Folk School in North Carolina. A lifelong member of the Methodist Church and a member of Gideons, International, he became famous for his carvings of biblical subjects such as the Adam and Eve shown in *Coming Home!* C. C.

Yvonne Wells

b. 1939
Active: Tuscaloosa, Alabama
Presbyterian

Unlike many self-taught artists, Wells is college educated, working as a high school physical-education teacher. The daughter of a Presbyterian minister, she took up quilting as an adult, moving from decorative patterns to appliqué narratives. Her topics fall into four categories: sociopolitical, religious, children's themes, and "potluck—whatever is left over from other projects." Wells has depicted a wide range of biblical themes such as Proverbs, the Beatitudes, the Fiery Furnace, Ezekiel's Wheel, and a three-quilt series, *The Whole Armor of God.* D. B.

Myrtice West

b. 1923
Active: Centre, Georgia
Evangelical Protestant (Baptist, Methodist)

Myrtice West lives in the small town of Centre, Alabama. Her most celebrated work is the Revelations Series, composed of thirteen paintings representing the apocalyptic visions of St. John, recorded in the New Testament's Book of Revelation. West created two other series that picture the Bible's end-time visions as portrayed in the Old Testament books of Ezekiel and Daniel. West grew up attending Baptist and Methodist churches and is staunchly conservative in her religious beliefs. Her art is highly literal, demonstrating a close reliance on the Bible and a premillennial understanding of the world's last days. C. C.

"Artist Chuckie" Williams

1957–1999
Active: Shreveport, Louisiana
Methodist

As a child, "Artist Chuckie" Williams, as he called himself, was taught the Bible by his Methodist mother, who regularly studied at home in lieu of attending church. He used many religious images in his work, believing Jesus called him to paint. Williams, influenced by popular culture, also painted celebrity caricatures, animals, landscapes, sports figures, portraits, maps, and cityscapes. "Artist Chuckie" primarily painted with acrylic on cardboard, wood, and paper, adding black text and glitter. His paintings are vibrant and flat, with exaggerated features and bold colorful brush strokes. K. L.

Purvis Young

b. 1943
Active: Miami, Florida
Unaffiliated

Purvis Young taught himself to paint after he was released from prison, where he served time for armed robbery. A voracious reader of books on the history of Western art, he has studied its great masters from Rembrandt to Picasso. His highly expressive style, which began with protest murals made for Miami's Goodbread Alley in the 1970s, often focuses on the struggles that confront African Americans. His art also demonstrates his familiarity with Native American lore and a variety of religions, including Christianity, Islam, Vodou, and Santeria. Young is sometimes critical of organized religion, observing the hypocrisy of church people who live in greater luxury than the less fortunate, yet he maintains a close relationship with God: "I look up in the sky and say, 'Thank you.' I don't follow man on earth." (*Souls Grown Deep*, Vol. 2, 419) C. C.

Individuals contributing to "Notes on the Artists" include Carol Crown, Erika Doss, Lynne Brown, Lee Kogan, Ann Oppenhimer, Susan Purvis, and Cheryl Rivers. Others were compiled by art history graduate students at the University of Memphis, including Deborah Cox, Debra Blundell, Katherine LoBianco, and Robbie McQuiston. Judi "Mac" Birkitt, a doctoral candidate in history, also contributed. Each entry listed above is followed by the initials of the writer.

Lenders to the Exhibition

American Folk Art Museum

Linda Anderson

Arient Family Collection

Matthew J. Arient

William Arnett

Jack and Ann W. Brittain and Their Children

Lynne and Jim Browne

Donald N. Cavanaugh and Edward G. Blue

Dan and Kristi Cleary

Columbus Museum of Art, Ohio

Jessie and Ronald Cooper

Susann Craig

A. Brooks Cronan, Jr., M.D., and Jo Cronan

John Denton

Jim Farmer and Scott Fields

Josh Feldstein

John and Teenuh Foster

Frank H. McClung Museum, University of Tennessee

Lorraine Gendron

Sally and Paul Hawkins

Audrey B. Heckler

Jenks Memorial Collection of Adventual Materials, Aurora University

Jas Johns, Collection of the Artist's Estate

Kentucky Folk Art Center

Cal Kowal and Anita Douthat

Marianne and Richard Lambert

Katherine and Thomas LoBianco

Randall Lott and Nancy McCall

Roger Manley

The Mennello Museum of American Folk Art

Milwaukee Art Museum

Joe Minter

Carl and Marian Mullis

William and Ann Oppenhimer

William C. Paley

Jan Petry

Joseph H. and Susan Turner Purvis

Lewis Regenstein

Tamara and Rollin Riggs

Robert Cargo Folk Art Gallery

Robert A. Roth

Chuck and Jan Rosenak

Skot Foreman Fine Art

Stephanie and John Smither

Mary M. Stiritz

William Thomas Thompson

John Turner

George and Sue Viener

Webb Gallery, Waxahatchie

Bruce and Julie Webb

Thomas N. Whitehead

Craig Wiener

Gunny Yawn

Bibliography

Because of the excellent bibliographic resources for the study of contemporary folk art (some are noted below under the heading "Art: General"), *Coming Home!*'s bibliography does not seek to be exhaustive. Rather it notes important sources referenced in the catalog and others that the essayists believe to be among the most useful for the study of Southern self-taught art in context.

The bibliography is divided into three major sections: Art, Religion and Southern Culture.

ART

General

Rosenak, Chuck, and Jan Rosenak. *Museum of American Folk Art Encyclopedia of Twentieth-Century American Folk Art and Artists*. New York: Abbeville Press, 1990.

———. *Contemporary American Art: A Collector's Guide*. New York: Abbeville Press, 1996.

Sellen, Betty-Carol, with Cynthia J. Johanson. *Self-Taught, Outsider, and Folk Art: A Guide to American Artists, Locations and Resources*. Jefferson: McFarland and Company, 2000.

———. *Outsider, Self-Taught, and Folk Art Annotated Bibliography: Publications and Films of the Twentieth Century*. Jefferson: McFarland and Company, 2002.

Focused Studies and Exhibition Catalogs

Adele, Lynne. *Spirited Journeys: Self-Taught Texas Artists of the Twentieth Century*. Austin: University of Texas at Austin/Archer M. Huntington Art Gallery, 1997.

Allamel, Frederic. "The Architectonics of a Honeymoon." *Southern Quarterly* 38, 4 (Summer 2000), 38–47.

American Folk Art: The Herbert Waide Hemphill, Jr., Collection. Milwaukee: Milwaukee Art Museum, 1981.

The Angel That Stands by Me: The Paintings of Minnie Evans [videocassette]. Produced and directed by Alie Light and Irving Saraf. 28 min. Light-Saraf Films, 1993.

Another Face of the Diamond: Pathways through the Black Atlantic South. New York: INTAR, Hispanic Arts Center, 1988.

Ardery, Julia. *Temptation: Edgar Tolson and the Genesis of Twentieth-Century Folk Art*. Chapel Hill: The University of North Carolina Press, 1998.

Arnett, Paul, and William Arnett, eds. *Souls Grown Deep: African American Vernacular Art of the South*, 2 vols. Atlanta: Tinwood Books, 2000–2001.

Art of William Edmondson, The. Nashville: Cheekwood Museum of Art in association with the University Press of Mississippi, Jackson, 1999.

Baking in the Sun: Visionary Images from the South: Selections from the Collection of Sylvia and Warren Lowe. Lafayette: University Art Museum, University of Southwestern Louisiana, 1987.

Beardsley, John. *Gardens of Revelation: Environments by Visionary Artists*. New York: Abbeville Press, 1995.

Benberry, Cuesta. *Always There: African American Presence in American Quilts*. Louisville: Kentucky Quilt Project, 1992.

Biebuyck, Daniel. "The Kindi: Aristocrats and Their Art among the Lega." In *African Art and Leadership*. Edited by Douglas Fraser and Herbert M. Cole. Madison: University of Wisconsin Press, 1972.

Black Art Ancestral Legacy: The African Impulse in African-American Art. Dallas: Dallas Museum of Art, 1989.

Bradshaw, Thelma Finster. *Howard Finster, The Early Years: A Private Portrait of America's Premier Folk Artist*.

Birmingham: Crane Hill Publishers, 2001.

Cardinal, Roger. "The Vulnerability of Outsider Architecture." *Southern Quarterly* 39, 1–2 (Fall–Winter 2000–2001): 169–86.

Celebrating the Vision: Self-Taught Artists of Alabama. Talladega: Jemison-Carnegie Heritage Hall, 2000.

Common Ground/Uncommon Vision: The Michael and Julie Hall Collection of American Folk Art. Milwaukee: Milwaukee Art Museum, 1993.

Crown, Carol, ed. *Wonders to Behold: The Visionary Art of Myrtice West.* Memphis: Mustang Publishing Company, 1999.

———. "A Continuing Revelation: Religious Vision in Southern Self-Taught Art." *Image: A Journal of the Arts and Religion* 24 (Fall 1999): 29–41.

———. "Who Made These Charts? The Legacy of the Adventists?" *The Outsider* 6, 2 (Winter 2002): 12–15.

Cubbs, Joanne. *The Gift of Josephus Farmer.* Milwaukee: University of Wisconsin, Milwaukee Art History Gallery, 1982.

Danchin, Laurent, and Martine Lusardy. *Art Outsider et Folk Art des Collections de Chicago.* Paris: Halle Saint Pierre, 1998.

D'Azevedo, Warren L., ed. *The Traditional Artist in African Societies.* Bloomington: Indiana University Press, 1973.

Delanhanty, Randolph. *Art in the American South: Works from the Ogden Collection.* Baton Rouge: Louisiana State University, 1996.

Dewhurst, C. Kurt. *Religious Folk Art in America: Reflections of Faith.* New York: E. P. Dutton in association with the Museum of American Folk Art, 1983.

Dillenberger, Jane Daggett. *The Religious Art of Andy Warhol.* New York: Continuum, 1998.

Dissanayake, Ellen. *Homo Aestheticus: Where Art Comes From and Why.* New York: Free Press, 1992.

Doss, Erika. "Religious Dimensions of Work by Contemporary Self-Taught Artists. Speculations on New Methodologies and Perspectives." In *Negotiating Boundaries: Issues in the Study, Preservation, and Exhibition of the Works of Self-Taught Artists.* Sheboygan: John Michael Kohler Arts Center, 2000.

———. *Twentieth-Century American Art.* New York: Oxford University Press, 2002.

Elijah Pierce, Woodcarver. Edited by Norma Roberts. Columbus: Columbus Museum of Art, 1992.

Ferris, William. *Local Color: A Sense of Place in Folk Art.* New York: McGraw-Hill, 1982.

Finster, Howard, as told to Tom Patterson. *Howard Finster Stranger from Another World: Man of Visions Now on This Earth.* New York: Abbeville Press, 1989.

Folk Art of Kentucky: A Survey of Kentucky's Self-Taught Artists. Lexington: University of Kentucky Fine Arts Gallery, 1976.

Four Outsider Artists: The End Is a New Beginning. Bethlehem: Lehigh University Art Galleries, 2001.

Generations of Kentucky: An Exhibit of Folk Art with Photographs by Guy Mendes. Louisville: Kentucky Art and Craft Foundation, 1994.

Gilley, Shelby R. *Painting by Heart: The Life and Art of Clementine Hunter, Louisiana Folk Artist.* Baton Rouge: St. Emma Press, 2000.

God, Man and the Devil: Religion in Recent Kentucky Folk Art. Lexington: Folk Art Society of Kentucky, 1984.

Goekjian, Karekin, and Robert Peacock. *Light of the Spirit: Portraits of Southern Outsider Artists.* Jackson: University Press of Mississippi, 1998.

Gordon, Ellin, Barbara R. Luck, and Tom Patterson. *Flying Free: Twentieth-Century Self-Taught Art from the Collection of Ellin and Baron Gordon.* Williamsburg: Colonial Williamsburg Foundation in association with the University of Mississippi, Jackson, 1997.

Gould, S. J. "James Hampton's Throne and the Dual Nature of Time." *Smithsonian Studies in American Art*, 1, 1 (Winter–Spring 1987): 47–57.

Gundaker, Grey. *Keep Your Head to the Sky: Interpreting African American Home Ground.* Charlottesville: University Press of Virginia, 1998.

Hall, Michael D. "You Make It with Your Mind: The Art of Edgar Tolson." *Clarion Ledger* 12, 2–3 (Spring–Summer 1987): 39.

Hall, Michael D., and Eugene W. Metcalf, eds. *The Artist Outsider: Creativity and the Boundaries of Culture.* Washington: Smithsonian Institution Press, 1994.

Harrison, Paul, Victor L. Walker, and Gus Edwards, eds. *Black Theatre: Ritual Performance in the African Diaspora.* Philadelphia: Temple University, 2002.

Hartigan, Lynda Roscoe. *The Throne of the Third Heaven of the Nations Millennium General Assembly.* Montgomery: Montgomery Museum of Fine Arts, 1977.

———. *Made with Passion: The Hemphill Folk Art Collection in the National Museum of Art.* Washington: Smithsonian Institution Press, 1990.

———. "Going Urban: American Folk Art and the Great Migration." *American Art* 14, 2 (2000).

Hemphill, Herbert Waide, Jr., ed. *Folk Sculpture, USA.* Brooklyn: Brooklyn Museum of Art, 1976.

Hemphill, Herbert Waide, Jr., and Julia Weissman. *Twentieth-Century American Folk Art and Artists.* New York:

E. P. Dutton, 1974.

Horton, Robert. *Kalabari Sculpture.* Lagos: Department of Antiquities, 1965.

Horwitz, Elinor Lander. *Contemporary American Folk Artists.* Philadelphia: J. B. Lippincott, 1975.

Hough, Katherine Plake, and Michael Zakian. *Transforming the Western Image in Twentieth-Century American Art.* Palm Springs: Palm Springs Desert Museum, 2002.

Howard Finster: Painter of Sermons. Lexington: Folk Art Society of Kentucky, 1988.

Jacobs, Joseph. *A World of Their Own: Twentieth-Century American Folk Art.* Newark: Newark Museum, 1995.

Kahn, Mitchell D. *Heavenly Visions: The Art of Minnie Evans.* Raleigh: North Carolina Museum of Art, 1986.

Kapunan, Sal. *My Taoist Vision of Art.* Boone: Parkway Publishers, 1999.

Kattenberg, Peter. *Andy Warhol, Priest: "The Last Supper Comes in Small, Medium, and Large."* Boston: Brill, 2001.

Keeping the Faith: An Exhibition of Religious Folk Art. St. Louis: Center of Contemporary Art, 1999.

Kienholz: A Retrospective. New York: Whitney Museum of American Art, 1996.

Kemp, Kathy. *Revelations: Alabama's Visionary Folk Artists.* Birmingham: Crane Hill Publishers, 1994.

Kogan, Lee. *The Art of Nellie Mae Rowe: Ninety-Nine and a Half Won't Do.* New York: Museum of American Folk Art, 1998.

Lampell, Ramona, Millard Lampell, and David Larkin. *O, Appalachia: Artists of the Southern Mountains.* New York: Steward, Tabori, and Chang, 1989.

Let It Shine: Self-Taught Art from the T. Marshall Hahn Collection. Atlanta: High Museum of Art, 2001.

Lindsay, Jack. "William Edmondson,"

Folk Art 20, 1 (Spring 1995).

Lippard, Lucy R. *Mixed Blessing: New Art in a Multicultural America.* New York: New Press, 1990.

———. *Overlay: Contemporary Art and the Art of Prehistory.* New York: Pantheon Books, 1983.

Livingston, Jane, and John Beardsley. *Black Folk Art in America: 1930–1980.* Jackson: University Press of Mississippi and the Center for the Study of Southern Culture for the Corcoran Gallery of Art, 1982.

Local Visions: Folk Art from Northeast Kentucky. Morehead: Morehead State University, 1990.

Lommel, Andreas. *Shamanism: The Beginnings of Art.* New York: McGraw-Hill, 1967.

Lovell, Charles M., and Erwin Hester, eds. *Minnie Evans: Artist.* Greenville: Wellington B. Gray Gallery, East Carolina University, 1993.

Lyons, Mary E. *Painting Dreams: Minnie Evans, Visionary Artist.* Boston: Houghton Mifflin, 1996.

Maizels, John. *Raw Creation: Outsider Art and Beyond.* London: Phaidon Press, 1996.

Manley, Roger. *The End Is Near! Visions of Apocalypse, Millennium, and Utopia.* Los Angeles: Dilettante Press, 1998.

———. *Signs and Wonders: Outsider Art Inside North Carolina.* Raleigh: North Carolina Museum of Art, 1989.

Manley, Roger, and Mark Sloan. *Self-Made Worlds, Visionary Folk Art Environments.* New York: Aperture, 1997.

Maresca, Frank, and Roger Ricco. *American Self-Taught: Paintings and Drawings by Outsider Artists.* New York: Alfred A. Knopf, 1993.

Meer, Frederick van der. *Apocalypse: Visions from the Book of Revelation in Western Art.* New York: Alpine Fine Arts Collection, 1978.

Metcalf, Eugene, and Michael Hall. *The Ties That Bind: Folk Art in Contemporary American Culture.* Cincinnati: The Contemporary Arts Center, 1987.

Missing Pieces: Georgia Folk Art 1770–1976. Atlanta: Georgia Council for the Arts and Humanities, 1976.

Morgan, David. *Visual Piety: A History and Theory of Popular Religious Images.* Berkeley: University of California Press, 1998.

———. *Protestants and Pictures: Religion, Visual Culture, and the Age of American Mass Production.* New York: Oxford University Press, 1999.

———. "Religion in the Context of Art." In *Like a Prayer: A Jewish and Christian Presence in Contemporary Art.* Charlotte: Tryon Center for Visual Art, 2001.

Morgan, David, and Sally M. Promey, eds. *Exhibiting the Visual Culture of American Religions.* Valparaiso: Brauer Museum of Art, Valparaiso University, 2000.

———. *The Visual Culture of American Religions.* Berkeley: University of California, 2001.

Moses, Kathy. *Outsider Art of the South.* Atglen: Schiffer Publishing, 1999.

Murray, Christopher. *Howard Finster: American Flag Paintings.* Washington: Govinda Gallery, 1992.

Natural Scriptures: Visions of Nature and the Bible. Bethlehem: Lehigh University, 1990.

Nellie Mae Rowe: Visionary Artist, 1900–1982. Atlanta: Southern Arts Federation, ca. 1983.

Ned Cartledge. Atlanta: Nexus Press, 1986.

Not by Luck: Self-Taught Artists in the American South. Milford: Lynne Ingram Southern Folk Art, 1993.

Oppenhimer, Ann F., and Susan Hankla, eds. *Sermons in Paint: A Howard Finster Folk Art Festival.* Richmond: University of Richmond, 1984.

Parrinder, Geoffrey. *African Mythology.* London: Paul Hamlyn, 1967.

Patterson, Tom. "Paradise Before and After the Fall." *Raw Vision* 35 (2001): 42–51.

Patton, Sharon F. *African American Art.* Oxford: Oxford University, 1998.

Perlmutter, Dawn, and Debra Koppmann, eds. *Reclaiming the Spiritual in Art: Contemporary Cross-Cultural Perspectives.* Albany: State University of New York Press, 1999.

Perry, Regenia. *Free within Ourselves: African-American Artists in the Collection of the National Museum of American Art.* Washington: National Museum of American Art, Smithsonian Institution, 1992.

———. *What It Is: Black American Folk Art from the Collection of Regenia Perry.* Richmond: Anderson Gallery, Virginia Commonwealth University, 1982.

Pictured in My Mind: Contemporary American Self-Taught Art from the Collection of Dr. Kurt Gitter and Alice Rae Yelen. Edited by Gail Andrews Trechsel. Birmingham: Birmingham Museum of Art, 1995.

Pinder, Kymberly N. "Our Father, God; Our Brother, Christ; or Are We Bastard Kin?: Images of Christ in African American Painting." *African American Review*, 31, 2 (Summer 1997): 223–33.

Point of View: American Folk Art from the William and Ann Oppenhimer Collection. Richmond: University of Richmond, 2001.

Popular Images, Personal Visions: The Art of William Hawkins 1895–1990. Columbus: Columbus Museum of Art, 1990.

Powell, Richard J. "Art, History, and Visions." *The Art Bulletin*, LXXVII, 3 (September 1995): 381–82.

Promey, Sally M. "The 'Return' of Religion in the Scholarship of American Art." *The Art Bulletin*, LXXXV, 3 (September 2003): 581–603.

Religious Visionaries. Sheboygan: John Michael Kohler Arts Center, 1991.

Rhodes, Colin. *Outsider Art: Spontaneous Alternatives.* New York: Thames and Hudson, 2000.

———. *Primitivism and Modern Art.* New York: Thames and Hudson, 1994.

Roach, Susan, ed. *On My Way: The Arts of Sarah Albritton.* Ruston: Louisiana Tech University Press, 1998.

Rodman, Selden. *Conversations with Artists.* New York: Devin-Adair Company, 1957.

Russell, Charles, ed. *Self-Taught Art: The Culture and Aesthetics of American Vernacular Art.* Jackson: University Press of Mississippi, 2001.

Self-Taught Artists of the Twentieth Century: An American Anthology. New York: Museum of American Folk Art, 1998.

Schaewen, Deidi von, and John Maizels. *Fantasy Worlds.* Koln: Taschen, 1999.

Spriggs, Lynne E. *Local Heroes: Paintings and Sculpture by Sam Doyle.* Atlanta: High Museum of Art, 2000.

Stanislewski, Mary Anne. *Believing Is Seeing: Creating the Culture of Art.* New York: Penguin Books, 1995.

Stone, Lisa, and Jim Zanzi. *Sacred Spaces and Other Places: A Guide to Grottos and Sculptural Environments in the Upper Midwest.* Chicago: School of the Art Institute of Chicago Press, 1993.

Swislow, Bill. Book Review of *Testimony: Vernacular Art of the African-American South. The Outsider* 6, 2 (Winter 2002): 9–11.

Tatham, David. "John Henry Bufford: American Lithographer." *Proceedings of the American Antiquarian Society* 86, I (1976): 47–73.

Testimony: Vernacular Art of the African-American South: The Ronald and June Shelp Collection. New York: H. N. Abrams in association with Exhibitions International and The Schomburg Center for Research in Black Culture, 2001.

Thompson, Robert F. "African Influence on the Art of the United States." In *Black Studies in the University: A Symposium.* Edited by Armstead L. Robinson, Craig C. Foster, and Donald H. Ogilvie. New York: Bantam Books, 1969.

———. *Flash of the Spirit: African and Afro-American Art and Philosophy.* New York: Vintage Books, 1984.

———. *Face of the Gods: Art and Altars of Africa and the African Americas.* New York: Museum of African Art, 1993.

Thompson, Robert F., and Joseph Cornet. *The Four Moments of the Sun: Kongo Art in Two Worlds.* Washington: National Gallery of Art, 1981.

Tuchman, Maurice, and Carol S. Eliel, eds. *Parallel Visions: Modern Artists and Outsider Art.* Los Angeles: Los Angeles County Museum of Art, 1992.

Turner, John F. *Howard Finster, Man of Visions: The Life and Works of a Self-Taught Artist.* New York: Alfred A. Knopf, 1989.

Visions of the Apocalypse: The Work of Myrtice West and the Rev. McKendree Long. Sweet Briar: Sweet Briar College, 1998.

Vlach, John M. *The Afro-American Tradition in Decorative Arts.* Athens: University of Georgia Press, 1990.

Wahlman, Maude S. *Signs and Symbols: African Images in African American Quilts.* New York: Studio Books, 1993.

Wertkin, Gerard C. *Millennial Dreams: Vision and Prophecy in American Folk Art.* New York: Museum of American Folk Art, 1999.

Westmacott, Richard. *African-American*

Gardens and Yards in the Rural South. Knoxville: University of Tennessee Press, 1992.

Wilson, Cleo. "Sermons on Scrolls: The Religious Art of Reverend Samuel David Phillips." *The Outsider* 3, 1 (Summer 1998): 12–13.

Wilson, James L. *Clementine Hunter: American Folk Artist.* Gretna: Pelican Publishing Company, 1990.

Yelen, Alice Rae. *Passionate Visions of the American South: Self-Taught Artists from 1940 to the Present.* New Orleans: New Orleans Museum of Art, 1993.

———. *A Spiritual Journey: The Art of Eddie Lee Kendrick.* New Orleans: New Orleans Museum of Art, 1998.

Young, Stephen. "'All of world–kind have been right here': The Theology and Architecture of Rev. H. D. Dennis." *Southern Quarterly* 39, 2 (Fall–Winter 2000–2001): 100–111.

Zolberg, Vera L., and Joni Maya Cherbo, eds. *Outsider Art: Contesting Boundaries in Contemporary Culture.* New York: Cambridge University Press, 1997.

RELIGION

Ammerman, Nancy Tatom. *Bible Believers: Fundamentalists in the Modern World.* New Brunswick: Rutgers University Press, 1987.

Balmer, Randall. *Mine Eyes Have Seen the Glory: A Journey into the Evangelical Subculture in America.* New York: Oxford University Press, 1989.

Berger, Peter. *The Sacred Canopy: Elements of a Sociological Theory of Religion.* Garden City: Doubleday, 1969.

Berkovitch, Sacvan. *The American Jeremiad.* Madison: University of Wisconsin Press, 1978.

Blum, Edith L. *Restoring the Faith: The Assemblies of God, Pentecostalism,*

and American Culture. Urbana: University of Illinois Press, 1993.

Bock, Darrell, ed. *Three Views on the Millennium and Beyond.* Grand Rapids: Zondervan, 1999.

Boyer, Paul S. *When Time Shall Be No More: Prophecy Belief in Modern American Culture.* Cambridge: Belknap Press of Harvard University Press, 1992.

———. "John Darby Meets Saddam Hussein: Foreign Policy and Bible Prophecy." *The Chronicle of Higher Education* (February 14, 2003): B10.

Braun, Willi, and Russell T. McCutcheon, eds. *Guide to the Study of Religion.* London: Cassell, 2000.

Brower, Kent E., and Mark W. Elliott, eds. *Eschatology in Bible and Theology: Evangelical Essays at the Dawn of a New Millennium.* Downers Grove: InterVarsity Press, 1997.

Burgess, Stanley M., and Gary B. McGee, eds. *Dictionary of Pentecostal and Charismatic Movements.* Grand Rapids: Zondervan, 1996.

Carpenter, Joel. *Revive Us Again: The Reawakening of American Fundamentalism.* New York: Oxford University Press, 1997.

Cherry, Conrad, ed. *God's New Israel: Religious Interpretations of American Destiny.* Chapel Hill: University of North Carolina Press, 1998.

Cleage, Albert B., Jr. *The Black Messiah.* Trenton: Africa World Press, 1995.

Clouse, Robert G., ed. *The Meaning of the Millennium: Four Views.* Downers Grove: InterVarsity Press, 1977.

Clouse, Robert G., Robert Hosack, and Richard Pierard. *The New Millennium Manual: A Once and Future Guide.* Grand Rapids: Baker Books, 1999.

Collin, John J., Bernard McGinn, and Stephen J. Stein, eds. *The Encyclopedia of Apocalypticism*, 3 vols. New York: Continuum, 1998.

Cone, James H. *God of the Oppressed.*

New York: Seabury Press, 1975.

Conklin, Paul. *American Originals: Homemade Varieties of Christianity.* Chapel Hill: University of North Carolina Press, 1997.

Cross, F. X., and E. A. Livingstone, eds. *The Oxford Dictionary of the Church,* 3rd edition. New York: Oxford University Press, 1993.

Daniels, Ted, ed. *A Doomsday Reader: Prophets, Predictors and Hucksters of Salvation.* New York: New York University Press, 1999.

Dayton, Donald, and Robert Johnston, eds. *The Variety of American Evangelicalism.* Downers Grove: InterVarsity Press, 1991.

Delumeau, Jean. *A History of Paradise: The Garden of Eden in Myth and Tradition.* New York: Continuum, 1995.

Eck, Diana L. *A New Religious America: How a "Christian Country" Has Become the World's Most Religiously Diverse Nation.* New York: HarperCollins, 2001.

Eliade, Mircea. *The Sacred and the Profane: The Nature of Religion.* Translated by Willard R. Trask. New York: Harcourt Brace, 1959.

———. *Myth and Reality.* Translated by Willard R. Trask. New York: Harper and Row, 1963.

Emmerson, Richard K., and Bernard McGinn. *The Apocalypse in the Middle Ages.* Ithaca: Cornell University Press, 1992.

Evans, James. *We Have Been Believers: An African American Systematic Theology.* Minneapolis: Fortress Press, 1992.

Frazier, E. Franklin. *The Negro Church in America.* New York: Schoken Books, 1964.

Fuller, Robert. *Naming the Antichrist: The History of an American Obsession.* New York: Oxford University Press, 1996.

Fulmer, Hal W. "Billy Graham." In

American Orators of the Twentieth Century: Critical Studies and Sources. Edited by Bernard K. Duffy and Halford R. Ryan. New York: Greenwood Press, 1987.

Grosso, Michael. *The Millennium Myth: Love and Death at the End of Time.* Wheaton: Theosophical Publishing House, 1995.

Halifax, Joan. *Shaman: The Wounded Healer.* London: Thames and Hudson, 1982.

Harvey, Paul. *Redeeming the South: Religious Cultures and Racial Identities Among Southern Baptist, 1865–1925.* Chapel Hill: University of North Carolina Press, 1997.

Hatch, Nathan I. *The Democratization of American Christianity.* New Haven: Yale University Press, 1989.

Hoyt, Thomas. "Interpreting Biblical Scholarship for the Church Tradition." In *Stony the Road We Trod: African American Biblical Interpretation.* Edited by Cain H. Felder. Minneapolis: Fortress Press, 1991.

Hunter, James Davison. *American Evangelicalism: Conservative Religion and the Quandary of Modernity.* New Brunswick: Rutgers University Press, 1983.

Hutton, Ronald. *Shamans: Siberian Spirituality and the Western Imagination.* London: Hambledon and London, 2001.

Kehoe, Alice Beck. *Shamans and Religion: An Anthropological Exploration in Critical Thinking.* Prospect Heights: Waveland Press, 2000.

LaHaye, Tim, and Thomas Ice. *Charting the End Times: A Visual Guide to Understanding Bible Prophecy.* Eugene: Harvest House Publishers, 2001.

Lawson, Josephine. *Reminiscences from a Simple Life: Or From Sweden to California.* Oakland: Messiah's Advocate, 1920.

———. *Wheel Chair Evangelism: My Childhood and Experiences in Gospel Work.* Pasadena: N.p., n.d.

Lindsey, Hal. *The Late Great Planet Earth.* Grand Rapids: Zondervan, 1970.

Marsden, George M. *Fundamentalism and American Culture: The Shaping of Twentieth-Century Evangelicalism, 1870–1925.* New York: Oxford University Press, 1980.

———. *Understanding Fundamentalism and Evangelicalism.* Grand Rapids: Wm. B. Eerdmans, 1991.

Mbiti, John S. *African Religions and Philosophy.* 2nd edition. Portsmouth: Heinemann, 1990.

McDannell, Colleen. *Material Christianity: Religion and Popular Culture in America.* New Haven: Yale University Press, 1995.

McGinn, Bernard. *Antichrist: Two Thousand Years of the Human Fascination with Evil.* San Francisco: HarperSanFrancisco, 1994.

McGinn, Bernard, and Bernhard Lang. *Heaven: A History.* New Haven: Yale University Press, 1988.

Metzger, Bruce M., and Michael D. Coogan, eds. *The Oxford Companion to the Bible.* New York: Oxford University Press, 1993.

Narby, Jeremy, and Francis Huxley, eds. *Shamans Through Time: 500 Years on the Path to Knowledge.* New York: Jeremy P. Tarcher/Putnam, 2001.

Newman, Kim. *Apocalypse Movies: End of the World Cinema.* London: Titan Books, 1999.

Pelton, Robert D. *The Trickster in West Africa: A Study of Mythic Irony and Sacred Delight.* Berkeley: University of California Press, 1980.

Phy, Allene Stuart, ed. *The Bible and Popular Culture in America.* Philadelphia: Fortress Press, 1985.

Prothero, Stephen. *American Jesus: How the Son of God Became a National Icon.* New York: Farrar, Straus, and Giroux, 2003.

Ricketts, M. L. "The Structure and Religious Significance of the Trickster-Transformer-Culture Hero in the Mythology of the North American Indians." Ph.D. dissertation, University of Chicago, 1974.

Sexon, Lynda. *Ordinarily Sacred.* Charlottesville: University Press of Virginia, 1992.

Smith, Jonathan Z. *Map Is Not Territory: Studies in the History of Religions.* Leiden: E. J. Brill, 1978.

Smith, Theophilus H. *Conjuring Culture: Biblical Formations of Black America.* New York: Oxford University Press, 1994.

Staniszewski, Mary Anne. *Believing Is Seeing: Creating the Culture of Art.* New York: Penguin Books, 1995.

Strozier, Charles B. *Apocalypse: On the Psychology of Fundamentalism in America.* Boston: Beacon Press, 1994.

Swatos, William H., Jr., ed. *Encyclopedia of Religion and Society.* Walnut Creek: AltaMira Press, 1998.

Sweet, Leonard, ed. *The Evangelical Tradition in America.* Macon: Mercer University Press, 1997.

Sweet, William Warren. *The Story of Religion in America.* New York: Harper, 1939.

Synan, Vinson. *The Holiness Pentecostal Tradition: Charismatic Movements in the Twentieth Century.* Grand Rapids: Wm. B. Eerdmans, 1977.

This Far by Faith: American Black Worship and Its African Roots. Washington: The National Office for Black Catholics, 1997.

Thompson, Damien. *The End of Time: Faith and Fear in the Shadow of the Millennium.* Hanover: University Press of New England, 1996.

Turner, Helen Lee. "Myths: Stories of the World and the World to Come." In *Southern Baptists Observed: Multiple Perspectives on a Changing Denomi-*

nation. Edited by Nancy Tatom Ammerman. Knoxville: University of Tennessee Press, 1993.

Unger, Merrill F. *The New Unger's Bible Dictionary*, rev., updated edition. R. K. Harrison, ed. Chicago: Moody Press, 1988.

Washington, James, ed. *Conversations with God: Two Centuries of Prayers by African Americans.* New York: HarperCollins, 1994.

Weber, Eugene. *Apocalypses: Prophecies, Cults, and Millennial Beliefs through the Ages.* Cambridge: Harvard University Press, 1999.

Wojcik, Daniel. *The End of the World as We Know It: Faith, Fatalism, and Apocalypse in America.* New York: New York University Press, 1999.

Woodson, Carter G. *The History of the Negro Church.* Washington: The Associated Publishers, 1928.

Wuthnow, Robert. *After Heaven: Spirituality in America Since the 1950s.* Berkeley: University of California Press, 1998.

Zaleski, Carol. *Otherworld Journeys: Accounts of Near-Death Experience in Medieval and Modern Times.* New York: Oxford University Press, 1987.

SOUTHERN CULTURE

Anderson-Green, Paula Hathaway. "'The Lord's Work': Southern Folk Belief in Signs, Warnings, and Dream-Visions." *Tennessee Folklore Bulletin* 43, 3 (September 1977): 113–27.

Caron, Timothy P. *Struggle over the Word: Race and Religion in O'Connor, Faulkner, Hurston, and Wright.* Macon: Mercer University Press, 2000.

Dixie Hummingbirds. *The Best of the Dixie Hummingbirds.* MCA 08811-28642.

Douglass, Frederick. *Life and Times of Frederick Douglass.* Hartford: Park Publishing Company, 1881.

Edwards, Harry S. *The Two Runaways and Other Stories.* New York: Century Press, 1889.

Faulkner, William. *Light in August.* New York: Vintage, 1972.

———. *Absalom, Absalom!* New York: Vintage, 1972.

———. *Requiem for a Nun.* New York: Vintage, 1975.

Fisher-Hornung, Dorothea, and Allison D. Goeller, eds. *Embodying Liberation: The Black Body in American Dance.* Hamburg: LIT Verlag Munster, 2001.

Fulmer, Hal W. "Southern Clerics and the Passing of Lee: Mythic Rhetoric and the Construction of a Sacred Symbol." *Southern Communication Journal* (1990): 355–71.

Gates, Henry L. *The Signifying Monkey: A Theory of African American Literary Criticism.* New York: Oxford University Press, 1988.

Genovese, Eugene. *Roll, Jordan, Roll: The World the Slaves Made.* New York: Vantage Press, 1976.

Gil, Jose. *Metamorphoses of the Body.* Translated by Stephen Muecke. Minneapolis: University of Minnesota Press, 1998.

Goen, C. C. *Broken Churches, Broken Nation: Denominational Schisms and the Coming of the American Civil War.* Macon: Mercer University Press, 1980.

Georgia Writer's Project. *Drums and Shadows: Survival Studies among the Coastal Georgia Negroes.* Athens: University of Georgia Press, 1940.

Goff, James R., Jr. *Close Harmony: A History of Southern Gospel.* Chapel Hill: University of North Carolina Press, 2002.

Gwynn, Fredrick L., and Joseph L. Blotner, eds. *Faulkner in the University: Class Conferences at the University of Virginia, 1957–58.* Charlottesville: University of Virginia Press, 1959.

Harvey, Paul. "Religion in the American South Since the Civil War." In *A Companion to the American South.* Edited by John Boles. Oxford: Blackwell Press, 2002.

Heyrman, Christine. *Southern Cross: The Beginnings of the Bible Belt.* New York: Alfred A. Knopf, 1997.

Hill, Samuel S. *Southern Churches in Crisis.* New York: Holt, Rinehart, and Winston, 1967.

———. *Religion and the Solid South.* Nashville: Abingdon Press, 1972.

———. *The South and the North in American Religion.* Athens: University of Georgia Press, 1980.

———, ed. *Encyclopedia of Religion in the South.* Macon: Mercer University Press, 1984.

Holland, DeWitte. *Preaching in American History.* Nashville: Abingdon Press, 1969.

Hurston, Zora Neale. *Moses, Man of the Mountain.* Philadelphia: J. B. Lippincott, 1939.

———. *Dust Tracks on a Road: An Autobiography.* Philadelphia: J. B. Lippincott, 1939.

Johnson, James W. *God's Trombones: Seven Negro Sermons in Verse.* New York: Viking Press, 1927.

Jones, Loyal. *Faith and Meaning in the Southern Uplands.* Urbana: University of Illinois Press, 1999.

Joyner, Charles. *Shared Traditions: Southern History and Folk Culture.* Urbana: University of Illinois Press, 1999.

Kell, Carl L., and L. Raymond Camp. *In the Name of the Father: The Rhetoric of the New Southern Baptist Convention.* Carbondale: Southern Illinois University Press, 1999.

Ketchin, Susan. *The Christ-Haunted Landscape: Faith and Doubt in Southern Fiction.* Jackson: University Press

of Mississippi, 1994.

Loveland, Anne C. *Southern Evangelicals and the Social Order, 1800–1860*. Baton Rouge: Louisiana State University Press, 1980.

Lovell, John. *Black Song: The Forge and the Flame: The Story of How the Afro-American Spiritual Was Hammered Out*. New York: Paragon House, 1972.

Mathews, Donald. *Religion in the Old South*. Chicago: University of Chicago Press, 1977.

Miller, Joyce Ann. "In the Handywork of Their Craft Is Their Prayer: African-American Religious Folk Art in the Twentieth-Century South." Master's thesis, University of Mississippi, 1992.

Miller, Randall M., and John L. Wakelyn. *Catholics in the Old South: Essays on Church and Culture*. Macon: Mercer University Press, 1983.

Miller, Randall M., Harry S. Stout, and Charles Reagan Wilson, eds. *Religion and the American Civil War*. New York: Oxford University Press, 1999.

Mills, Gary B. *The Forgotten People: Cane River's Creoles of Color*. Baton Rouge: Louisiana State University Press, 1972.

Mitchell-Kerman, C. "Signifying." In *Mother Wit from the Laughing Barrel: Readings in the Interpretation of Afro-American Folklore*. Edited by Alan Dundes. Englewood Cliffs: Prentice-Hall, 1973.

Montgomery, William. *Under Their Own Vine and Fig Tree: The African-American Church in the South, 1865–1900*. Baton Rouge: Louisiana State University Press, 1992.

Moses, Wilson J. *Black Messiahs and Uncle Toms: Social and Literary Manipulations of a Religious Myth*. University Park: Pennsylvania State University Press, 1982.

Murphy, Joseph M. *Working the Spirit: Ceremonies of the African Diaspora*.

Boston: Beacon Press, 1994.

Naipaul, V. S. *A Turn in the South*. New York: Alfred A. Knopf, 1989.

O'Connor, Flannery. *Mystery and Manners*. Edited by Sally and Robert Fitzgerald. New York: Farrar, Straus, and Giroux, 1969.

Ownby, Ted. "Struggling to Be Old-Fashioned: Evangelical Religion in the Modern Rural South." In *The Rural South Since World War II*. Edited by Douglas R. Hurt. Baton Rouge: Louisiana State University Press, 1998.

Raboteau, Albert. *Slave Religion: The "Invisible Institution" in the Antebellum South*. New York: Oxford University Press, 1979.

———. *Canaan Land: A Religious History of African Americans*. New York: Oxford University Press, 2001.

Reed, John Shelton, and Dale Volberg Reed. *1001 Things Everyone Should Know about the South*. New York: Broadway Books, 1996.

Sasson, Diane Hyde. "'The Stone': Versions of a Camp-meeting Song Collected in North Carolina." *Southern Folklore Quarterly* 42, 4 (1978): 375–84.

Smith, Lillian. *How Am I to Be Heard: Letters of Lillian Smith*. Edited by Margaret Rose Gladney. Chapel Hill: University of North Carolina Press, 1993.

Sobel, Mechal. *The World They Made Together: Black and White Values in Eighteenth-Century Virginia*. Princeton: Princeton University Press, 1987.

———. *Trabelin' On: The Slave Journey to an Afro-Baptist Faith*. Princeton: Princeton University Press, 1990.

Southern, Eileen. *The Music of Black Americans: A History*. 3rd edition. New York: W. W. Norton, 1997.

———, ed. *Readings in Black American Music*. New York: W. W. Norton, 1983.

Spencer, Jon Michael. *Blues and Evil*.

Knoxville: University of Tennessee Press, 1993.

Stuckey, Sterling. *Slave Culture: Nationalist Theory and the Foundations of Black America*. New York: Oxford University Press, 1987.

Walker, Alice, ed. *I Love Myself When I Am Laughing . . . And Then Again When I Am Looking Mean and Impressive: A Zora Neale Hurston Reader*. Old Westbury: Feminist Press, 1979.

Wilson, Charles Reagan. *Baptized in Blood: The Religion of the Lost Cause, 1865–1920*. Athens: University of Georgia Press, 1980.

———. *Judgment and Grace in Dixie: Southern Faiths from Faulkner to Elvis*. Athens: University of Georgia Press, 1995.

———. "Flashes of the Spirit: Creativity and Southern Religion." *Image* 24 (Fall 1999): 72–86.

Wilson, Charles Reagan, and William Ferris, eds. *Encyclopedia of Southern Culture*. Chapel Hill: University of North Carolina Press, 1989.

Wolfe, Charles K. *In Close Harmony: The Story of the Louvin Brothers*. Jackson: University Press of Mississippi, 1996.

Wright, Richard. *Uncle Tom's Children*. New York: Harper and Brothers, 1938.

———. *Black Boy: A Record of Childhood and Youth*. New York: Harper and Brothers, 1945.

Photography Credits

Illus. I-1 David Horan

Illus. I-2 David Horan

Illus. I-3 Copyright © Myrtice West, photo reproduced with permission from Rollin Riggs

Illus. I-4 David Horan

Illus. I-5 Bill Crawford, CNC Photographics

Illus. III-1 Copyright © 2004 Kate Rothko Prizel & Christopher Rothko / Artist Rights Society (ARS), New York

Illus. III-2 Smithsonian American Art Museum, Washington, D.C. / Art Resource, NY

Illus. III-3 Copyright © Kiki Smith, Ellen Page Wilson, courtesy Pace Wildenstein, New York

Illus. III-4 Copyright © 2004 Andy Warhol Foundation for the Visual Arts / ARS, New York, Richard Stoner

Illus. III-5 Copyright © Nancy Reddin Kienholz, photo courtesy of L. A. Louver, Venice, CA

Illus. III-6 David Horan

Illus. IV-1 David Horan

Illus. V-1 Stephen Pitkin, Rockford, IL, with permission from William Arnett

Illus. V-2 Dirk Bakker

Illus. V-3 Smithsonian American Art Museum, Washington, D.C. / Art Resource, NY

Illus. VI-1 Carol Crown

Illus. VI-2 David Horan

Illus. VII-1 Carol Crown

Illus. VII-2 David Horan

Illus. VII-3 David Horan

Illus. VII-4 David Horan

Illus. VII-5 Carol Crown

Illus. VII-6 Carol Crown

Plate 1 Randy A. Batista

Plate 2 Peter Jones

Plate 3 David Horan

Plate 4 David Horan

Plate 5 Linda Anderson

Plate 6 Linda Anderson

Plate 7 Linda Anderson

Plate 8 David Horan

Plate 9 David Horan

Plate 10 Courtesy of Phyllis Kind Gallery

Plate 11 Bill Crawford, CNC Photo-graphics

Plate 12 David Horan

Plate 13 David Horan

Plate 14 David Horan

Plate 15 David Horan

Plate 16 Mary S. Rezny

Plate 17 Cal Kowal

Plate 18 Mary S. Rezny

Plate 19 John Parnell

Plate 20 Bill Crawford, CNC Photo-graphics

Plate 21 David Horan

Plate 22 David Horan

Plate 23 August Bendal

Plate 24 W. Miles Wright

Plate 25 David Horan, with permission from Luise Ross Gallery

Plate 26 David Horan, with permission from Luise Ross Gallery

Plate 27 John R. Glembin

Plate 28 David Horan

Plate 29 David Horan

Plate 30 Peter Vitale

Plate 31 David Horan

Plate 32 David Horan

Plate 33 David Horan

Plate 34 David Horan

Plate 35 David Horan

Plate 36 The Mennello Museum of American Folk Art

Plate 37 David Horan

Plate 38 John Turner

Plate 39 Brandon Webster Photography

Plate 40 David Horan

Plate 41 Randy A. Batista

Plate 42 Cavanaugh and Blue

Plate 43 David Horan

Plate 44 David Horan

Plate 45 David Horan

Plate 46 David Horan

Plate 47 David Horan

Plate 48 David Horan

Plate 49 David Horan

Plate 50 David Horan

Plate 51 David Horan

Plate 52, Bill Crawford, CNC Photographics

Plate 53 David Horan

Plate 54 David Horan

Plate 55 David Horan

Plate 56 Katherine Wetzel

Plate 57 New Orleans Museum of Art

Plate 58 Bill Crawford, CNC
 Photo-graphics

Plate 59 David Horan

Plate 60 David Horan

Plate 61 David Horan

Plate 62 David Horan

Plate 63 David Horan

Plate 64 David Horan

Plate 65 David Horan

Plate 66 David Horan

Plate 67 David Horan

Plate 68 David Horan

Plate 69 David Horan

Plate 70 David Horan

Plate 71 David Horan

Plate 72 Columbus Museum of Art

Plate 73 David Horan

Plate 74 David Horan

Plate 75 David Horan

Plate 76 William Bengtson

Plate 77 Columbus Museum of Art

Plate 78 David Horan

Plate 79 David Horan

Plate 80 David Horan

Plate 81 David Horan

Plate 82 David Horan

Plate 83 Lynn Lown

Plate 84 David Horan

Plate 85 David Horan

Plate 86 David Horan

Plate 87 David Horan

Plate 88 David Horan

Plate 89a, Plate 89b, Plate 89c
 David Horan

Plate 90 Bill Crawford, CNC
 Photo-graphics

Plate 91 Bill Crawford, CNC
 Photo-graphics

Plate 92 David Horan

Plate 93 David Horan

Plate 94 Bryan Blankenship

Plate 95 David Horan

Plate 96 David Horan

Plate 97 George and Sue Viener

Plate 98 Chuck and Jan Rosenak

Plate 99 David Horan

Plate 100 David Horan

Plate 101 Bill Crawford, CNC
 Photographics

Plate 102 David Horan

Plate 103 Bill Crawford, CNC
 Photographics

Plate 104 Joshua Kaplan

Plate 105 William Thomas Thompson

Plate 106 William Thomas Thompson

Plate 107 David Horan

Plate 108 Efraim Lev-er

Plate 109 Mary S. Rezny

Plate 110 David Horan

Plate 111 David Horan

Plate 112 David Horan

Plate 113 David Horan

Plate 114 David Horan

Plate 115 David Horan

Plate 116 Copyright © Myrtice West,
 permission Rollin Riggs

Plate 117 Copyright © Myrtice West,
 permission Rollin Riggs

Plate 118 Copyright © Myrtice West,
 permission Rollin Riggs

Plate 119 Copyright © Myrtice West,
 permission Rollin Riggs

Plate 120 Copyright © Myrtice West,
 permission Rollin Riggs

Plate 121 Copyright © 1999,
 Maryland E. Williams, David Horan

Plate 122 Skot Foreman Fine Art

Contributors

ESSAYISTS

Carol Crown is curator of *Coming Home!* and an associate professor of art history at the University of Memphis. She holds the Ph.D. in medieval art history from Washington University, St. Louis. Her research focuses on the connections between art and religion, especially in the work of contemporary self-taught artists. Dr. Crown is the editor and essayist of *Wonders to Behold! The Visionary Art of Myrtice West* (Mustang Publishing Company, 1999), an anthology of writings by leading folk art scholars and writers in the field.

Erika Doss is director of American studies and a professor of art history at the University of Colorado, Boulder. She specializes in the study of American and contemporary art history, material culture, visual culture, and critical theories of art history. Dr. Doss is the author of *Twentieth-Century American Art* (Oxford University Press, 2002) and *Elvis Culture: Fans, Faith, and Image* (Lawrence: University Press of Kansas, 1999).

Hal Fulmer is a professor and dean of the College of Communication and Fine Arts, Troy State University and executive director of the Southern States Communication Association. Dr. Fulmer holds a Ph.D. in rhetorical theory and maintains an active interest in Southern oratory, especially that of Southern clerics. His writing on Billy Graham appears in *American Orators of the Twentieth Century: Critical Studies and Sources* (Greenwood Press, 1997).

N. J. Girardot, professor of religious studies at Lehigh University, is a specialist in Chinese religions and author of numerous books including *Daoism and Ecology: Ways within a Cosmic Landscape* (Harvard University, 2001). A long-time folk art enthusiast, Dr. Girardot is a leading specialist on the work of self-taught artists. His work appears in *Self-Taught Artists of the Twentieth Century: An American Anthology* (Chronicle Books, 1998).

Paul Harvey, associate professor of history, University of Colorado at Colorado Springs, researches and writes in the field of post–Civil War American religious history, popular culture, war and society, and the history of American music. Dr. Harvey is the author of *Redeeming the South: Religious Cultures and Racial Identities among Southern Baptists, 1865–1925* (University of North Carolina Press, 1997).

Lee Kogan is the director of the American Folk Art Museum's Folk Art Institute, curator of special projects for the Contemporary Center of the museum, and an adjunct professor of art and art education at New York University. She writes and lectures extensively on American folk art and is the author of *Nellie Mae Rowe: Ninety-Nine and a Half Won't Do* (Museum of American Folk Art, 1999).

Babatunde Lawal, professor of African, African American, and Diaspora art, Virginia Commonwealth University, served as the first Dorothy Kayser Hohenberg Chair of Excellence in Art History at the University of Memphis. The author of numerous books in the field of African art, including *The Gelede Spectacle: Art, Gender, and Social Harmony in an African Culture* (University of Washington Press, 1996), Dr. Lawal's work on contempo-

rary folk art appears in both volumes of *Souls Grown Deep: African American Vernacular Art* (Tinwood Books, 2000–2001).

Leslie Luebbers is director of the Art Museum of the University of Memphis and project director of *Coming Home! Self-Taught Artists, the Bible, and the American South*. She holds the A.B. in history from Wellesley College, M.A.T. in history from Johns Hopkins University and M.A. and Ph.D. in the history of twentieth-century art and architecture from New York University's Institute of Fine Arts. She writes about contemporary art and architecture.

Cheryl Rivers, a member of the American Folk Art Museum's Folk Art Institute, holds the Ph.D. in American studies. She has published in the *Folk Art Messenger* and in numerous catalogs published by the American Folk Art Museum. She is editing a book on the self-taught artist Donald Mitchell for the Creative Growth Center in Oakland, California.

Charles Reagan Wilson, director of the Center for Southern Culture and professor of history at the University of Mississippi, is the author of numerous books on the art, religion, music, and culture of the South, including *Judgment and Grace in Dixie: Southern Faiths from Faulkner to Elvis* (University of Georgia Press, 1995). He is coeditor of the *Encyclopedia of the Southern Culture* (University of North Carolina Press, 1989).

OTHER CONTRIBUTORS

Lynne Brown, a docent at Atlanta's High Museum of Art and one of contemporary folk art's most enthusiastic supporters and collectors, writes for the *Folk Art Messenger* and serves on the National Advisory Board for the Folk Art Society of America.

Ann Oppenhimer is the founder and president of the Folk Art Society of America, publisher of the *Folk Art Messenger* and a collector of contemporary folk art. Works from her collection are featured in the touring exhibition *Point of View: Folk Art from the William and Ann Oppenhimer Collection*.

Susan Turner Purvis was the first person to recognize the talent of self-taught artist Eddie Lee Kendrick and encouraged the organization of the exhibition *A Spiritual Journey: The Art of Eddie Lee Kendrick* in 1998, for which she wrote the educator's guide.

Current and past University of Memphis graduate students who contributed to the catalog include Judi "Mac" Birkitt, Debra Blundell, Deborah Cox, Katherine LoBianco, Robbie McQuiston, and Susan Sanders.

Index